Father of the Modern Circus
'BILLY BUTTONS'

T0204432

Reviews

*F*ather of the Modern Circus: The Life & Times of Philip Astley pulls together the wide range of information available on the great man (while even unearthing more) and ends up contributing a worthwhile tome to celebrate Circus 250.

Yes, Astley is considered the 'Father of Modern Circus' but this book rightly places him within his historical and artistic context, honestly pointing out his faults and highlighting the innovations he implemented. Because of this we have the sense of the man, and not solely the mythology that links us to him. Those interested in the art form will learn about the roots of what we have today and those of us that have spent years within it will discover more of what we love about it.

Happy Birthday Circus, and with this book we have yet more to celebrate.

Tim Roberts
Directeur Pédagogique de la Formation Professionnelle
École de Cirque de Québec

The new book by Steve Ward, *Billy Buttons*, is a very well researched slice of the life and times of Philip Astley, the Father of the Circus.

It is not in any way a dry historical document, but pulls you into the story and the lives of the principals. It not only deals with Astley and his larger than life story, but fills in all the important historic events of Great Britain of the time. I was swept up in the story and found it hard to put down.

Chuck Johnson
Former President of the American Youth Circus Organisation

Billy Buttons offers a well-researched, factual account of the life and times of Phillip Astley; the man referred to as the 'Father of the Modern Circus'.

It offers a fascinating and informative insight into the origins of the modern-day circus: shaped by a visionary entrepreneur who challenged and changed the fashions and mores of late eighteenth-century English society.

A welcome addition to the genre.

Ian Scott Owens
Circus Arts Education

It's a really lively read. I like your writing style and think it is engaging for people who don't already have an affinity with the subject. This is really good as we are keen for Astley's story to be shared widely.

Kat Evans
External Projects Manager, Institute for Research and
Knowledge Exchange, Staffordshire University

... a thoroughly researched piece of colourful history. An astounding well of information for any circus lover.

Olli Ricken, professional clown and circus educator, New Zealand

Father of the Modern Circus 'BILLY BUTTONS'

The Life & Times of Philip Astley

Steve Ward

PEN & SWORD HISTORY

First published in Great Britain in 2018 by
Pen & Sword History
an imprint of
Pen & Sword Books Ltd
47 Church Street
Barnsley, South Yorkshire
S70 2AS

Copyright © Steve Ward, 2018
ISBN 978 1 52670 687 4

Typeset in Ehrhardt by
Geniies IT & Services Pvt Ltd

Printed and bound by CPI Group (UK) Ltd, Croydon, CR0 4YY

Pen & Sword Books Limited incorporates the imprints of Atlas,
Archaeology, Aviation, Discovery, Family History, Fiction,
History, Maritime, Military, Military Classics, Politics, Select,
Transport, True Crime, Air World, Frontline Publishing,
Leo Cooper, Remember When, Seaforth Publishing,
The Praetorian Press, Wharncliffe Local History, Wharncliffe Transport,
Wharncliffe True Crime and White Owl.

For a complete list of Pen & Sword titles please contact
PEN & SWORD BOOKS LIMITED
47 Church Street, Barnsley, South Yorkshire, S70 2AS, United Kingdom
E-mail: enquiries@pen-and-sword.co.uk
Website: www.pen-and-sword.co.uk

For Linda, my constant encouragement and support

Contents

Acknowledgements

In compiling this book I have received help and support from many people. Although they are far too numerous to mention in full, I am grateful for the assistance they have given me, but I would specifically like to mention the following:

The staff of the National Fairground Archive in Sheffield; the staff of the Brampton Museum in Newcastle-under-Lyme; the staff of the British Library, both in London and in Boston Spa; the staff of The Leeds Library; Andrew Van Buren; Marius Kwint; Claire Batley, Senior Archivist at the Parliamentary Archives; Stuart Ivinson of the Royal Armouries Library in Leeds; Martin Wills, Lisa Traynor and Henry Yallop of the Royal Armouries in Leeds ... and my wife Linda, whose help and support I wouldn't be without.

Foreword

Dear, dear, what a place it looked, that Astley's; with all the paint, gilding, and looking-glass; the vague smell of horses suggestive of coming wonders; the curtain that hid such gorgeous mysteries; the clean white sawdust down in the circus ... the clown who ventured on such familiarities with the military man in boots – the lady who jumped over the nine-and-twenty ribbons and came down safe upon the horse's back – everything was delightful, splendid, and surprising!

<div align="right">

The Old Curiosity Shop, Charles Dickens, 1841

</div>

For many of us who have been to a circus as a child, the wonderment of it all stays with us for the rest of our lives, just as with Charles Dickens above. The circus is a magical place – a place where the impossible becomes possible; a place of dreams and imagination – and it has entertained us for 250 years. Although feats of physical activities have been with us for thousands of years, the story of the rise of the 'modern' circus is both fascinating and colourful. And it may not have happened had it not been for a man named Philip Astley. His story is the story of the foundations of the circus as we might recognise it today: the performing horses, the ringmaster, the acrobats, the clowns, and all the other paraphernalia of the circus world. Born out of war, this fashionable entertainment rapidly rose to popularity during the latter part of the eighteenth century and beyond; Astley's became the place to see and be seen. It was a place of entertainment for all ranks; from royalty to commoner, it had no boundaries.

The name of Astley is synonymous with the circus, and it is his story that is told in this book. From humble beginnings to an international impresario, researching his life and legacy has been a fascinating journey of discovery. I hope it will be entertaining as well as informative. Those of you who are circus fans will, I hope, find something new in this book; some aspect of circus you never knew about. For those with a passing interest, I hope to share with you a world as you might never have imagined it: the triumphs and disasters, the trials and tribulations, and the downright bizarre – the world of the circus.

<div align="right">

Steve Ward
Leeds, 2018

</div>

Introduction

The circus is a very British institution. It seems to permeate our cultural psyche. Stop anyone in the street and ask them if they know what a circus is and you will get a definite answer. There are very few who have no understanding of what a circus is, irrespective of their opinions. Circus imagery is around us everywhere; from brightly coloured circus posters to advertising motifs on television, the circus is with us. It has been written about in literature; it has been a source for some of the great artists; it has been the subject of many films; it appears on postage stamps and other ephemera; it is a basis of many children's toys and games; it features in graffiti; and provides invaluable source material for schools and libraries. It has even infiltrated our very language. How often do we hear of juggling the finances, walking a fine wire, clowning around, and putting one's head into the lion's jaw? On the other hand, the word is frequently used in a pejorative way to reflect something chaotic and anarchic. But this in itself reveals just how much the circus has been ingrained in our society across the years. It seems that it has been with us forever, but the circus as we know it today is a relevantly modern creation. The associated brightly coloured big top and the razzmatazz are very much an American import, but the foundations for all this were laid in eighteenth-century Britain.

It was a turbulent century. The nation would see the growth of the Industrial Revolution, with Britain moving from an agrarian to an industrial economy. Thousands of people would move to the growing cities, causing rapid urban expansion – and increased poverty. To meet a growing demand, manufacturing would move from the domestic system of home-based production to large industrial factories. It was a period in which Britain fought several wars, mainly against the French. There were wars across Europe, and it was a time of Imperial expansion, with Britain establishing a firm footing in Canada and India; the East India Company would become a strong force within the subcontinent for many years. It was also a time of military defeat, with Britain losing the revolutionary war in its American colonies. The eighteenth century was a time of exploration and discovery, too. Captain James Cook made three voyages before his untimely death in 1779 at the hands of natives in Hawaii. During his expeditions he 'discovered' Australia, New Zealand and many of the Pacific islands, claiming them all as part of an expanding British Empire.

On the home front, Britain was witnessing a century of social and political unrest. As the country began to move towards a more market-based economy it brought large groups of workers together, who were to share the same working conditions on a daily basis. This created a 'class consciousness' that would lead to a working–class action against a perceived oppressive government and rotten political system. During the second half of the century, there were many riots and protests across the country. High food prices brought about a series of orchestrated actions, known collectively as the 'food riots'. The government sent troops to deal with these as well as to prevent wide-scale civil disorder. The events of the French Revolution made the government very afraid that the same could happen in Britain. Popular Reform activists, such as John Wilkes, had the support of the general populace. Writers such as Thomas Paine (*The Rights of Man*, 1791) and Mary Wollstonecraft (*A Vindication of the Rights of Woman*, 1792) expounded their philosophies for democratic reform. Radical organisations were established towards the end of the century. The London Corresponding Society of Artisans and The Scottish Friends of the People Society were two more notable ones; all supported a more egalitarian society and a rejection of the monarchy and the aristocracy. It had only been in the previous century that Britain had gone through a period of civil war. The government, fearing a popular revolution, countered with the Seditious Meetings Act of 1795, requiring meetings of fifty or more persons to be licensed. It was a period of great instability and uncertainty, compounded by the fact that King George III suffered from increasing episodes of mental illness.

Social revolutions very often bring about artistic revolutions, and it was in this period of confusion and volatility that the foundations of the 'modern' circus were laid. Philip Astley is commonly credited with the foundation of the circus in 1768. Some have even said that he invented the circus, but it is difficult to invent something that already exists, albeit in other forms. When Astley mounted his horse and gave an exhibition of *haute école* and trick riding, he was not even the first to do so. He never used the word 'circus' and he never called his performance area the 'ring'; that would be for others to name. So what claim does Astley have in being the father of the modern circus? First and foremost, he was a natural showman and an entrepreneur. He was not a reserved man and almost everything that he did was with ostentation. He was arrogant, egotistical, bombastic, and had a firm self-belief. Astley was also a great imitator; he was not afraid to take someone else's ideas and develop them into something bigger and better to suit his own purpose. It was this ability to develop ideas into a new style of popular entertainment and to place them within a purpose-built venue that gives him the accolade of being the 'founder' of the modern circus. Yes, there were others in the field, and these increased in number as the popularity of the 'circus' grew.

Astley was the right man in the right place at the right time. If he had not been, then I am sure we would be giving the accolade to another. The time was right for the development of circus as an embryonic art form; it would have happened anyway, without a doubt. Artistic revolution was in the air. Success breeds imitation, and many sought to emulate Astley throughout his lifetime and beyond. His is a story of rags to riches; of country apprentice to war hero; of daring escapes; of triumphs and disasters; of rubbing shoulders with royalty; and of international fame. His story is as colourful and fascinating as the circus itself.

Chapter 1

Life before Astley

Philip Astley did not invent the circus. Generic physical skills had been in existence for thousands of years before his time. The origins of many of these will never be known. We do not know who was the first person to balance across a thin rope or walk upon stilts or manipulate objects in time and space and begin to juggle, or, more importantly, why. Many of these skills will have had their origins in practical needs, and I have an image in my mind of some primitive person raking potatoes or roots from the hot embers and then tossing them from hand to hand because they were too hot to hold. Who knows? Many circus skills are rooted in ancient folk cultures. On the island of Crete, Minoan frescoes show young acrobats vaulting over charging bulls, but it is not just the Minoan culture that shows us physical 'circus' activities being exhibited. A wall painting in the fifteenth tomb at Beni Hassan in Egypt depicts female jugglers and acrobats, and dates from about 1900 BC. A century earlier, also in Egypt, the young Pharaoh Pepi gave the first recorded performance of a clown. In the ancient Greece of 700 BC, wandering clown figures were seen in Sparta. Meanwhile in China, the tradition of circus goes back some 4,000 years and is steeped in symbolism; traditional plate spinning was thought to be a way of man communicating with the gods. During the Han dynasty, plate spinning and acrobatics were used to impress visitors to the Emperor's court. In parts of Africa, traditional stilt dancers used their magical powers to reach up high to drive away evil spirits from the village. Many of these skills had a religious or ritualistic context. There is still something quite magical about someone who can juggle or stilt walk or ride a unicycle, and their skills seem to transcend the human experience. For us mere mortals these people are beyond human, imbued with magic. Little wonder that in ancient Japan an army was put to flight by the sight of one soldier juggling with seven swords.

Throughout the Middle Ages, the tradition of the itinerant performer continued. They appeared under a variety of names from the ninth to the seventeenth centuries: jongleurs, gleemen, troubadours and jesters. These would be adept in a diversity of skills: acrobatics, juggling, legerdemain and foolery. Sometimes they were skilled in music and song as well. They performed where they could, at fairs and markets and anywhere else a crowd might gather, such as depicted in the seventeenth-century painting *The Village Fair*, by Pieter Brueghel the Younger. At a time when social mobility was very constrained – farmers begat farmers, carpenters

begat carpenters and so on – the jester could, and sometimes did, move beyond his class. Occasionally, these performers would be engaged or retained by noblemen, and their displays of physical skills we would acknowledge in a circus today. One unidentified jongleur is referred to by G. Speaight (1980), who described his ability to sing a song well, and make tales to please young ladies. He could throw knives into the air and catch them without cutting his fingers. He could balance chairs and make tables dance; he could somersault and walk upon his hands.

However, jongleurs were not always desirable people. The fourteenth-century Italian poet Petrarch referred to them as 'people of no great wit and impudent beyond measure'. If jongleurs were not well accepted then there was another form of entertainer who accorded even less respect – the gleeman. As entertainers, they were very much considered the lowest of the low. Female counterparts to these male entertainers were also recorded at this time. These were known as gleemaidens and could be as skilled as the men. It is thought that female performers were not as uncommon during the medieval period as we might imagine. In her book *The King's Fool: A Book about Medieval and Renaissance Fools* (1993), Dana Fradon maintains that buffoonery was one of the few professions open to women at that time. Certainly there were female jesters, or jestresses, at courts right up until the beginning of the eighteenth century. One such jestress, named La Jardinière, served the court of Mary Queen of Scots, and in 1536 it is recorded in state papers that another, Lucretia the Tumbler, be appointed as a Chamberer to attend on the Princess Mary. Later, in 1544, records show that included in the Queen's Payments is a sum of 'three geese for Jane Foole'. Jane the Foole, or Jane Foole as she was commonly referred to, is perhaps the only female jester to ever be depicted in a painting. In the collection of paintings at Hampton Court is one of Henry VIII and his family. In the far right corner is the figure of Will Somers, the court jester, and on the left is a figure that is thought to be Jane.

By the middle of the seventeenth century, things were to change drastically for itinerant performers. With the ending of the Civil War and the execution of Charles I, the English Commonwealth was established under the control of Oliver Cromwell. During the period of the Interregnum, from 1649–60, performances of dancing and plays by live actors were forbidden but the state did not challenge performances by puppets or other entertainers such as the jongleur and the rope dancer. It is a little known fact that Cromwell himself had in his service at least four 'buffoons'. All the skills of the jesters and other itinerant performers endured chiefly because of their popular nature. They were entertainers of the people, and people still needed to be entertained during those turbulent times. They survived in gatherings such as borough fairs like Bartholomew Fair, Southwark Fair and other May fair gatherings. Bartholomew Fair was first created by a character named Rahère, jester to Henry I in the twelfth century.

William Hogarth gives us a vivid picture of what a borough fair would have looked like in his 1733 engraving *Southwark Fair* or *The Humours of a Fair*. A multitude of people are taking in the amusements and entertainments. People are pushing and shoving in their efforts to see what is going on. In the middle of the square is a very pretty woman playing a drum, accompanied by a small black boy on a trumpet. Above and behind them a man performs tricks on a slack rope slung between two buildings. This man is well known as Violante. Between the church tower and a nearby tree another aerial performer called Cadman, known as the 'flying man', has fixed a rope. With his arms outstretched he descends the rope headfirst. Placards advertising forthcoming entertainments are all around. Behind the rope dancer is one advertising Maximillian Muller, the famous German Giant, who is reputed to have stood over 8 feet tall. On the right of the square another placard shows two contortionists. Beneath that placard, on a balcony, is a drumming monkey accompanying the famous Isaac Fawkes, a noted juggler and magician of the period. He is demonstrating a magic trick to the crowd. A dwarf drummer leads a man upon a horse. The man is holding a fearsome looking sword in his hand and it is said that he will later be giving a demonstration of swordsmanship. Behind the gamblers and near a blind piper with his puppets, there is a dancing dog. Complete with hat, sword and cane, he is a very miniature of the gallants in the crowd. To the left of the picture a balcony collapses. These temporary booths were quite often thrown up very quickly just for the fairs and are were not at all well constructed. Men and women begin to tumble to the ground onto the heads of those below as a small monkey clings desperately to one of the uprights. In his detailed engraving, Hogarth has given us what must have been a bustling, chaotic assault on the senses.

By the turn of the seventeenth century, these markets had become less focused on business and increasingly more on pleasure, with myriad entertainments, and now lasted for up to four weeks. Diarists such as John Evelyn and Samuel Pepys both visited Southwark Fair and commented on the sights to be seen. Evelyn describes seeing monkeys and asses dancing on a tightrope. He observed an Italian girl dance and perform tricks on the tightrope to much admiration, so much so that the whole court went to see her. Another interesting exhibition that he saw, which could be taken directly from a modern circus, was that of a strong man who lifted up a piece of an iron cannon weighing about 400 pounds using only the hair of his head.

In 1668, Pepys referred to visiting a 'very dirty' Southwark Fair, where he went to see Jacob Hall dancing on the rope, 'to visit the mare that tells money and many things to admire – and then the dancing ropes … and so to Jacob Hall's dancing of the ropes; a thing worth seeing, and mightily followed …'

He later met Hall in a nearby tavern and struck up a conversation with him. Pepys asked Hall if there had ever been times when he had fallen during his shows,

to which Hall said, 'Yes, many, but never to the breaking of a limb.' During his visits to Bartholomew Fair from 1663 to 1668, Pepys records seeing many rope dancers, clearly a popular entertainment. In each of these fairground entertainments can be found the elements of circus as we may recognise it today. Perhaps the beginning of the 'modern' circus would have started here, had it not been for the intervention of the English Civil War and the ensuing period of the Commonwealth, in which the arts and entertainment were almost wiped from the face of the country.

There is an old saying, 'Wherever the crowd, there a performer', and the London borough fairs such as Southwark, Bartholomew and the Greenwich May Fair became a magnet for all kinds of itinerant performers and their followers. But as well as being places of entertainment, these fairs had a darker and seedier side. They could also be places of drunkenness, prostitution and crime, and some people were very wary when visiting them. In the same year that Hogarth produced his engraving, a woman was trampled to death by the crowd at Southwark Fair, and earlier, in 1702, at the May Fair in Greenwich, a constable was fatally wounded during a riot. Because of the growth of urbanisation within London many of the boroughs were becoming more residential. There was increasing opposition from residents as the annual fairs caused much congestion and an increase in crime. There was great opposition to the fairs in general, and in 1763 Southwark Fair was banned by the authorities, although Bartholomew Fair continued well into the nineteenth century.

When the monarchy was restored in 1660, King Charles II brought with him a new era for the arts. Having been exiled in the French court during the period of Cromwell's rule, Charles had acquired a taste for the more artistic pursuits of the theatre, music, opera and art. He reopened the theatres and encouraged and supported performances. Nell Gwynne, one of the more well known of his several mistresses, was an actress herself. Charles also brought with him all the fashionable ideas of the French court, including that of the pleasure garden, very much influenced by what he had seen at the garden at the Palace of Versailles. At a time when London and other major cities were overcrowded, dirty and odious, these gardens were created on the edges of the urban sprawl to provide a space where people could go to 'take the airs'. More importantly, these became places for those of rank and fashion to display themselves. These pleasure gardens provided ample opportunity to swagger or stroll through the carefully manicured leafy walks of a romantic rustic idyll. This was a sensual, visual era and people liked to see and be seen, especially if they deemed themselves above the common classes. They went to the ever-increasing number of theatres; they began to wear elaborate and fanciful costumes that mirrored those of the theatre; and they liked to promenade in the growing number of pleasure gardens of the period.

By the middle of the eighteenth century, there were more than sixty pleasure gardens in the whole of London. Some were licensed to present music and dancing whilst those without a licence provided spaces for the playing of bowls or the taking of tea. As they became more and more fashionable, other provincial cities copied London. These were places designed for pleasure; places of intrigue and assignations.

New Spring Gardens opened to the public in 1661 in Lambeth, South London. John Evelyn, the diarist, called it a 'prettily contrived plantation' and Samuel Pepys picnicked on cakes, powdered beef, and ale during a visit to the gardens. On another trip, Pepys recalled, 'There came to us an idle boy to show us some tumbling tricks, which he did very well, and the greatest bending of his body that ever I observed in my life.'

In 1732, under the management of Jonathan Tyers, New Spring Gardens was reinvented as the new Vauxhall Gardens and people were charged a one shilling admission fee. Now the pleasure garden was not exclusive and anyone could enter who could pay the entrance fee. The garden extended over 12 acres and set into the leafy hedgerows along the walks were recessed bowers where one could rest or take tea. Royalty were regular visitors and Tyers built the Prince of Wales Pavilion for Prince Frederick. This was the age of the celebrity, with many aristocrats, actors, writers and artists using the pleasure gardens for recreation. In 1781, the presence of the Duke and Duchess of Cumberland attracted more than 11,000 visitors, and in 1784, the centennial celebration of the birth of George Frederick Handel drew a vast crowd. So people now had the possibility of rubbing shoulders with aristocrats or even royalty.

Amongst the walks and greenery, small pavilions and booths were erected so that the visitors could rest awhile from their walking to sit, eat, drink and converse. With gravelled walks bordered by fragrant bushes and overhung with trees, within which hundreds of glowing oil lamps were hung at night, it must have been a fairytale sight for the pleasure seekers. However, Tobias Smollett, in his 1771 work *The Expedition of Humphry Clinker*, gives us a very different picture through the eyes of his character Matthew Bramble:

> What are the amusements of Ranelagh? One half of the company are following at the other's tails, in an eternal circle; like so many blind asses in an olive-mill … while the other half are drinking hot water, under the denomination of tea, till nine or ten o'clock at night, to keep them awake for the rest of the evening. … Vauxhall is a composition of baubles, overcharged with paltry ornaments, ill conceived, and poorly executed. … The walks, which nature seems to have intended for solitude, shade and silence, are filled with crowds of noisy people, sucking

up the nocturnal rheums of an anguish climate; and through these gay scenes, a few lamps glimmer like so many farthing candles.

As they developed, the gardens became places of entertainment and pleasure, art works were displayed in pavilions and music was played. In June 1764, even an eight-year-old Mozart gave a performance on the harpsichord in Chelsea's Ranelagh Gardens. Masquerades were always popular and recitals were given, very often accompanied by firework displays later in the century. But the gardens now also became venues for performers of physical feats. In the late seventeenth century, at the gardens on the site of the present-day Sadler's Wells theatre, rope dancers were engaged to entertain the public.

Performances also took place inside the building itself. From 1750 to 1800, there are several recorded performances of what we might term circus-style entertainments. Michael Maddox performed wire dancing and 'tricks with a long straw'. In 1768, a Mister Spinacutti and his performing monkey made an appearance. There were tumblers such as Paul Redigé, also known as the 'Little Devil', and another named Placido, as well as the Bologna and sons' act of feats of strength, and Costello and his performing dogs. One of Smollett's other characters, the maid Winifred Jenkins, gives a very vivid description of a visit to Sadler's Wells:

> I was afterwards at a party at Sadler's Wells where I saw such tumbling and dancing on ropes and wires that I was frightened and ready to go into a fit – I tho't it all inchantment [sic]; and believing myself bewitched, began to cry.

In Marylebone Gardens in 1738, a tall tower was erected so that a performer could walk across a stretched rope with a wheelbarrow, something that Charles Blondin was to do much later when he famously crossed Niagara Falls. These acts inspired as much awe and wonder then as they do today but there was one particular style of performance that came to the fore during the eighteenth century that would have a lasting influence.

Clowns are synonymous with the circus. Although there were several clowns performing at this time, the nickname Joey owes much to one particular clown, Joseph Grimaldi. Born in 1778 in Clare Market, a slum district of London, he came from a long line of Italian performers. His father, Joseph Giuseppe Grimaldi, was an actor and dancer, known often as 'the Signor'. As well as a noted performer, he was also the ballet master at the Theatre Royal in Drury Lane. Joseph's young mother had been an apprentice to his father, who was a strict disciplinarian and often beat his children. He had a morbid fascination with death and would often feign death to see how his children would react. He even gave his eldest daughter

strict instructions that he was to be decapitated after his death, and this to be actually carried out before a group of onlookers.

Despite his quirks of personality, Joseph senior was a successful performer and took his two-year-old son onto the stage at the Drury Lane theatre in 1780. There is a colourful description of this appearance in his memoirs, published in 1838. His father playing the character of a clown, young Joseph appeared as a monkey, led on stage by a chain attached around his waist. His father would then swing him around on the chain at arm's length with ever-increasing speed. Unfortunately during an early performance, the chain snapped and Joseph was hurled into the audience, landing in the lap of one very surprised elderly gentleman, but thankfully uninjured. Within a year he was appearing as 'the little clown' in a piece entitled *Harlequin's Wedding*, and then making regular appearances in another piece named *Harlequin Junior*. By the age of six, 'Master Grimaldi' was rapidly becoming a prominent stage actor and reputed to be earning the sum of £1 per week.

Many of Grimaldi's performances were centred on the character of Harlequin, and these were often referred to generically as Harlequinades. These were very often presented as a comic close to the performance at the end of an evening of more serious entertainment. Complete with a magical transformation scene and the increased use of mechanical scenery and effects, these shows became very popular. Today, the Harlequin is a familiar character, with his colourful diamond patterned close-fitting costume, black tricorn hat and black eye mask, but this character was an English development of the earlier sixteenth-century Italian *Commedia dell'Arte* character Arlecchino.

The *Commedia dell'Arte* was a peculiarly Italian form of entertainment during the sixteenth and seventeenth centuries. Itinerant groups of *Commedia* actors would travel the country performing at markets, fairs and sometimes at the request of the aristocracy. The storylines were never written down as a script and were passed on orally from master to apprentice. It was not until the mid-eighteenth century that playwrights such as Carlo Goldoni developed the *Commedia* ideas into structured and scripted plays. Fast-moving and slick, the *Commedia* performances were always improvised and centred on a series of defined comic routines known as Lazzis.

The work of the *Commedia dell'Arte* spread widely throughout Europe, reaching as far as England. Here many of the *Commedia* characters became incorporated into the theatre and entertainments of the time. Even Shakespeare makes reference to the 'lean and slippered pantaloon' character of Pantalone in *All's Well that Ends Well* in the famous 'All the world's a stage' speech. We can still recognise some of these stock characters today – the grumpy old man, the bumbling professor, the boastful cowardly landlord, the layabout and the nimble minded wheeler-dealer.

The eighteenth-century English Harlequinade changed Harlequin into the central character of the piece. Unlike Arlecchino, this new Harlequin became the romantic lead figure in his quest to win the hand of Columbine against the wishes of her father, or sometimes her guardian, Pantaloon. In the early eighteenth century, Harlequin was a silent character and gave much of his performance in mime, although later in the development of the Harlequinade, dialogue was added. Pantaloon was ably assisted in his comic attempts to keep Harlequin and Columbine apart by a servant named Pierrot and an additional character referred to as Clown. It was as Clown that Joseph Grimaldi made his name.

Joseph's Clown character was very visual and he developed his own particular style of make-up. A blank white face was topped by a distinctive black wig, very often with upswept hair. His eyebrows were painted as black arches over his eyes. To complete the picture, his lips were reddened and he sported a large red triangular pattern over each cheekbone. His costume, consisting of a tunic and knee breeches, was predominantly white, sometimes with multicoloured spots and sometimes with coloured stripes, complete with a ruff around his neck. Even into the early twentieth century, many clowns still wore make-up and costume that reflected Grimaldi's influence.

His performances were also very physical. In one show alone he would be diving in and out of windows, tumbling across the stage and on the receiving end of all sorts of rough treatment from other characters. In 1813, a review in *The Times* called Grimaldi:

> the most assiduous of all imaginable buffoons and it is absolutely surprising that any human head or hide can resist the rough trials which he volunteers. Serious tumbles from serious heights, innumerable kicks and incessant beatings come on him as matters of common occurrence and leave him every night fresh and free for the next night's flagellation.

But Grimaldi was an indefatigable worker and during the height of the pantomime season would often be appearing at two theatres on one evening, so popular was his Clown character. On one particular occasion he was appearing at Sadler's Wells theatre and immediately after finishing the performance he then had to make an appearance on stage at the Theatre Royal, Drury Lane. He managed to run there in eight minutes – not bad for a distance of just under 2 miles after an exhausting physical performance! In another instance he was appearing at Sadler's Wells theatre but then had to be at the Italian Opera House in the Haymarket, some 2½ miles distant. He managed this in fourteen minutes, apparently delayed by knocking over an elderly lady along the way. After a short appearance at the Opera House he then ran back to Sadler's Wells theatre in

thirteen minutes, with just enough time to don his Clown costume for the concluding part of the entertainment there.

Grimaldi became the most popular clown of the late eighteenth and early nineteenth centuries. As well as appearing in the London theatres, he travelled widely throughout the country, including performances in Ireland. Often his shows were sold out and people had to be turned away from the theatre.

By the age of forty-eight, Grimaldi was physically worn out. The years of gruelling nightly shows with the incessant physicality of his performance, at times appearing in two theatres in one night, the provincial tours and the personal tragedy of his young wife dying in childbirth, had all taken their toll. He had risen to become what we might call a 'national treasure' but by the 1820s he began to perform less and less, and in 1828 he took his retirement from the stage. He appeared for a final time at the Theatre Royal, Drury Lane, where he had first begun his career in 1780.

Grimaldi died in relative obscurity at his home in Islington in 1837, a broken and depressed man with an inclination towards alcohol. He was buried in St James's churchyard, Pentonville, and the area around it later became the Joseph Grimaldi Park. In the park is a coffin-shaped casket set into the ground, with phosphor bronze tiles set into its surface. These tiles respond to pressure and create musical notes, and by dancing on the 'grave' of Grimaldi, it is possible to play the melody of his most famous song, *Hot Codlins*.

Joseph Grimaldi became the most celebrated clown of his time and has left a long legacy. He was often referred to as 'Joey' and this name has become synonymous with circus clowns right through to the present. As Richard Findlater states in his 1955 biography of Grimaldi, 'Here is Joey the Clown, the first of 10,000 Joeys who took their name from him.' Even today, clowns from all over the world gather annually on 31 May to lay wreaths on the grave of Grimaldi in homage to the man, and on the second Sunday in February each year since 1940, clowns have come together at the Holy Trinity Church in Hackney for an annual service to celebrate clowns.

Throughout the eighteenth century and into the early nineteenth century, physical performance skills not only survived but developed as highly popular forms of entertainment, supported by all classes of society. They took place in a wide variety of venues, from borough fairs and pleasure gardens to the London stage. The circus, as we would recognise it today, was about to be born, and it would take one man to pull it all together. That man was Philip Astley.

Chapter 2

The mysterious early years

For all that Philip Astley was well known during his lifetime, little is actually known about his early life. Most of the information that we have about him comes from secondary sources, the vast majority of which were written after his death. His date and place of birth are commonly given as the 8 January 1742 in Newcastle-under-Lyme, in north Staffordshire. Unfortunately, Astley was born before the Victorian obsession with record keeping, the compulsory registration of births, deaths and marriages being introduced into England and Wales in 1837. Before this date such events were recorded in local parish registers, some of which have not survived the test of time. To date, there are no extant parish registers that can definitively corroborate Astley's birth or baptism. Although not exhaustive, none of the online repositories for parish registers show the baptism of a Philip Astley, or name variant, within a five-year band before and after 1742. The nearest contemporary source that we have is the frontispiece to Astley's book *The System of Equestrian Education*, where, beneath his silhouette, is written 'Born; Jany. 8th 1742'. In fact, although the year of his birth remains constant throughout almost all written commentaries, there are some sources that give his date of birth as early as 20 January 1741. In his death notices, Astley's age is given variously between seventy-one and seventy-five years, making his birth in the time period from 1739 to 1743. In his memoirs, published in 1823, Jacob Decastro cites Astley's date and place of birth as being in Newcastle-under-Lyne [*sic*], on 8 July 1742. Decastro was a comic performer who worked with Astley's company and would have known him well. It is, of course, possible that as he was writing from memory he simply confused the months. Another writer, John Adamson, in his 1887 French volume *Les Anciens Cirques – Un Soir Chez Astley*, also records Astley's date of birth as 8 July. But here, he may well have been drawing his references from Decastro's earlier work. Adamson's sources are suspect, as many other facts that he gives about Astley are clearly incorrect.

There are also contradictions to where he may have been born. In the eighteenth century, birth certificates did not exist to prove one's date or place of birth. To say that one 'came from' or was 'of' somewhere was enough to imply a birth place. I might say that I am from Leeds, where I have lived for more than half my life, but I certainly was not born there. Someone not knowing much about me might well assume my birth place was in Leeds. William Granger, in

his piece *A Biographical sketch of Philip Astley Esq.*, in Volume 8 of his flamboy-
antly titled *The New and Original and Complete Wonderful Museum and Magazine
Extraordinary* (1804), gives Astley as being a native of London, whilst yet another
anonymous writer states that he was a native of Manchester. Sadly for us, Astley
never wrote an autobiography, as this may well have settled the debate. In the
absence of birth or baptism records, gravestones can be an invaluable source of
information. Perhaps the nearest we can get to an accurate record of his date
and place of birth is the memorial inscription on his headstone. He died in
Paris, France, in 1814, and was buried in the Père Lachaise Cemetery. An official
record was made of all memorial inscriptions in the cemetery and published in
September 1816, only two years after his death and therefore relatively contem-
poraneously. The volume is held in the French National Library (hereafter BNF)
and the entry in the record reads:

N. 521, planche IX
A la mémoire
*De M. Phillipe ASTLEY, écuyer, ppr. De l'amphithéâtre royale de Londres
et de celui, rue du faubourg du Temple à Paris, décédé le 20 Octobre 1814, âgé
de 73 ans, né à Manchester, en Angleterre, 20 Janvier 1741.*
[Le Champ du Repose, Vol. 1, Paris, 1816]

[To the memory of Monsieur Philippe Astley, squire, proprietor of the
Royal Amphitheatre in London and of that in the Rue du faubourg du
Temple in Paris, died 20 October 1814, aged 73, born in Manchester,
England, 20 January 1741. (Author's translation)]

If this inscription is accurate, and we cannot definitively say that it is without
cross-checking it against other primary evidence, it raises questions that are dif-
ficult to answer. We do not know who commissioned the memorial but clearly
it was someone who had some knowledge of Astley's life. It cannot have been a
random selection of Manchester as his birth place. Anyone not knowing anything
about his life might well have put London, as this is the city he is most associ-
ated with, so there must be a justifiable reason why Manchester was recorded.
Unfortunately, the memorial stone has long since disappeared and, like many
other earlier burials, Astley's remains have probably been removed to the ossu-
ary at the cemetery. All that we have left to acknowledge him is the record of his
memorial inscription.

 In his lifetime Astley often mentioned having relatives in Manchester, so
clearly there is a Manchester connection somewhere. Thomas Swindell's 1907
work *Manchester Streets and Manchester Men* makes the observation: 'Philip

Astley, although born in Newcastle[-under-Lyme], had a number of relations in Manchester.' The 1885 work *The Annals of Manchester* also states: 'Philip Astley, the equestrian, paid his first professional visit to Manchester, of which town he claimed to be a native, March 2 [1773].'

If we could confirm his parentage then perhaps this might give us a clearer picture. We know, from later writings, that his father's name was Edward and that he was a cabinetmaker in Newcastle-under-Lyme. His mother's name is never mentioned but, looking for an Edward Astley marriage on genealogical websites, the only record to be found within a suitable time frame is for an Edward Astley marrying a Sarah Leech on 3 May 1741 at the parish church of St Mary, St Denys and St George in Manchester (www.ancestry.co.uk). Alternative records are for an Edward Ashley and an unknown Elizabeth, as cited on the register for daughter Elizabeth Ashley's baptism (www.ancestry.co.uk), and for an Edward Ashley and Anne Mare marriage on 1 May 1743 in Gnossal, Staffordshire. It does appear that the names Astley and Ashley were often interchanged on records. Once again, without corroborating evidence we cannot say definitively that any of these are Philip Astley's parents but it opens up several possible lines of thought. The first marriage record above would make sense of Astley's own claims to having relatives in Manchester. Secondly, there is the possibility that Astley was actually born and baptised in Manchester, although there are no extant records of this, and that the family later moved to Newcastle-under-Lyme. Thirdly, that Astley was not his birth name and that his mother was possibly unmarried or widowed and then married an Edward Astley, Philip subsequently taking that name. This would be appropriate for both records, and might explain the friction between Philip and his stepfather. A fourth possibility is that his given name at baptism was not Philip, although there are no other male Astley (and similar) names within the available baptism records for the time frame.

We rarely get a glimpse of the private life of Philip Astley. Much later in his life, on 3 June 1797, he placed an interesting personal advertisement in the *Staffordshire Advertiser*. It reads:

Twenty Guineas Reward and a HANDSOME PIECE OF PLATE

Any Parish Clerk, Register, or other Person can discover the above marriage [above was an image of two rings joined by two clasped hands, with the names inside each ring], viz. SIMON ASTLEY, late of Mayford, near Stone, Staffordshire, (Innholder), and ANN PHILLIPS, which took place between the years 1670 and 1690 will receive TWENTY GUINEAS REWARD, and a Handsome Piece of Plate.

P. Astley, Westminster Bridge, Lambeth, London

The advertisement goes on to request any information on the baptisms of William Phillips and his sister Ann (presumably the Ann above) from 1640 to 1670, for a ten guineas' reward. It also gives a little genealogical information in that William apparently lived in Burton upon Trent in 1720 with his son Thomas, who became Master of the Grammar School in Uttoxeter in 1726. Thomas then took Holy Orders and was Rector of Egginton in Derbyshire in 1747 when he died (www.findmypast.co.uk). The only extant baptism records for a William and Ann Phillips that I have been able to discover, and who share a common father and mother, are for Checkley, Staffordshire. Ann's is in 1675 and William's in 1677 (www.family-search.org). This is not conclusive evidence that these two individuals are the ones that Astley was looking for. Simon Astley was indeed an inn holder in Meaford (Mayford). Unfortunately, I have been unable to trace any primary record of a marriage for Simon and Ann. However, in his will and testament, dated 6 January 1698, he names his wife Ann Astley as the sole executrix of his estate and he also gives her the authority to dispose of the estate as she sees fit for the maintenance and education of *all* his children (Lichfield Record Office).

One wonders why Philip Astley should have been so eager to trace these people. Did he feel the need to establish his roots in later life? Were they relatives? Certainly, Simon Astley and his wife would have been of a generation that could have been his grandparents, but we would need to show that Edward Astley's parents were Simon and Ann. There are some records that give a Simon (Simoni) Ashley as the father of Edwardus (1690), Elizabeth (1693), and Phillip (1698), all baptised in Stone, Staffordshire (www.familysearch.org). The mother's name is not recorded, so we cannot directly relate these siblings to Simon and Ann. Also, if Edwardus (Edward) is to be the father of our Philip Astley it would mean he was in his fifties when he fathered Philip and his siblings. This is not impossible but I feel it is unlikely, and does seem to reinforce the argument that perhaps Astley (Ashley) was not Philip's birth name. There is a record (www.familysearch.org) for the baptism of an Edward Ashley on 19 February 1721 in Newcastle-under-Lyme to parents Philip and Elizabeth. These seem more likely grandparents than Simon and Ann. This does need further research to corroborate the facts. There is no record to show whether anyone ever responded to the advertisement or claimed the reward.

Whatever the circumstances of his birth, we do know that the Astley (Ashley) family were in Newcastle-under-Lyme by 1743. We also know that Philip had two sisters, Sarah and Elizabeth. The parish registers of St Giles in Newcastle-under-Lyme give baptism records for a Sarah Ashley on 15 February 1743, and for an Elizabeth Ashley on 27 October 1745. Both of these married and produced the nieces and nephews that are mentioned in Philip Astley's will. There is also a record of a John Astley being baptised on 26 June 1747, so it would appear that

Philip had three siblings, and not two as often later recorded. Little is written about John Ashley, and what happened to him we do not know. All of these children have Edward Astley (Ashley) given as their father. Some online records (www.family-search.org) show this family as Ashley but transcription errors are frequent and, looking at the original documents held in the Staffordshire Record Office, it is easy to see how the name has been mistakenly transcribed.

Philip Astley spent his early years in the bustling provincial market town of Newcastle-under-Lyme. The town was situated on the main London to Carlisle route and, as a Turnpike Trust had been set up in the town in 1714 to improve and maintain the main roads, it became quite prosperous. By the end of the eighteenth century the population of the town had risen to about 4,500. Local trades included the manufacturing of soft-paste porcelain tableware, brewing, the production of clay tobacco smoking pipes, clockmaking, and felt hat making. For a cabinetmaker such as Edward Astley, this would have been a good outlet for his skills. Wooden moulds were needed for both clay pipe making and for the hatting industry, and clocks required cases. Philip Astley was apprenticed to his father from an early age, perhaps as young as seven years old, and cabinetmaking would be a craft he would return to briefly in later years.

Being an important staging post for the increased amount of traffic passing through the town, Newcastle-under-Lyme boasted many inns and taverns; there were sixty-nine listed by 1835. The Angel, and the Eagle and Child had been in the town since the early seventeenth century. The Roebuck, on the High Street, was described by Lord Torrington as 'one of the most savage, dirty ale-houses' he had ever been in (*A History of the County of Stafford*, Vol 8, 1963). All of these have long gone, along with the Talbot, King's Head and Woolpack. At a time when horse power was the main means of transport through the town, Philip Astley would have grown up surrounded by horses and would have probably learnt to ride at an early age.

We now encounter another mystery in his life. Popular history would have it that, in 1759, after an argument with his father, Philip took a horse and rode to Coventry, where he enlisted into Colonel Eliott's Light Dragoons, also known sometimes as Colonel Eliott's Light Horse. The regiment had been commissioned in March 1759, and immediately began recruiting. Most of the volunteers were recruited very quickly, mainly in the London area. By the July, the regiment only required seventy-eight men to complete its establishment. In the 1862/63 journal entitled *Once A Week*, William Pinkerton writes in an article entitled 'Astley's': 'One of the first recruits who enlisted in the gallant corps was a lad only seventeen years of age, named Philip Astley, the son of a respectable tradesman at Newcastle under Lyne [*sic*].'

We know that the regiment did recruit in the provinces, as here in an advertisement in *The Leeds Intelligencer* of 1 May 1759:

To all YOUNG MEN
Of Spirit and good Character inclined to serve his Majesty
Amongst the LIGHT-HORSE, who behaved so gallantly
last Campaign in FRANCE;
They will be received into the only Regiment of
Light DRAGOONS
Commanded by Colonel GEORGE AUGUSTUS ELIOTT,
And into Captain MARTIN BASIL'S own Troop

If Astley was one of the first to volunteer for the regiment, it seems unconvincing to me that he would have ridden the 65 miles from Newcastle-under-Lyme to Coventry, especially as it seems that he left home suddenly as a result of an argument with his father. His joining the army in this way feels like a more impulsive action. It would be far more logical that his enlistment took place in London, and there is a convincing argument that the Astley family had moved to London before this date.

Charles Dibdin (the younger) wrote in his 1824 *Account of the Royal Amphitheatre, Westminster Bridge*:

He [Philip Astley] was born at Newcastle-under-Lyme in 1742 and came to London with his father, who was a cabinetmaker, in 1753 or 4, and worked at his father's business till 1759, when he enlisted in the 15th or Eliott's own Light Horse.

This is interesting, because in the 1753 *Westminster Rates Books 1634–1800* (www.findmypast.co.uk) there is an entry for an Edward Astley residing at Dean Street, in the parish of St Anne, Soho. This is a significant address, as we shall discover later. In the 1755 *Register of Duties Paid for Apprentices' Indentures, 1710–1811* (www.ancestry.co.uk), on 13 January there is an entry for an 'Edward Astley of the parish of St Mary le Strand, Cabinet Maker, taking on Jos. Russell' as an apprentice. This is all very intriguing; could this Edward be the father of our Philip?

When Philip Astley died in 1814, he made bequests to nephews and nieces. Three of the nieces were the daughters of his sister Sarah, who then went by the married name of Gill. Her story is tragic and complex, but significant in unravelling the question of the Astley family in London. There is an entry in the *Register Book of Marriages of the parish of St George, Hanover Square*, in London for 26 June 1762 for the marriage of Alexander Dusser and Sarah Astley. The entry reads: 'June 26 Alexander Dusser, B, & Sarah Astley, a minor, with consent of Edwd. Astley, father of the sd. Sarah, LAC.'

The actual marriage record (www.findmypast.co.uk) refers to Edward as Sarah's 'Lawful Father'. From this we can deduce that Alexander Dusser and Sarah Astley were both residents of the parish and that Sarah was below the age of twenty-one. We know that Sarah Astley was baptised in 1743. This would make her only nineteen in 1762, and therefore requiring parental consent to marry. But Sarah Dusser is not Sarah Gill … yet.

Alexander Dusser died in 1764, leaving Sarah a widow at the age of twenty-one, and quite wealthy. She was also a young mother, her daughter Elizabeth Georgiana having been baptised on 24 June 1763 (www.findmypast.co.uk). Georgiana is also referred to by name in the will of Alexander Dusser. Sarah Dusser, widow, goes on to marry a Thomas Malyin (sometimes written as Maylin), widower, on 18 October 1766 in the parish of St Botolph (www.ancestry.co.uk). One of the witnesses at this marriage was none other than Phillip Astley, her brother. This would make sense. Astley had been discharged from the Dragoons earlier that year and was living in London with his wife Patty. Having received his discharge earlier in the year, why would he settle in London if there were no familial ties? I believe that he returned to London because his family was already there. His father was continuing his cabinetmaking business and his sister Sarah had married there. In addition, the seldom referred-to brother, John, also married at St George's. The *Register Book of Marriages of the parish of St George, Hanover Square* has an entry for 30 April 1769 for a marriage of John Astley to Mary Turner. Only his sister Elizabeth remained in Newcastle-under-Lyme, marrying a James Hall in 1767. Her husband died in 1778 and Elizabeth then went on to marry a John Harding in 1781 (www.ancestry.co.uk).

It will be noted in the above paragraph that, on Sarah's marriage certificate, he signed his name Phillip Astley, as opposed to the more commonly accepted Philip Astley. I have adhered to the latter form throughout this work for consistency. However, when he married Patty Jones on 8 July 1765 in St George's, Hanover Square, he signed his name Phillip (www.ancestry.co.uk). On the marriage allegation, dated two days before the wedding, the person completing the form had written Philip, and an additional 'l' has been inserted. The form is signed by Phillip Astley. The capital letter A in his surname has a distinctly rounded cursive form. If we compare this signature to the signature on Sarah Dusser's marriage certificate, we can see that it is identical.

Sadly, Sarah was widowed once again. In July 1768, Thomas Malyin died and Sarah again remarried later that year in Lambeth, on 8 October, to a Robert Gill (www.ancestry.co.uk). The couple went on to have four daughters, the nieces referred to in Philip Astley's will.

Philip settled in St Anne's, Soho. The *Register of Duties Paid for Apprentices' Indentures, 1710–1811* (www.ancestry.co.uk) has entries on 20 September 1766 for

a 'Philip Astley, Cabinetmaker, of St Anne's, Soho', employing an apprentice 'Jno. Hughes', and the same on 2 April 1767, employing a 'Thos. Phillips'. Is it merely a coincidence that an Edward Astley, cabinetmaker, also resided there in 1755 and that a few years later, a Philip Astley, also a cabinetmaker, should be there? I think not, and I believe that there is enough evidence to support the argument that the Astley family moved to London during the 1750s and not, as popularly history would have us believe, after Philip had become successful as a performer.

His early years may be shrouded in mystery but in 1759 we do know that he joined Colonel Eliott's Light Dragoons. From this point onwards his life becomes better documented. It is now that we turn our attention to Philip Astley, war hero.

Chapter 3

Astley: the heroic Dragoon

Philip Astley grew up in a time of war and rumours of war. The eighteenth century brought Britain into armed conflict across three continents, as well as on home soil. The early part of the century had seen Britain at war with Spain until about 1742, when general hostilities ceased. However, it was a politically volatile period and there was only to be a respite of a few years before Britain became embroiled in further conflict. Across Europe, hereditary noble families were to fight for supremacy, invading each other's lands and claiming crowns. The War of Austrian Succession, largely between the great states of France and Austria, drew Britain in as an ally of Austria, the Hanoverians, and the Hessians. For Britain, throughout this era, the predominant enemy was France. With colonies in North America, India, and the West Indies, France sought to develop its global trading economy, in direct competition with Britain. On 11 March 1744, France declared war on Britain in North America, a reciprocal declaration following in April. On 24 May 1744, the first major engagement took place in Nova Scotia, when the French destroyed the British fort at Canso. Both sides, supported by native populations, would continue hostilities until the Treaty of Aix-la-Chapelle in 1748 brought about an uneasy peace. On the other side of the world, the British and French were competing for trade supremacy in India. As a direct result of the war in Europe, both countries were drawn into armed conflict in what is known as the First Carnatic War, in 1746. This was concluded by the treaty of 1748, but war broke out again the following year, without the endorsement of the respective governments, and it lasted until 1759.

If foreign wars were not enough, the threat of a Catholic Jacobite uprising in 1745 in Scotland was enough for the Duke of Cumberland's army in the Netherlands to be later recalled to deal with the situation. With the promise of French support, Charles Edward Stuart, known as Bonnie Prince Charlie to his supporters, and the Young Pretender to his enemies, landed in the Hebrides in August 1745. The Highland clans gathered to his cause and as he marched south to Edinburgh, his numbers grew in strength. By September he was facing his first major battle with British forces and took a resounding victory at Prestonpans. The Jacobite army continued southwards, taking the city of Carlisle in November, and by December it was in Derby. But the promised French support had not materialised and the army became disillusioned and began to withdraw back to Scotland. By now the

Duke of Cumberland and his army had returned to England and relentlessly pursued the Jacobites, the two sides finally facing each other at the Battle of Culloden in April 1746. It was a decisive victory for the British Army and the Jacobite uprising had been defeated. Bonnie Prince Charlie spent five months eluding capture before he managed to escape to France.

If 1748 was to see a lull in military conflicts, it was to be all but a temporary one. Throughout Europe resentment was still bubbling away. The region of Silesia, largely covering land in present-day southern Poland, had been taken from Austria by Frederick II of Prussia (Frederick the Great) during the wars of 1740–48. Austria now made moves to wrest it back from Prussia, and this conflict was to embroil most of the major powers of Europe, in what became known as the Seven Years' War. In the earlier conflict, Britain had allied itself with Austria against the French. Now France was backing Austria, along with Russia, Sweden, Spain and Saxony. Pitted against France, Britain now found new allies in Prussia, Hanover and Portugal. As the British monarch, George II, was a Hanoverian, Britain found it necessary to protect its ruler's European possessions in the state of Hanover against French domination. War against France was declared once again on 18 May 1756. It was an expensive war. Simon Schama (2001) records that by 1758, the British parliament granted a military budget of £12.5 million, an unprecedented amount. The money was raised by excessive government borrowing and punishing taxes. It was enough to maintain an army of 90,000 and a navy of 70,000 as well as territorial militia of some 35,000. But far-flung wars required even more men, and it was against this backdrop that Colonel Eliott's Light Horse (or Dragoons) was to be established, in which Philip Astley was to see service.

The British regiments of Heavy Cavalry had gained an enormous reputation during the age of Marlborough, and bodies of Light Horse were never fully established or retained in service. On the occasions when they had been, they had been modelled along the lines of the foreign hussars. Originating in Hungary, hussars were troops of light horsemen who fought in small groups. The name hussar itself is derived from the Hungarian word Húsz, meaning twenty. In 1756, such a troop was added to the existing regiments of Dragoons and Dragoon Guards on the British establishment. Dr John Fortescue's *A History of the British Army* gives a detailed description of the arms and equipment a Light Horseman would carry, as quoted in *XVth (King's Hussars) 1759–1913*, by Colonel H.C. Wylly:

> The arms of these light troops were a sort of carbine with the bar and sliding ring, with a bayonet but no sling … the belts tanned leather, the bridles and bits small and light, as were the saddles. They carried no side pouches, like the Dragoons, but in lieu of it a swivel, which played up and down their shoulder belt, to which the carbine was sprung or fastened,

and hung with the muzzle downwards during exercise, as they fired on horseback as well as on foot. ... They also used their pistols, but at first they only had one each man, as they carried in their right holster either an axe, hedging bill or spade. Instead of hats they wore a cap, or helmet, made of strong black jacket leather, with bars down the sides, and a brass bar at top; the front red, ornamented with brass work, with the cypher and crown and number of the regiment to which they belonged, with a tuft of horse hair on the back of their front – half red and the other half the colour of the facing of the regiment.

Such a regiment, mounted on light, agile horses, had proved its worth during the Battle of Culloden. The men, armed with swords, pistols and carbines, had efficiently harried remnants of the Jacobite army for several miles, killing many. At the end of the Scottish campaign, many troopers transferred their service to regiments of Light Dragoons, and saw active service in Europe.

With Britain's involvement in the Seven Years' War it was decided to create a complete permanent regiment of Light Horse. The duty fell to Colonel George Augustus Eliott, already a seasoned, and wounded, cavalry commander. The first notice of this appeared in *The London Evening Post* on 10 March 1759:

We hear that the Regiment of Light Armed Cavalry will be raised with the utmost expedition, and that George Augustus Elliot [*sic*] Esq., Lieut. Colonel to the Second Troop of Horse Grenadier Guards, will have the command of it.

The press seem to have pre-empted the actual issuing of the warrant to raise the regiment, dated 17 March 1759:

GEORGE R.
WHEREAS We have thought fit to order a Regiment of Light Dragoons to be forthwith raised under your command which is to consist of Six Troops of Three Sergeants, Three Corporals, Two Drummers, One Hautboy [a reeded musical instrument akin to the oboe but it may here also mean a fife], and Sixty Private Men, in each Troop, besides Commissioned Officers.

These are to authorise you by Beat of Drum or otherwise to raise so many Volunteers in any country or part of Our Kingdom of Great Britain as shall be wanted to complete the Said Regiment to the above mentioned numbers. ...

Given at Our Court at St James's this 17th Day of March 1759, in the Thirty-Second Year of Our Reign.
By His Majesty's Command,
BARRINGTON

To Our Trusty and Well Beloved George Augustus Elliot, Esq., Col. of Our Fifteenth Regt. of Light Dragoons, or to the Officer appointed to raise Men for Our Said Regt.

Given the above numbers, the full regiment would have comprised 414 men plus commissioned officers. By 20 March, the number of officers appointed was twenty, making the regimental complement of 434 men, plus the commanding officer.

The new regiment was modelled very much on the Prussian Light Cavalry. Eliott himself was listed as a subscriber to the 1757 translated edition of *Regulations for the Prussian Cavalry* by William Fawcett. This is a 408-page book of regulations covering all aspects of the management of such a regiment, including horse drills and exercises, pay, conditions, uniform, and even marriage:

> The men must keep a steady seat upon their horses, and have their stirrups so short, that when they raise themselves from the saddle ... they may be able ... to make a larger stroke.
>
> A Trooper on horseback is always to project his belly a little, and keep the rest of his body back, to hold his bridle short, and in a straight line before him ... to keep his elbows close to his body and not to move his arm when his horse trots.
>
> No non-commissioned Officer shall marry without leave obtained from the Colonel of the Regiment, who shall not grant it to any non-commissioned Officer applying for it, unless he can make his fortune by a marriage, especially if he is but young.

Recruiting began almost immediately and many volunteers were drawn from London and its surroundings. As we have suggested in the previous chapter, it seems logical that Philip Astley was in that first wave of recruits, especially as he is referred to as 'one of the first recruits who enlisted in the gallant corps'. Many volunteers were drawn from a large number of unemployed tailors and clothier workers who had come to petition Parliament with certain grievances concerning their trade. It was because of this that the regiment acquired the nickname of the 'Tailors', or the 'Tabs'. When the regiment was moved to Kent in July 1759

to 'assist the civil authorities in suppressing disturbances, and in apprehending rioters' (Harris & Co. 1837), it was only seventy-eight men short of its full complement.

Philip Astley was well over 6 feet tall and must have struck an imposing figure. The average height of a recruit was 5 feet 8 inches, so he would have been head and shoulders above the others – not a man easy to miss in a crowd. He would have been a resplendent figure in his new uniform and equipment, as dictated by the Secretary of the Clothing Board:

> a short coat lapelled and turned up with dark green, white lining and white waistcoat with a green collar; broad white buttons and button holes; two white shoulder straps, two pairs of white linen breeches; jockey boots and spurs; the Cloak with a green Cape and lined with white; the Saddle of tann'd leather, shaped after the old Hunting stock; instead of Housing and Caps, a green Saddle Cloth after the Hungarian manner, laced with white lace and a red stripe, the King's Cypher and Crown embroidered on the fore part and the Device of the Regiment (L.D.) on a red ground within a wreath of Roses and Thistles on the back part; instead of a Hat, a Copper Cap enamell'd with black, brass Crest with white and red Hair; the front turned up, with the King's Cypher and Crown painted or enamelled on it, a flap rolled up behind, in order to cover the neck on occasion; a tann'd leather Cartouche box instead of Pouch; a tanned leather shoulder belt with a running Spring Swivel, and a tann'd leather sword belt.
>
> (H.C. Wylly, 1913)

Buff gloves were worn, and black or brown gaiters were issued for dismounted duties. With Astley being so tall it would be surprising if his uniform was not made specifically for him, rather than the standard sized issue for the average trooper.

In addition to all of this he would have been issued with a pistol, a carbine and a sword. The carbine, like the pistol, was a flintlock. Both weapons had the same bore of 0.67 inches, so the same ball could be used in either weapon. The 1760 Eliott Light Dragoon pistol accompanied the carbine. It was shorter barrelled and lighter than the 1756 pattern pistol. Very few of these survive and the Royal Armouries holds a very rare example. The 1760 Eliott pattern carbine had a 29-inch barrel, significantly shorter than the flintlock musket of the infantry, and was designed to be used on horseback. The previous 1756 pattern carbine had a 37-inch barrel and was accompanied by a 17-inch long bayonet, something the 1760 carbine did not have and contrary to what Wylly records above. It was also significantly heavier and wieldier to handle. Powder and ball had to be loaded

through the muzzle and rammed home with the wooden ramrod before firing. Early models had a form of safety catch to prevent accidental firing, but by 1765, most of these had been removed and the fixing holes filled in. Whilst it was possible to fire the weapon on horseback, it was very impractical and more frequently the Dragoons used their carbines while dismounted. Eliott carbines could be fitted with a 7-inch sling bar at the rear, to be slung from a belt while on horseback. The carbine would have been charged and primed, ready to discharge. However, slung from the belt muzzle down it was not unknown for the wadding to work loose while the horse was galloping. They were also prone to misfiring as they were very susceptible to moisture, the powder becoming damp. A 1760 Eliott pattern carbine held in the Royal Armouries Museum collection has an inscription on the top of the barrel that reads 'Gen. Eliotts Dragoons'. This is rather puzzling. Eliott was not promoted to full general until 1778, well after the introduction of the second pattern carbine in 1773. There are two possible explanations; either the 1760 pattern carbine was still in use in 1778 or the inscription was made when Eliott was promoted to lieutenant general in 1765. It is not known if all carbines issued at this time bore this inscription.

The sword was the most important and effective weapon for the Dragoon. This would have been a slightly curved 34-inch blade with a leather-bound wood grip cover around a steel hilt. A carved lion's head pommel was a feature of swords belonging to the XVth Dragoons. Officers' swords were generally straight bladed and also carried the lion's head motif. Astley himself, in 1794, wrote a reflective volume entitled *Remarks on the Profession and Duty of a Soldier*, and he devoted a complete chapter to *Observations on the Use and Formation of Dragoon Swords*. In this he expounds the virtue of the straight sword against the curved scimitar style of sword used by some foreign cavalry regiments:

> That squadron, at the time of charging the enemy, armed with straight swords, and well directed between the horses' ears, I fully conceive will have a pre-eminent advantage over the squadron armed with scimitars, as the velocity of the horse is such, as to render the sword arm so exceedingly powerful and quick as to transfix the weapon in an opponent almost instantaneously.

Astley was quickly spotted as being a talented rider and he was selected to be sent to the Earl of Pembroke's house at Wilton, in Wiltshire, for further training under the celebrated Angelo Tetramondo. The Earl of Pembroke was lieutenant colonel in the regiment. As he was a keen horseman, he had established his own private *manège* at his Wiltshire home. Angelo was internationally famous as a teacher of equitation, riding and fencing, and the Earl had persuaded him to train a select

number of riding instructors for the regiment. By the time that the regiment was ready to be sent into Europe, Astley was skilled as a rough rider, instructor and horse breaker, and had been promoted to the rank of corporal.

On 10 June 1760, the regiment set out for Europe, with flags and pennants flying. The regimental guidon had a green ground and was fringed with silver. At the top left and bottom right were red patches displaying a white horse, and at the top right and bottom left were red patches displaying the rose and thistle motifs. The centre device was a white hound attacking a brown stag, surrounded by a natural coloured wreath of roses and thistles. The regiment embarked at Gravesend and set sail for Bremen. Each trooper was equipped with two horses; although further horses would be requisitioned once they were in Europe, this would have meant a tremendous number would have had to be transported across the North Sea. They arrived on 21 June and Astley, almost immediately, distinguished himself:

> When Mr Astley first went abroad … on their landing, a favourite horse belonging to one of the principal officers in the regiment broke from his sling, and tumbled in the sea. His master, seeing the horse in this imminent danger of drowning, offered a large gratuity to any one of the men who would venture themselves in the sea, so as to catch the halter of the horse, and by this means lead him to shore. … In all the regiment none could be found to risk his life in the recovery of the horse but Mr Astley; he accordingly stripped off his coat and waistcoat, and leaped into the sea, and swam until he caught hold of the halter, by which he led the horse safe to shore.
>
> (*The Caledonian Mercury*, 23 September 1782)

For this act of bravery Astley was immediately rewarded by being promoted to the rank of sergeant. A copy of Astley's Certificate of Service, published in *The Times* of 25 June 1788, creates an even more expansive picture of this incident: 'At the disembarkation of the troops … by his spirited activity was the principal means of saving several men and horses, in imminent danger, from the accidental oversetting of a boat.'

The regiment then marched to Zwesten, in Hesse, to join the forces of the Hereditary Prince of Brunswick. A detachment of the French Army, comprising six battalions of infantry, a regiment of hussars and a train of artillery, were encamped in the vicinity of the nearby village of Emsdorf. The Prince intended to surprise the French forces and, on 21 July, launched an attack, with himself at the head of the 15th Dragoons. He instructed the men to place oak branches in their helmets to evince a firmness of engagement. It must have worked because two battalions of the French were routed. The 15th then attacked the enemy's right flank and drove through to cut off the French retreat, attacking body after body of men

until the French surrendered. More than 500 French soldiers surrendered to the 15th that day. The Battle of Emsdorf was a major victory for the allied forces, due largely to the action of Eliott's 15th Dragoons. In total, more than 2,500 French soldiers and officers surrendered, nine guns were taken, along with one howitzer, and nine pairs of colours were captured. Astley covered himself with glory that day. Despite being unhorsed and wounded, he managed to capture one of the colours and return with it to his own lines. He was again wounded at the siege of Cassel in 1761, something that he referred to in a published letter to a friend in 1789:

> I some time ago had the misfortune to burn the tendon of my right ancle [*sic*], near the gun-shot wound I got whilst you and I were in front of Hesse Cassel in the last wars in Germany.
>
> (*The Times*, 3 September 1789)

He would later have the honour of presenting the captured colour to His Majesty King George III at a review in Hyde Park, when the regiment returned to England. But the battle had been won at a cost to the regiment. Seventy-five men were killed and fifty were wounded. What must have saddened Astley was that 116 horses were killed and fifty-six wounded.

Having sustained so heavy a loss, the regiment was 'rested' for some days near Paderborn. They were then sent to Hanover for refitting and remounting, where they remained until August before rejoining the forces of General Lückner at Hardegsen. Throughout the subsequent two years, Eliott's 15th Dragoons took part in many battles and skirmishes, always with distinction. Astley was usually in the thick of it and, on 30 August 1762, he distinguished himself yet again:

> The Hereditary Prince ... was severely wounded in the hip; some of Eliott's Light Horse, among whom Astley and Ovitts were conspicuous, rallied to his assistance, cut down the French Hussars, by whom the fallen Prince was surrounded, and thus permitted of his being brought away safely.
>
> (H.C. Wylly, 1913)

The incident is also recorded in Astley's Certificate of Service:

> That, at the battle of Friedburg [Wylly gives this as the battle of Johannesburg], when on the advanced guard ... he personally assisted, under a very heavy fire, in bringing off His Serene Highness the Hereditary Prince of Brunswick, when His Highness was wounded, within the Enemy's lines.
>
> (H.C. Wylly, 1913)

There are varying accounts of this incident: Astley himself at times claimed to have personally rescued the Prince single-handedly. There is little doubt that he was involved, and he was very probably one of several Dragoons involved in the action. William Ovitts, who went on to live until he was over ninety years of age, was recorded in *The Drogheda Journal* of 26 January 1825, as 'single-handed, galloped after them, killed the three French soldiers, and rescued the Prince.' The article in *Once A Week* (1862–63) recalls that Astley, 'when in command of four men only, he charged a considerable body of hussars, and rescued the Prince of Brunswick, then lying wounded within the enemy's lines.' As a sergeant he would have had command of a troop, and Ovitts was possibly one of the Dragoons with him at the time. Perhaps the more accurate picture is given in Astley's Certificate of Service and that individual heroic exploits are more down to old soldiers' tales.

The war in Europe slowly ground to stalemate. In 1762, both Russia and Sweden withdrew from the war, both making peace with Prussia. On 15 November, the suspension of all hostilities was agreed and King George III now insisted that all British troops should return to England. It was to be a slow process for the 15th. They spent the winter in quarters in the Netherlands before embarking for England on seven transports on 22 March 1763. They landed at Yarmouth and Gravesend, and then proceeded to Hounslow. On 5 April 1763, they marched over Westminster Bridge: 'With every man a sprig of box in his hat in token of victory, having been in almost every engagement in Germany, and always beat the enemy' (*The Gentlemen's Magazine*, 5 April 1763).

Little did Astley think that in a few short years he would be returning to Westminster Bridge in an entirely different capacity. On 21 July, the regiment was reviewed by King George III in Hyde Park:

> The Men and Horses made a fine Appearance and went through the different Parts of their Exercise, Firing and Manouevres, with great Dexterity and Exactness, to the Satisfaction of a numerous Crowd of Spectators. When the Regiment passed His Majesty in Parties and Grand Divisions, a Pair of French Colours were carried before them [in fact there were sixteen stands of Colours presented that day], which that brave Corps had taken from the Enemy in the late War.
>
> (*The Derby Mercury*, 22 July 1763)

By all accounts, it was one of these colours that Astley had the honour of personally presenting to the King and his party. However, the review did not pass without incident. It would seem that Colonel Eliott, in sheathing his sword while his horse was restless, managed to wound himself in the thigh. How ironic that after several years in the battlefield, he returns home to wound himself with his own sword!

Also during the review, the crowd was so large that many climbed into trees for a better view. A bough on one of the large trees broke and several people fell to the ground. There were several broken limbs and one person was so badly crushed that there was little hope of recovery.

By now Astley had risen to the rank of sergeant major of horse. He was a seasoned and battle-hardened soldier who had shed blood for his country. And it must be remembered that he was still a young man, only twenty-one years of age. By August, the regiment had been reduced to a peacetime establishment of six troops. During 1764, the Prince of Brunswick paid a visit to London. While processing through the streets, the Prince recognised a cheering trooper – none other than Philip Astley himself. The Prince acknowledged him, much to the amazement of other bystanders.

Later in the year, the regiment was stationed in Shrewsbury, and in December a War Office Order made the average height of a trooper at 5 feet 5 inches to 5 feet 7 inches. Astley would still retain his imposing figure. The horses were to be from 14.3 to 15 hands – a hand being approximately 4 inches and the height measured from the ground to the shoulder. These were quite small and light horses, unlike the larger animals of the heavy cavalry. Astley, with his more than average height and build, must have looked a colossus astride his mount. In June 1765, the regiment returned to London for another review in Hyde Park. So pleased was the King that he ordered that the regiment would, from that point on, be called the King's Regiment of Light Dragoons and that the uniforms should have blue facings rather than the original green. He also permitted them to display the battle honour 'Emsdorf' on the regimental colours, the first time that any regiment of the British Army had been allowed to do so. After the review the regiment was stationed in Hounslow for escort and ceremonial duties.

Time was moving on for Astley. He had risen to the highest non-commissioned rank that he could achieve. The wars had come to an end and perhaps for Philip Astley, man of action, peacetime duties held little appeal. He needed a new challenge, and in 1766, he requested a discharge from service. His discharge paper reads:

> Regiment of Light Dragoons, commanded by Lieutenant General George Augustus Eliott
>
> These are to certify, that Philip Astley, Serjeant Major in the above regiment, and in Sir William Erskine's troop, hath served for the space of seven years, and upwards, honestly and faithfully, much becoming a gentleman, but, by his own request he is hereby discharged; having first been accounted with for all his pay, and arrears of pay, as appears as his receipt at the back hereof.

> Given under my hand, and Seal of the Regiment, at Darby [*sic*], the 21st day of June 1766
>
> > William Erskine
> > Lieutenant Colonel
> > (*The Times*, 25 June 1788)

So, Philip Astley was no longer a soldier. Popular history would have us believe that he made his way from Derby to London to seek fame and fortune as a riding master. But I believe that he may have already been there. A general consensus of archivists and librarians that I talked to all interpret the latter part of his discharge papers, 'Given under my hand ...', to indicate only that William Erskine was in Derby on the day that he signed the Order. It does not necessarily show that the regiment, or Astley, was there. T. Hayer (1978) cites military orders that instruct the regiment to move to Derby in October of that year to deal with rioting, four months after Astley's discharge. Whether or not Astley was in London or Derby on discharge, there were more pressing reasons for him to settle in London.

From Halfpenny Hatch to Westminster Bridge

Why would the young Philip Astley, brought up in provincial Staffordshire, a war hero, a man of action, on being discharged from service not return to his home town? Even if, as we are to believe, his relationship with his father was a stormy one, he was close to his sisters and would surely have wanted to visit them. But no; he next appears in London. I suggest that, for reasons I have already explained, his family were already there. An even more important reason for him to go to London was that he had married there in 1765. His regiment had returned from the Seven Years' War in 1763 and spent most of the following years, until his discharge, in and around London. He was, according to accounts, an exceedingly handsome man and, coupled with his imposing stature, it is hardly surprising that he would have had many female admirers. One particular young woman, with long golden hair, caught his eye – a certain Patty Jones. It may have even been that they knew each other before he enlisted in the Dragoons if, as I have suggested, the Astley family were in London before 1759.

Philip and Patty were married on 8 July 1756 at the church of St George in Hanover Square, London, as entered in the *Register Book of Marriages* for the church. The Ancestry website holds digital copies of the application for a Bishop's Licence to marry, dated 6 July. Patty was a spinster of the parish of St George, only a few streets away from the parish of St Anne's in Soho. Some writers have claimed that this marriage was not the Philip Astley of 'circus' fame. An extensive trawl across all marriage records for the period produced no other result for a Philip Astley–Patty Jones marriage anywhere in the country. M. Rendell (2014) suggests that perhaps they did not actually marry at all but simply lived together as man and wife. Part of the justification for saying that this is the wrong marriage is that Philip Astley was still in the Dragoons at the time and that he gave his status as a 'Gentleman of the parish of Egham, Surrey'. Firstly, there is no reason why he should not have married while still in service; many soldiers did and their wives remained at home. Patty could well have stayed in London while Philip saw out his final year in service, and all the more reason for him to settle in London on discharge. Perhaps the fact that he was newly married precipitated his request to be discharged from service. The second justification for this being the wrong marriage is based on Philip's given status. However, false statements were very often made on marriage certificates. This was done for many reasons, usually to impress.

My own father is a case in point. When he married he stated that his father was a 'retired solicitor'. Nothing could have been further from the truth. After many years of searching I discovered that he was in fact a chemical dyer in a textile factory in Leeds. My father had created this fact solely to impress his father-in-law. With Philip Astley's expansive nature it would have been a simple step to label himself as a 'Gentleman', perhaps with an eye to leaving the Army within a short time. And as for stating that he lived in Egham, this is not an impossibility. Egham is not so very far away from Hounslow or Windsor and we know that the 15th Dragoons occasionally carried out escort and ceremonial duties in Windsor. Perhaps they were temporarily stationed at Egham during this time. Granger (1804) claims that he married a Miss Charlotte Taylor, but there is nothing to substantiate this claim and I have been unable to find any records at all for such a marriage.

Patty Jones was born Martha (or Mary) Jones but, for reasons unknown, became known as Patty. She came from the aristocracy and her grandfather had been Sir Thomas Longueville, the 4th Baronet of Wolverton. His wife had been Maria Margaretta Conway, a significant name, as we shall see. As Sir Thomas only produced daughters, the baronetcy expired. In *Burke's Extinct and Dormant Baronetcies of England, Ireland and Scotland* (2nd edition, 1841) there is a reference to Patty Jones, who married 'Philip Astley, of Lambeth'. Lambeth is not Egham, but at the time when this volume was being composed, Philip Astley was rising to fame and living in Lambeth. It is also worth noting that Philip and Patty named their son John Conway Philip Astley. The Conway name was passed down through the generations and it can be no coincidence that Patty named her son after the family name. With an aristocratic heritage, perhaps this is why the non-commissioned officer Astley was granted leave to marry Patty while he was still a serving soldier.

1768 is given as the year in which Astley gave his first performances. But he had left the Army in 1766, so what had he been doing in the intervening two years? There is strong circumstantial evidence to support the idea that he may have returned to his old trade of cabinetmaking. The *Register for Duties Paid for Apprentices' Indentures 1710–1811* (www.ancestry.co.uk) shows that on the 20 September 1766, a Philip Astley, cabinetmaker of St Anne's, Soho, took on John Hughes as an apprentice. Again, on 9 April 1767, he takes on another apprentice, by the name of Thomas Phillips. Also in 1767, on 26 March, Philip Astley was sworn as a juror at an inquest held in the parish of St Anne into the death of a Stephen Gaudry, who had committed suicide by slashing his throat with a razor. This is recorded in the *City of Westminster Coroners' Inquests into Suspicious Deaths* (www.londonlives.org). I find it difficult to believe that there could have been another Philip Astley, who was also a cabinetmaker by trade, living in the parish of St Anne's in Soho – the same parish in which an Edward Astley also plied the

trade in 1755. The final piece of evidence that, I believe, confirms that this is 'our' Philip Astley is to be found in the *Westminster Baptism Transcriptions* of the parish records of St Anne's in Soho. These show that John Conway Philip Astley, son of Philip and Patty, was baptised on 21 May 1767. He had been born a month earlier, on 20 April 1767 (www.findmypast.co.uk).

M. Rendell (2014) claims that by the summer of 1767, Astley had got a job as a groom, assisting a Mr Sampson at his riding school. E. Rimdault, in *Notes and Queries* (1854), also writes: 'Astley was the pupil of Sampson, and his successor in agility.'

It is quite possible that Astley knew Sampson, who was a former cavalryman in Lord Ancram's Light Dragoons. One can imagine that they might have shared military reminiscences over an ale or two, and their love of horses would have been a bond. I am sure that Astley spent some time at Sampson's, as well as the other riding schools in London, and whilst this may have had a strong influence on him, I think that Astley worked at his cabinetmaking as his main source of income during this time. It may well have been that he continued with cabinetmaking for a time after he had first begun his performances. Charles Dibdin, in his 1824 publication *An Account of the Royal Amphitheatre, Westminster Bridge*, writes: 'To defray the expenses of his exhibitions he worked at the cabinet business during the time unemployed in his new professional pursuits.'

Astley would have been aware of the number of equestrian performers in London; they were nothing new. As early as the seventeenth century, before Astley's time, there had been exhibitions of equestrian skills. William Stokes had presented horses at Sadler's Wells. In his 1652 book *The Vaulting Master*, illustrations show him vaulting over one and two horses and balancing on one foot in the saddle. Stokes claimed to have 'reduced vaulting to a method' but his exhibitions were given with stationary horses; it would be the eighteenth century that saw the exhibition of galloping trick riding. One of the earliest of these trick riders was Thomas Johnson. He performed in Bristol in 1753. A newspaper cutting from the time states that, 'Mr Johnson will perform his wonderful exploits of horsemanship on Durdham Downs. Between four and five in the afternoon.'

His programme, as given by Manning-Sanders, was as follows:

Firstly he will ride two horses, as fast as they can go, all round the course, with one foot in the saddle. Secondly he will ride 100 or 200 yards, on his head, his feet being directly upright. Thirdly, he will without any manner of support, ride 300 yards standing on the saddle with one leg only. This being a performance never before attempted by any other person in England. It is hoped the spectators will give him such encouragement

as they may think the execution of so extraordinary an undertaking deserves. The said Thomas Johnson is to be spoke with at the sign of the Ship, in March Street.

He was still performing in Bristol in 1758:

Bristol, July 22. Monday and Wednesday last the famous Thomas Johnson rode round the Course on Durdham Downs on two Horses, with one Foot on each Saddle; and likewise rode an hundred Yards standing on his Head upon the Saddle. There was a numerous Concourse of People each Day.

(*The Derby Mercury*, 25 July 1758)

Clearly, Thomas Johnson was a well-known equestrian performer; T. Frost (1881) claims:

While serving in the army, he [Astley] learned some feats of horsemanship from an itinerant equestrian named Johnson, perhaps the man under whose management Price introduced equestrian performances at Sadler's Wells ...

According to Frost, this Thomas Johnson obtained the lease on a tea garden and bowling green called Dobney's Place, Islington, in 1767, and Price went on to give equestrian performances here, as well as at Sadler's Wells. Johnson, having accrued in the region of £2,600 from his trick riding displays, retired to Ireland, where he unsuccessfully took up farming. He died in early 1785 'in extreme poverty ... for the want of the common necessities of life, in the solitary corner of a cellar in Arran street [in Dublin]' (*Saunders's News-Letter*, 14 December 1785).

Sampson, mentioned above, first performed at the Weaver's Arms, in Mile End before establishing his riding school at the Three Hats Inn, Islington. His exhibitions on a galloping horse included leaping to the ground and firing a pistol before remounting. He would stand on his head while the horse was in full motion and then hang upside down with his hand brushing along the ground. He also gave exhibitions on two horses. James Boswell makes reference to Thomas Johnson, the 'Irish Tartar', being at the Three Hats in 1763, and describes the entertainment thus:

I was highly diverted. It was a true English entertainment. The horses moved about to the tune of *Shilinagarie* [a popular Irish tune], for music, such as it is, makes always a part of John Bull's public amusements.

The Three Hats Inn, or the Jubilee Gardens, as Decastro refers to it, had gaily painted boxes for refreshments encircling a spacious green, thereby creating a natural amphitheatre for equestrian performances – something that would have a profound influence on Astley's later plans. Johnson, Price, and Sampson were all contemporary well-known exponents of the art of equestrianism, and drew large crowds. Another equestrian performer of the period was apiarist Daniel Wildman, who performed on horseback with his bees. He would wear them around his face as a beard and around his arms as a muff. He later went on to publish *A Complete Guide for the Management of Bees* in 1785. Astley would have seen all of these perform and, I am sure, would have got to know them well. With his military experience and undoubted equestrian skills, they would have been an inspiration to him, and so, in 1768, he took the first steps in setting up his own riding school.

Walking around the streets of Lambeth and Southwark today, it is hard to imagine what the place would have looked like in the mid-eighteenth century. Only street names give an indication of the earlier topography; Lower Marsh is a street that links the two boroughs. John Rocque's 1746 map of Westminster and Southwark (www.motco.com/map) shows the south bank of the river Thames lined with timber yards and 'stairs' – points at which boats could be taken across the river. Behind the timber yards there was a lot of open land; some of it was cultivated, and some of it marshy. This was criss-crossed by paths that linked the main thoroughfares. By the time that Horwood produced his map in 1792 (www.motco.com/map), we can see that the area is beginning to develop. There are more designated roads but there is still a significant amount of open land, crossed by various paths. One of these paths in Southwark, named Glover's Halfpenny Hatch, can be clearly seen on the map. It linked Neptune Place with Broad Wall. The path was a short cut for pedestrians but because the land was owned by a Mr Glover, they had to pay a halfpenny toll to use it; hence the name Halfpenny Hatch. It was on a leased piece of open ground near Halfpenny Hatch that Philip Astley chose to open his riding school. The location has long since been developed but Chris Barltrop, veteran circus performer, has researched the area by overlaying old and new maps. He has pinpointed the present-day White Hart public house, on Cornwall Road, as being the site, or very near to the site, of the original Halfpenny Hatch. The environs of Waterloo station now cover where Astley would have given his performances.

Why Astley should have chosen Southwark for his first venture is not known. Traditionally, the south bank had been the home of entertainments such as the early Elizabethan theatres, bull and bear baiting, cockfighting and dog fighting. As the other equestrians and their riding schools were on the north side, Astley might have felt that there was more opportunity in this 'untouched' area. Perhaps it was that the lease was cheap and available; we simply do not know. He had received

a horse from the regiment on his discharge. This is not to be confused with the 'Gibraltar Charger' that Lieutenant General Eliott presented him with much later. He then went on to purchase a small horse from Smithfield Market, for which he paid five pounds. This would become, with training, his beloved Billy the Learned Horse. Having obtained the land, he pegged out a circular ride; he never referred to it as a ring. It was here that he established the idea of performing in a circle of some 42 feet in diameter. The centripetal force created by the horse travelling in a circle assisted him in his balancing routines. It also made viewing by the audience much more comfortable than having to continually turn their heads from side to side, as at a tennis match. Supported by Patty, herself a competent and skilful equestrienne, he opened the doors for business.

Exactly when he made his first performance is not clear. Some writers say that it was as early as January, others not until June. With performances being given in the open air I am inclined to the opinion that it was unlikely to have been January. News reports of the period show that for January 1768 in London and across Britain there were severe frosts and snow:

> It appears by the Thermometer, and References to a regular authentic Diary of the Weather for upwards of a Century past, that the Weather has been three Degrees colder this Frost [winter period] than at any one Time within the last eighty preceding Years.
>
> (*The Ipswich Journal,* 16 January 1768)

April saw mixed weather, with warm spells in Edinburgh but stormy elsewhere. Certainly by April, Astley was performing because one of the earliest cuttings advertising his exhibition of equestrianism is to be found in the British Library collection. It is hand dated 4 April 1768, but unfortunately the newspaper from which it has been cut is not mentioned:

> ACTIVITY on HORSEBACK by Mr Astley, late Serjeant [*sic*] Major in His Majesty's Royal Regiment of Light Dragoons, commanded by Lieut General Eliott. Near twenty different attitudes will be performed on one, two and three horses every evening during the summer season, excepting Sundays at his Riding School near the Wright's House or Halfpenny Hatch, Lambeth Marsh, not the Dog and Duck.
>
> Turn down on the left hand, as soon as over Westminster Bridge or at the Turnpike. Doors to be opened at four, and he will mount at five. Seats one shilling, standing places at sixpence. Will be much obliged to those ladies and gentlemen who will honour him with their company and will do everything in his power to gain their favour.

N.B. He will ride at the New Spring Gardens, Chelsea, of which notice will be given in this paper.

Astley is quite clear in giving directions to his amusements. He did not want his audience to go to the Dog and Duck Inn, where a Mr and Mrs Wolton were giving equestrian demonstrations. A later account of his first opening, quoted in *Bell's New Weekly Messenger* of 12 November 1827, quotes another advertisement that gives even more precise directions:

Turn down on the left hand, as soon as over Westminster Bridge or at the Turnpike, and over Black Friars Bridge by Christ Church turn on the right – being situated between the two bridges and near Cuper's Gardens.

Also in 1768, Mr Sampson and his wife were giving displays at the Globe Inn on St George's Fields. As well as advertising in the newspaper, Astley also takes on personal promotion. Astride his horse and in full military uniform, he handed out advertising in the streets around Halfpenny Hatch.

There are some other interesting points in his advertisement. Clearly he expects many of the audience to come across the river from the north bank via Westminster Bridge. Secondly, his performances were given in the early evening and not, as some have claimed, throughout the day. Could this indicate, as Dibdin maintained, that Astley continued working as a cabinetmaker during his early years as a performer? It would make some sense for a married man with a young son to have some secure income rather than relying upon the vagaries of the audience and the weather. Thirdly, it seems that he was not relying solely upon the performances at Halfpenny Hatch. If he was exhibiting at New Spring Gardens as well, does this mean he was giving two shows an evening at two different venues? Certainly he was beginning to make a name for himself. A hand transcribed copy of a newspaper cutting dated 15 April 1768 attests to this:

New Spring Gardens, Five Fields, from the road leading to Ranelagh ... Mr Astley's performance of Horsemanship meets with universal approbation on the above Green where he exhibits every Ranelagh evening (weather permitting) his surprising new feats of Horsemanship, many things never attempted by any but himself. Admission 1 shilling. (BL)

It has to be said that the newspaper cutting stating that he would ride at 'New Spring Gardens, Chelsea' is a little ambiguous. The borough of Chelsea is on the north bank of the Thames, and the Ranelagh Gardens were situated where the Chelsea Flower Show is now held every year, near the Chelsea Royal Hospital.

New Spring Gardens was also the former name of the Vauxhall Gardens, on the south bank, and at that time, the Chelsea Bridge linking north and south banks had not yet been constructed. There was also a distinct difference in the clientele of the two gardens. Vauxhall Gardens was far more rumbustious, as opposed to the more genteel atmosphere of the relatively newly established Ranelagh, which focused upon music and masques. Smollett's character Lydia, in his 1771 work *The Expedition of Humphrey Clinker*, describes Ranalegh as being:

> adorned with the most exquisite performances of painting, carving, and gilding, enlighted with a thousand golden lamps, that emulate the noonday sun; crowded with the great, the rich, the gay, the happy, and the fair; glittering with cloth of gold and silver, lace, embroidery, and precious stones. While these exulting sons and daughters of felicity tread this round of pleasure, or regale in different parties, and separate lodges, with fine imperial tea and other delicious refreshments, their ears are entertained with the most ravishing music, both instrumental and vocal.

If he was giving two performances a night then it would be more logical to ride the 1½ miles to the Vauxhall Gardens (New Spring Gardens) rather than to the more distant Chelsea, across the river. However, Astley's advertising is specific and the account of his exhibition there does refer to the New Spring Gardens, Five Fields, being on the road leading to Ranelagh. Although Vauxhall Gardens was still occasionally referred to as New Spring Gardens or Spring Gardens, it would seem to be that in 1768 there was an area in Chelsea, near the Ranalegh Gardens, that was commonly named New Spring Gardens.

An account of his exhibition, given in 1770 (BL), in which he calls himself the 'original English Hussar', runs as follows:

> He makes his horse lie down, imitating death
>
> He rides at full speed standing with one foot on the saddle
>
> He balances himself without holding at full speed, standing on the saddle
>
> He picks up a sixpence from the ground at full speed
>
> He sweeps his hand along the ground
>
> At full speed he springs from the saddle to the ground and from the ground to the saddle
>
> He then rides two and three horses
>
> He presents the Tailor Riding to Brentford
>
> All given in four Acts

Much of this exhibition had been seen before in the performances of Johnson, Price and Sampson. Astley was not exactly an innovator but what he was good at was taking an idea and developing it until he made it his own. Billy the Little Learned Horse was a case in point. Other equestrians had trained their horses to lie as still as death but Astley turned it into an heroic show. Willson Disher (1937) gives a description of it. The horse would lie as if dead in the middle of the arena and Astley would commence his prologue:

> *My horse lies dead, apparent at your sight,*
> *But I am the man who can set things to right,*
> *Speak when you please, I am ready to obey,*
> *My faithful horse knows what I want to say,*
> *But first pray give me leave to move his foot.*
> *That he is dead is quite beyond dispute.*

At this point Astley would lift the leg of the horse, which would not react at all. He would then continue in his loud and commanding sergeant major's voice:

> *This shows how brutes by heaven were designed*
> *To be in full subjection to mankind.*
> *Rise, young Bill, and be a little handy,*
> *To serve that warlike hero Granby.*

And at this point the horse would rise to its feet with no obvious command from its master. To conclude, Astley would then turn to his audience and announce:

> *When you have seen, all my bills expressed*
> *My wife, to conclude, performs the rest.*

He would then lead off Little Billy to thunderous applause as his wife Patty entered the arena to conclude the show with a display of her own trick riding – standing on her head, also firing a pistol while balancing on two horses.

The sketch *The Tailor Riding to Brentford* was another of Astley's interpretations of a popular act that he developed and first presented in 1770. The act had its origins in the volatile political upheavals of the times. The year 1768 was notorious for rioting in London. By the middle of the year the Spitalfields weavers and the Wapping coal heavers had rioted. Groups of hatters, tailors and glass grinders also joined the riots. Also in that year, a radical Member of Parliament by the name of John Wilkes returned from a period of exile in Paris. He had been found guilty of seditious libel against the King in 1764. He had anticipated being arrested on his

return but the government, not wanting to inflame an already politically tense situation, deferred. Wilkes was elected, with popular radical support, as the Member for Middlesex. In April he surrendered himself to the King's Bench, where he was sentenced to one year's imprisonment and a fine of £500. He was imprisoned in the King's Bench prison in Southwark. When news of this was heard, large crowds began to gather on open land at St George's Fields, between Southwark and Lambeth. On 10 May, more than 15,000 people had gathered outside of the prison demanding justice for Wilkes. A detachment of Guards was sent to quell the protest and formed up in four rows in front of the prison. The crowd was angry and the Riot Act was read for a first time. The situation became inflamed and a group of soldiers chased and shot dead an alleged protestor. This created even more turmoil. The Riot Act was read again and a troop of Horse Guards sent for. Stones were thrown and eighteen soldiers were injured. The foot soldiers were ordered to open fire on the crowd, and then the Horse Guards rode up and discharged their pistols. It is commonly accepted that eleven rioters were killed and fifteen wounded. At this the crowd began to disperse but the action of the military triggered further unrest around the city. It was reported that sawyers began to destroy saw mills and that watermen destroyed boats and threatened bridges.

The Tailor Riding to Brentford was based on the fanciful exploits of a tailor who was desperate to get to the hustings in time to vote for Wilkes. Being an inept horseman, it allowed for all sorts of comic slapstick gags to be woven into Astley's equestrian act. Astley took the character and named him Billy Buttons, and in doing so made the sketch his own. Billy Buttons was one of the first distinct slapstick characters to appear in the 'circus'. He would be performed many times long after Astley's death, and in different variations; but Billy Buttons was his creation. In this act Astley elevated the role of the horse to a performer in its own right. It was no longer the vehicle solely to display the 'manly feats' of the rider, but became an integral part of the performance. Astley would appear in some form of comic costume, disguised as Billy Buttons, the tailor. The horse would be standing still but when Billy Buttons tried to mount, it would walk off, leaving him flat on his face. This would have been repeated several times. Eventually, he manages to mount the horse but finds himself facing the wrong way. He has to dismount in order to remount facing the right way. When he does finally mount, the horse lowers its head and promptly deposits him on the ground. And so the routine continues, each time the horse getting the better of the rider until eventually Billy Buttons chases the horse around the arena, only to end up being chased by the horse. Finally, he manages to mount, reveals himself as Philip Astley and continues with his exhibitions. It was a very popular routine, and has continued to be so throughout the ages, appearing in numerous versions in many circuses.

His performances proved very popular and an unattributed handwritten transcription in the British Library, dated September 1768, states: 'It is said, the person, who now amuses the town with surprising feats of activity on horseback, clears little less than forty guineas per day.'

Forty guineas was a significant amount of money. The National Archive converter gives it a current equivalent of over £2,500. His audience must have been quite large. If everyone paid one shilling, as advertised, then it would have been at least 800 people. If they all paid sixpence each then the crowd would have been about 1,600. So we could estimate that somewhere in the region of 1,000 people per performance were watching his shows. And with a possible two performances per night, he was doing very well. It is hardly surprising that, with this success and new-found wealth, he wanted to expand his work.

By 1769, he was casting his eye at a more suitable piece of land at the southern foot of Westminster Bridge. Again, we do not know exactly what prompted his move from Halfpenny Hatch. Being near a main thoroughfare across the Thames, perhaps there was a greater 'footfall' of customers with easier access to the premises. *The Newcastle Courant* of 1 December 1837 gives an account of this acquisition, drawn from an article in a publication entitled *Colburn's New Monthly* in November of that year:

> In the spring of 1769 he took a piece of ground from an old man on Stangate Street, who formerly kept a preserve for pheasants there, but at that time a timber-yard; he advanced him 200l. [£200] and had the timber, etc., secured to him by way of mortgage: the old man left England and was never heard of again: at the same time he found a diamond ring, worth 60l. [£60] on Westminster Bridge, which was never advertised. He enclosed the timber-yard ... with a high paling and built a wooden house in the situation of the present entrance [on Westminster Bridge road]; the lower part he made into stables, and the upper a long room for the gentry. The three rows of seats round the ride had a sort of pent-house covering – the centre was entirely open. He then advertised that slight showers would not prevent performances and that proper music was provided. Long Room 2s. [2 shillings]; Riding School 1s., Open at 4, mount at 5.

Astley clearly had an ambitious plan in mind. From giving exhibitions of equestrian skills in a relatively open space, such as at Halfpenny Hatch, he now had his own contained performance space that catered for all classes of audience. He was also able to offer lessons in equestrianism during the day, before the evening performance. He named his space the British Riding School, and G. Worsley (1987) gives a more detailed description of the place:

It was a simple white-washed timber structure built around a 60 foot arena. Decoration was restricted to the outside where passers-by were enticed by posters of various acts. Along the edge of the roof pranced cut-out horsemen. Cut-out acrobats balanced precariously in a human pyramid at one end of the grandstand, while over the gable … stood Astley on his horse [a cut-out figure].

He was also beginning to expand his performance troupe. In *The St James' Chronicle* of 7 November he advertised for 'a facetious gentleman to entertain the company', his first clown. By 1770 he was employing one of his fourteen-year-old 'students', a Master Griffiths, and he was exhibiting a Signor Don Diego and his tumbling routine. Later, in 1771, he also employed a Mr and Mrs Hughes as additional equestrian performers. Astley was also quite adept at involving the audience, as performers themselves:

At six o'clock, Mr and Mrs Astley, at the foot of Westminster Bridge, still continue, till further notice, to exhibit, besides their Amazing Feats of Horsemanship, a comic race by four capital performers [members of the audience], tied all over their heads in sacks. This droll invention, together with the Taylor Riding to Brentford, the Broadsword as in real action, the Deception with the Cards, Mrs Astley's Activities on two Horses, is surprising and allowed to be the compleatest [*sic*] Performance in England.

(unattributed news cutting, 16 June 1771, BL)

The winner of this comic race received a silver watch. This audience involvement is something that still happens in circuses today. It is interesting to note that Astley was also venturing into the world of magic, performing card tricks. In 1785 he published *Natural Magic: or, Physical Amusements Revealed*. This was a magician's manual with explanations of several conjuring tricks of the time.

The popular story of his finding a valuable diamond ring has never been substantiated, although many have written about it. It may even have been a story put out by Astley himself. In the same manner, the story of Astley calming the King's horse as it threatened to unseat him while crossing Westminster Bridge one day in 1771 has never been corroborated. Astley claimed that in reward for his actions that day he and his company were invited to give a Command Performance before the King and invited guests in Richmond Gardens. This did take place, so clearly there must have been some grain of truth in Astley's claims. The *Kentish Gazette* of 16 July 1771 gives a report of it:

His Majesty having expressed a warm desire of seeing the celebrated
Mr and Mrs Astley perform their various feats of horsemanship, they
attended yesterday in Richmond Gardens, and performed before their
Majesties and the Royal family; when His Majesty was so much charmed
with the activity and skill displayed by these riders that he desired them to
attend again this day at the above place to see the entertainment repeated.
His Majesty made Mr Astley a present of two 20l. banknotes, and Her
Majesty gave ten guineas to Mrs Astley.

Not only one Command Performance – but two. It proved to be a significant, and
lucrative, moment for the Astleys because in the audience at one of the perfor-
mances was the French Ambassador, who invited them to Paris to perform before
the French king and royal family. Accordingly, at the end of the season, the Astleys
set sail for France, where they performed before King Louise XV, 'le Bien Aimé'
[the Beloved], and his queen at Fontainebleau. These royal connections were
something that quite regularly appeared in advertising, as here dated 25 April 1772
(BL), when they had returned to England:

Likewise Mrs Astley will display the same feats of Activity as she did
before their Majesties in Richmond Gardens, and likewise before the
whole Court of France at the Grand Camp at Fontainebleau, being the
only one of her sex that ever had that honour.

When he had travelled to France, Astley had left the British Riding School in the
capable hands of his rising star Charles Hughes. However, on his return to London
he discovered that Hughes and his wife had left the company and had set up their
own British Horse Academy on the south bank, near Blackfriar's Bridge. They
had also engaged the services of a Miss Huntley, a rope dancer who had been per-
forming at Sadler's Wells. Astley was incensed and a fierce and bitter rivalry grew
between them. Astley introduced his young son John to the arena, performing on
horseback at five years old. Hughes countered by presenting his eight-year-old sis-
ter under the exotic name of Sobieska Clementina. Astley was not to be outdone.
He presented a strong man act who could balance a nine-year-old girl on his hand,
and Mr Wildman with his equestrian bee act. By 1773, he had added tumbling and
vaulting, including a Spanish gentleman who:

throws himself into the Air a considerable Height, turns round and …
like a Tennis Ball, which rebounds, throws himself back again without
touching the Ground with his Hands.
(A short description of the various feats of activity exhibited at Astley's
Fenwick Collection Tyne & Wear Archives)

In the five years of performing, Philip Astley had created the first permanent venue for his exhibitions. He was now presenting a variety of entertainments that far surpassed anything similar in London. But 1773 was to usher in a period of conflict with both rivals and the authorities that would lead to the spread of his particular style of entertainments across Great Britain and ultimately much of the world. It would also place Astley's as the dominant force in the profession.

Chapter 5

On the road: Astley the showman

In June 1737, an Act was brought before Parliament pertaining to theatrical representations in public. The Act begins:

> An Act to explain and amend so much of an Act, made in the Twelfth Year of the Reign of Queen Anne, intituled [*sic*] 'An Act for reducing the Laws relating to Rogues, Vagabonds, sturdy Beggars, and Vagrants, into One Act of Parliament; and for the more effectual punishing such Rogues, Vagabonds, sturdy Beggars, and Vagrants, and sending them whither they ought to be sent, as relates to common Players of interludes'.
>
> (*Journal of the House of Lords*, Volume 25, June 1737, Parliamentary Archives)

The Act meant that unless performers or venues were licensed, punishments could be issued. In London by 1773, only the Drury Lane and Covent Garden theatres had a royal patent for theatrical performances. Licences for music, singing and dancing were issued at the discretion of local magistrates but neither Astley nor Hughes had acquired the necessary permission. Accordingly, at the end of the season, both places of entertainment closed. In order to avoid prosecution, Hughes took his small company to Europe. In the July, Astley took his entire company to France, as noted here in *Jackson's Oxford Journal* of 24 July 1773: 'Yesterday morning set out for the south of France, Mr and Mrs Astley, of Westminster-Bridge, with all his troop of riders. It is supposed, on a moderate computation, they have cleared this season four thousand pounds.'

Clearly he was doing well. On his return from France, Astley set out on a tour of England, taking his exhibitions far and wide. Sometimes he would perform in open-air arenas, as he had done at Halfpenny Hatch, and at other times he would take over and adapt existing theatres for his exhibitions. He must have realised that there was a market for his exhibitions in the provinces because there is a record of him having visited Liverpool before the end of the 1773 season. There is a record for *Williamson's Liverpool Advertiser* of 12 February 1773 (cited in *Annals of the Liverpool Stage*, 1908) that shows that Astley and his pupils from London had performed to over 20,000 members of the public in the area of Mount Pleasant in Liverpool.

On 15 November 1773, the Astleys had arrived in Ireland, and by January 1774, he and his company were performing in Dublin:

For the Benefit of MR ASTLEY'S CHILDREN
Who will THIS NIGHT exhibit great Variety with such Elegance and Ease as will greatly surprise the Spectators. By His Majesty's Servants. At the New Theatre in CAPEL STREET. On Saturday next, the 8th of January, 1774, will be presented a Comedy, called THE WEST INDIAN. At the end of the third Act, a HORNPIPE, in the character of a British Sailor. End of the Play, a song, by one of MR ASTLEY'S CHILDREN, eight years old to which (by particular desire) will be added THE JUBILEE with various Alterations and Additions, particularly the surprising and uncommon Exhibitions of the sagacious Animal the LITTLE MILITARY HORSE which will go through the Whole of his different Performances in a manner beyond Conception.

Also, Mr ASTLEY and his CHILDREN will exhibit in a manner never attempted in THIS KINGDOM, which will be a sufficient Proof of his Abilities, LOFTY TUMBLING by two capital Performers (Clown Costmopolitan) with variety of Flip-flap and Somersets [*sic*], backwards and forwards, by a young Gentleman from Sadler's Wells, London. Variety of CHAIR and TABLE TRICKS, entirely new. The Whole will conclude with a fine TRANSPARENT SCENE, representing the Town of STRATFORD, Illuminated in a brilliant Manner.

(*Saunders's News-Letter*, 5 January 1774)

From the above advertisement we can see that Astley had taken over a theatre for his purposes and was presenting a very varied bill. From the wording it would seem that the company had been there a time before because it was a benefit night. Such an occasion was where the profits from that evening's performance went directly to the named beneficiary, in this instance, Mr Astley's 'children'. Some have taken this to indicate that Astley had more than one child, but the use of the word children refers to his younger performers. The one thing that does appear to be missing from the show is the horses, with the exception of Little Billy. However, the piece in the newspaper goes on:

GRAND VARIOUS EXHIBITIONS ON HORSEBACK
Mr Astley having been solicited by Numbers to put his Riding-School on the Inn Quay, Dublin, on the same Footing as that in London, in order that everyone may have an Opportunity of seeing his surprising and uncommon Exhibitions before he leaves Dublin, he gives this public

Notice that he is building a Shilling Gallery, and will exhibit, with his Children, Pupils, Little Horse, etc., on Thursday the 13th inst.

Doors to be open at 12, and mount precisely at one, by the Post Office Clock. Proper music engaged. Admittance Upper Gallery only one British Shilling, commodious covered Boxes two British Shillings each – N.B. If Thursday should prove wet, the Exhibition will be deferred till Friday.

So, it was a variety show in a theatre and an equestrian exhibition in an open-air riding school on Inns Quay, on the north bank of the river Liffey, very near to where the Four Courts was erected. A later entry, on 12 January, informs us that it was a 'circular' riding school and that he would continue to perform there until 21 January, after which he would be returning to London. On the variety programme in the New Theatre there now appeared a 'Learned Dog'. As it turned out, the weather was wet:

On account of the rain, which prevented Mr Astley from riding on Saturday last, by which great Numbers were disappointed of seeing those much admired manly Feats of Activity; Mr Astley begs leave to inform the Public that himself, Children, Pupils, Little Horse and Dog will exhibit this day and tomorrow, being positively the last time of per-forming ... unless the weather proves quite fair Mr Astley will not ride.

(*Saunders's News-Letter*, 21 January 1774)

Astley left Dublin and arrived in London during March, as reported in the *Saunders's News-Letter* of 30 March. It seems that he made a diversion via Paris, where he had engaged 'several of the most principal Performers for Activity of Body in Europe'. With this new company he set off again for Dublin, intending to open at the Inns Quay on the Easter Monday, 3 April. He was certainly in Dublin by the 15th, with Mrs Astley taking a featured part in proceedings:

THE BEES
Mrs Astley will this, and every day this week (and positively no longer) exhibit with three Swarms of BEES and command THEM ON HER ARM, imitating a Lady's Muff [a tube made of fur into which the hands can be placed to keep warm].

(*Saunders's News-Letter*, 15 April 1774)

The following month Mrs Astley is still performing the Bee routine, but now surprising the audience by also commanding them to march across a table, 'which

they will absolutely do in a manner beyond Conception', as reported in the *Saunders's News-Letter*, 6 May 1774. Her Bee routine has echoes of that which Daniel Wildman performed earlier with Astley. Clearly he had either instructed Mrs Astley how to handle bees or she had simply copied his act. Wildman was certainly not with the Astley company while they were in Dublin. Bees must have been a novelty for Astley because a few days later he is advertised as 'discovering to the Company a Method to take the Honey and the Wax without destroying the Bees'. He even allows the under-ten-year-olds to be allowed into the gallery and boxes at half price, so that they 'may have an Opportunity of seeing this extraordinary performance, which they may hereafter remember'. It must have been quite a challenge to travel with three swarms of bees and to maintain them during their stay in Dublin.

Astley seems to have had an enquiring mind. Not only was he a skilled performer in his own right but he promoted many different things. The nineteenth-century American showman P.T. Barnum is renowned for the variety of his public exhibitions. In Astley, Britain had its own version of Barnum almost a century earlier. When he performed in Dublin he had his variety show, his equestrian exhibition, and he also had a small museum of curiosities. When he had appeared in Dublin in the January, immediately following the entry for his show there was advertised 'The Chronoscope' (*Saunders's News-Letter*, ibid.). It was housed at Mr Clarke's, hosier, of Dame Street. The Chronoscope was described as: 'A most elegant piece of mechanism, composed of Architecture, Sculpture, Music and Painting, decorated with various Devices of Jewellery Work, which are displayed in a most brilliant Manner.'

Along with many other exhibits there was a:

> variety of Flowers and other ornaments, which, with the many and various Motions performed by Clock-work as of human figures, the natural motions of the Trunk, Eyes, Ears and Tail of the Elephant, turning, opening and shutting of Flowers ... and the Motions of Serpents as if alive ... and cannot fail of giving Satisfaction to the curious Spectator.

There were certainly two Chronoscopes in circulation at the time. Astley makes reference to a Mr Cox's Museum on William Street, which was also exhibiting a Chronoscope, amongst other exhibits. Astley compares the two in *Saunders's News-Letter* of 12 January 1774: 'It is true, Mr Cox's Museum has been the general Talk of the Polite, both in Town and Country, for some Time past; yet such Ladies and Gentlemen that have seen this [Astley's chronoscope] give it the preference.'

James Cox was a London jeweller who had been granted a licence in 1772 to sell museum lottery tickets at the price of one and a half guineas each. The lowest prize was £150 and the highest was £5,000, without deductions. Each lottery

ticket bought allowed free entry into his museum of exhibits, which included the Chronoscope. It was a moneymaking scheme that would have been worthy of Astley himself. A Chronoscope was exhibited at the Red Bear in Leeds during September 1773 (*The Leeds Intelligencer*, 21 September 1773). Again, the wording is very similar to the above in that it refers to those who have seen 'Mr Cox's Museum, give this the preference'. There was no mention of Astley but there is intimation that this was his exhibition. He was certainly performing in Leeds at the time for in the same edition of the above newspaper there is a large illustrated advertisement for 'Horsemanship and Activity' in a 'commodious Croft in Lands Lane' by Mr and Mrs Astley. Astley's young son, given as only six years old, was also billed to perform on two horses. It seems that Astley had a travelling museum as far back as 1772, for in the *Bath Chronicle and Weekly Gazette* of 1 October 1772, there appears the following:

> Yesterday was removed from the Ladies Coffee-Room, to the Queen's Head, Cheap Street, that most brilliant Piece of Jewellery the CHRONOSCOPE, or the NABOB in TRIUMPH; where it will be exhibited till Saturday, at 1s. each – As Mr Astley has brought with him his little learned Military Horse ... he gives the following notice. That for two nights only, viz. Friday and Saturday ... at that large commodious room the Queen's Head ... he will perform in a manner really astonishing.

In January 1773, Astley and his pupils were performing in Shrewsbury, before moving on to Chester (*The Shrewsbury Chronicle*, 23 January 1773). Along with the usual exhibitions there was: 'The CHRONOSCOPE now exhibiting at the Raven Assembly Room is one of the most surprising pieces that ever made its appearance in this town ... of which Mr Astley appeals to many hundreds that have already seen it.'

By the time that he had returned to Dublin in April 1774, Astley was advertising the exhibition as 'Astley's Museum on Dame Street at only Sixpence each'. Along with the Chronoscope, were other such delights as:

> the much admired Automiton musical young Lady, being the only one in Europe. The above figure is so inconceivably attracting, that many have pronounced it rather the Creation of absolute Magic, than the Production of human Mechanism ... the Chronoscope. This Piece has four Fronts and is as compleat [*sic*] a Piece as any in Europe, being of elegant Workmanship in Gold, Silver, and Jewellery, and that in great Variety. Admittance only a British sixpence.
>
> (*Saunders's News-Letter*, 15 April 1774)

In April, Astley was making it clear that his stay in Dublin would be quite short and that it 'will be impossible for him ever to return to this Kingdom again', and that the boards that had been erected around the riding school would be sold at auction. In the May he announced that his company and museum would tour Carlow, Kilkenny, Waterford, Clonmell and Cork. By June, he was back in Dublin, but the season was coming to a close, and it was announced in the *The Hibernian Journal* on Monday, 20 June that the entertainments at the riding school at Inns Quay would finish the following week. There is a feeling that Astley is leading towards a grand finale in Dublin. The same report continues:

> This evening the whole grand Display of Horsemanship, lofty Tumbling, with Fire-Works, Mr Astley's Children, which for Agility of Body, are incomparable; the surprising Exhibition with Three Swarms of Bees, the little Horse turned Conjuror; the Magical Tables, in four grand Changes. Also, various Deceptions, with Cards, Watches, Birds etc. In short, the whole Performance will be inconceivably entertaining ... Mr Astley intends, in a short time, to retire from such laborious Exercise.

In fact, he must have stayed in Dublin a further week because *Saunders's News-Letter* of 1 July carries the following advertisement, unaccountably in French, followed by an expanded English version on 6 July:

> *Les grandes Souplesse de Manége de Monsieur ASTLEY. Aujourd'huij Mr Astley Representers (outres les grandes Representations) faire voir son grand pouvoir dans la Magie Blanche, en coupant le tête d'un Pigeon, a 30 Verges de Distance, et a son ombre par la Reflexion d'un Miroir Magic ce qui n'at jamais paru dans ce Roijaume.*

> [This Morning, besides the usual Diversions, Mr ASTLEY, to prove the White Magic really curious, will cut off a Pigeon's Head 30 Yards Distance (by the help of a Looking-glass). This Experiment and Operation the celebrated Sieur Nicodemy, of Florence, exhibited to the Policy of that Place, with uncommon Applause, and was presented with a considerable Sum for his surprising Invention.]

One could say that Astley left Dublin with a bang, and certainly the decapitation of a pigeon's head by pistol shot was an explosive finale. But here again, we have an instance where Astley was taking the work of another performer, albeit acknowledging it in this case, and making it his own.

Astley's advertising from the period often shows a heightened sense of occasion, encouraging an audience to attend. He often used terms such as 'the first', 'uncommon', 'incomparable', and 'surprising' to describe the various acts. Phrases such as 'the only one in …', 'manner beyond conception', 'manner never seen before', 'most brilliant manner' and 'cannot fail to give satisfaction' are also frequently to be found. All of this is Astley's showmanship, enticing the audience to witness something that they cannot miss. His well-used 'positively the last time', or a variation on that theme, would be to urge the audience to see the exhibitions before they were to finally disappear. Astley's was a great crowd puller. In an age when public entertainments and amusements were a large part of peoples' ordinary lives, one can imagine that it would almost have been a social stigma for someone to admit that they had not been to Astley's. We have a modern-day comparison in television. In our televisual age it is sometimes easy to forget that for people before the era of the moving image, public entertainments were an important focus for social cohesion. For most people today the television is their main source of entertainment, and in some cases it dominates their lives. How often do we get asked something like, 'Did you see such-and-such on *Eastenders* last night?' or 'Did you watch *Big Brother*?' I do, and when I reply that I watch neither of those programmes, eyebrows are raised in surprise. Sometimes it makes me feel that I am the odd one out, and perhaps that was what it may have been like for anyone who did not manage to 'catch a show' at Astley's.

Another interesting point during Astley's stay in Dublin that year is that for the first time in any advertising, we see a reference to one of Philip Astley's sisters. The performance on 8 June was for 'the benefit of Mr Astley's Sister' (*Saunders's News-Letter*, 8 June 1774). It does not tell us what she did or how long she had been with the company, but she must have been with it for a while to earn a 'benefit night'. I suspect that she had been with Astley for the season in Dublin. He had two sisters, Elizabeth and Sarah, and although his advertising included many named performers, it unfortunately does not name the sister. It is not entirely clear which sister was performing with him. Elizabeth, the older of the two, had first married in Newcastle-under-Lyme in 1767. His other sister, Sarah, as we have seen, first married in London in 1762. Although some have suggested that it was Elizabeth who was performing with Philip, given the circumstantial evidence of the relative marriages and residencies, I feel it is more likely to have been Sarah who was the performer.

In April 1774, Astley received some welcome news. Following the closure of his Westminster Bridge riding school, the matter had been taken before the Surrey Magistrates Court. *The Northampton Mercury* on Monday, 4 April 1774, reported:

> On Monday the following Trial came on at the Assizes at Kingston –
> Some of the Justices of Surry [*sic*], were Plaintiffs, and Astley the Riding
> Master, formerly at the Foot of Westminster Bridge, Defendant, when a
> Verdict was given for the Defendant, his Exercises in Horsemanship not
> being prohibited by the Act.

From the above it seems that the hearing took place on Monday, 28 March, at a time when Astley had recently returned from engaging artists in France. Although it does not implicitly state the fact, it is more than likely that Astley attended the hearing in person. You will note that the verdict only stated that 'Exercises in Horsemanship' were not prohibited. But, as we have seen above, in addition to exhibitions of horsemanship Astley had now developed his performances to include elements of theatre, music, song, tumbling, and conjuring as well as a performing horse, dog – and, of course, the bees. Although the horses were still the bedrock of his performances, he was developing much more of a variety entertainment, something we begin to recognise. Having won his case it might have been expected that he would immediately return to London to reopen the riding school. However, he clearly had a good season running in Dublin, and even when that concluded at the end of 1774, he did not immediately return home but went to Edinburgh. In the November we find him and his pupils exhibiting 'Horsemanship and Activity' at Comely Garden – Edinburgh's equivalent to the Vauxhall Gardens in London, and situated very near Holyrood Palace. This was a morning show, with doors being opened at eleven o'clock and mounting precisely at twelve. He also took his travelling museum with him. *The Caledonian Mercury* of 28 November gives us this information:

> Mr ASTLEY'S MUSEUM is now preparing for exhibition in the Auction-room below Balfour's Coffee-house, and is intended to be opened for the inspection of the Nobility, Gentry, and others, on THURSDAY next, at FOUR o'clock in the afternoon and continues open till NINE the same evening. A servant will attend the door, to show the company in. Admittance ONE SHILLING. A proper explanation will be given to each company.

Clearly, late night opening was not an issue and Astley anticipated that his museum would be of interest to a wide social group. Astley himself continued his equestrian exhibitions with a parade through the city streets two hours before his show. By the December, he was giving performances in three different venues in the city:

> The EXHIBITION of the Little MILITARY HORSE etc.
> In the same manner as Mr Astley had the honour to perform before the present Royal Family at Richmond.

Medieval jugglers, male and female, perform together. *(Library of Congress)*

Grimaldi, with characteristic bottle and string of sausages. *(Author's collection)*

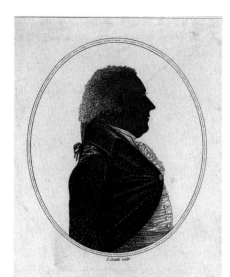

PHILIP ASTLEY.

Born Jan.ʸ 8ᵗʰ 1742

*Twas here the Painter's Task to trace
But the mere Semblance of his Face,
The Portrait of whose Mind, more true,
Lo! his own Work presents to view.*

Philip Astley: silhouette from the frontispiece of his book *The System of Equestrian Education, 1802. (Reproduced with permission of the National Fairground Archive)*

Marriage certificate for Phil(l)ip Astley and Patty Jones. *(London Metropolitan Archives)*

KNOW all Men by these Presents, That We *Philip Astley of the Parish of Egham in the County of Surry Gentleman* are hereby become bound unto the Right Reverend Father in God *Richard* by divine Permission Lord Bishop of London, in the Sum of Two Hundred Pounds of good and lawful Money of Great Britain, to be paid to him the said Right Reverend Father in God, or his lawful Attorney, Executors, Successors or Assigns: For the good and faithful Payment of which Sum, we do bind ourselves, and both of us, jointly and severally, for the whole, our Heirs, Executors and Administrators, firmly by these Presents, Sealed with our Seals, Dated the *sixth* Day of *July* in the Year of our Lord 17 *65*

THE Condition of this Obligation is such, That if hereafter there shall not appear any lawful Let or Impediment, by Reason of any Pre-Contract, entered into before the Twenty-fifth Day of *March* 1754, Consanguinity, Affinity, or any other lawful Means whatsoever; but that *Phillip Astley Batchelor and Patty Jones Spinster* may lawfully solemnize Marriage together, and in the same afterwards lawfully remain and continue for Man and Wife, according to the Laws in that Behalf provided: And moreover, if there be not at this present Time any Action, Suit, Plaint, Quarrel, or Demand, moved or depending before any Judge Ecclesiastical or Temporal, for or concerning any such lawful Impediment between the said Parties: Nor that either of them be of any other Parish or Place, nor of any better Estate or Degree, than to the Judge at granting the Licence is suggested,

And lastly, if the said Marriage shall be openly solemnized in the Church, or Chapel in the Licence specified, between the Hours appointed in Constitutions Ecclesiastical confirmed, and according to the Form of the Book of Common-Prayer, now by Law established, and the above bounden *Philip Astley* do save harmless and keep indemnified, the above-mentioned Right Reverend Father in God, his Chancellor and Surrogates, and all other his Officers and Ministers whatsoever, by reason of the Premises; then this Obligation to be void, or else to remain in full Force and Virtue.

Philip Astley

Sealed and Delivered
in the Presence of

Rob. Grant

1765

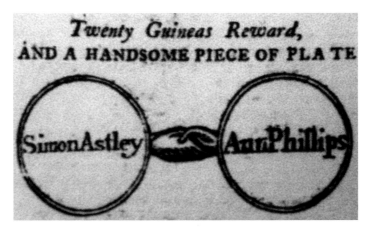

Advertisement for missing relatives. *(Staffordshire Advertiser, 3 June 1797)*

Marriage certificate of Sarah Dusser (née Astley) to Thomas Maylin. Note the signature of Phillip Astley as witness. *(London Metropolitan Archives)*

Enlargement of Astley's signature on his marriage certificate. *(London Metropolitan Archives)*

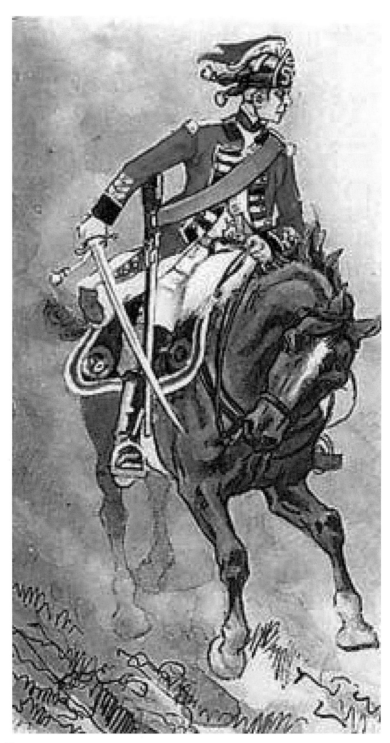

A 15th Dragoon. *(1960s trade card illustration)*

15th Dragoons 1760 issue pistol and carbine as used by
Astley. *(Author photograph by permission of the Royal Armouries)*

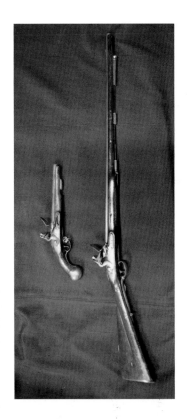

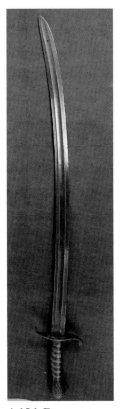

A 15th Dragoon trooper's sword.
*(Author photograph by permission of the
Royal Armouries)*

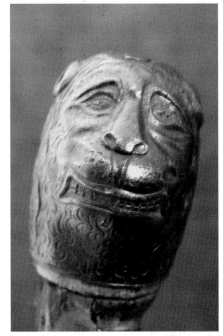

The lion-headed pommel of the trooper's sword.
(Author photograph by permission of the Royal Armouries)

Johnson performing at The Three Hats, 1758. *(Engraving from* The Grand Magazine*)*

Mr Price performing feats of equestrianism at Dobney's. *(Engraving from* London Pleasure Gardens of the 18th Century, *by W. Wroth, 1896)*

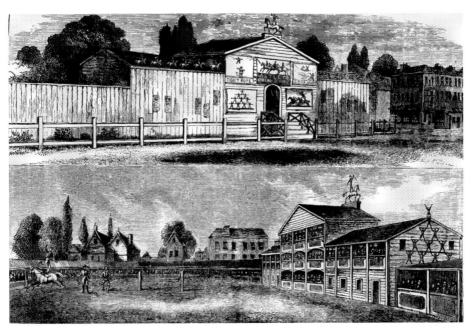

Views of Astley's Amphitheatre at Halfpenny Hatch, c.1770. *(Engraving published in* Old and New London, *by E. Walford, 1878)*

The White Hart public house, now on the site or very near to the original Halfpenny Hatch. *(Author photograph)*

Horsemanship and Activity: advertising for Astley's performances in Leeds.
(Leeds Intelligencer, *21 September 1773*)

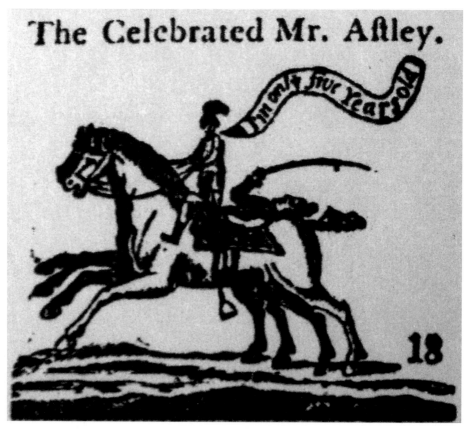

A 1773 newspaper advertisement showing John Astley performing at 'five years old'. (Stamford
Mercury, *29 March 1773*)

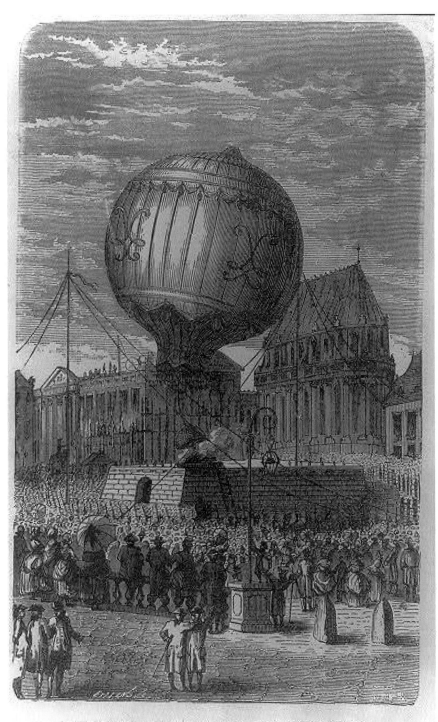

ASCENT OF THE 19TH SEPTEMBER, 1783, AT VERSAILLES.

The Montgolfier brothers' balloon ascent in Paris, 1783. *(Library of Congress)*

DÉTAIL DES EXERCICES
Du Fameux Singe, nommé GÉNÉRAL JACO.
AMPHITHEATRE du Sieur ASTLEY,
Rue du Fauxbourg du Temple.

Nº. 1. Il est monté sur un chien ; 2. il donne sa cartouche à son Maitre, pour faire voir qu'il n'est pas un Déserteur ; 3. il quitte son habit ; 4. il danse en regle sur la corde, avec son balancier ; 5. il saute comme un Sauteur ; 6. il donne ses pieds gauche & droit pour qu'on lui mette du blanc ; 7. il met son balancier derriere son dos, & il fait le changement comme les Danseurs de corde ; 8 il fait l'équilibre avec une pyramide de lumieres ; 9. il porte deux lanternes à la main, pour éclairer son Maitre à la maison ; & plusieurs Tours différens

Advertising for General Jacko at Astley's Amphitheatre in Paris, 1785. *(Bibliothèque nationale de France)*

Advertising image for the 1784 season at Astley's in Paris. *(Bibliothèque nationale de France)*

Exercices suprenans des Sieurs Astley. Advertisement showing Astley's ingenious stage on horse-back. *(The Memoirs of J. DeCastro, 1824)*

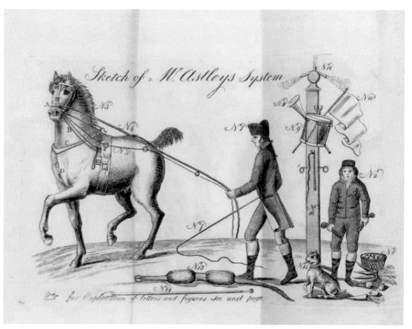

Plate from Astley's *The System of Equestrian Education*, 1802. *(British Library)*

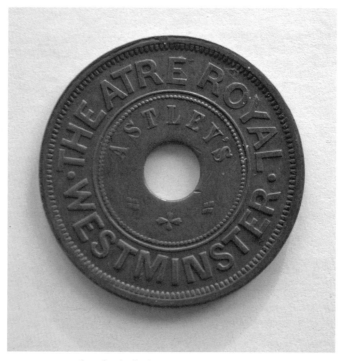

Nineteenth-century entry token for Astley's. *(Author photograph by permission of Andrew Van Buren)*

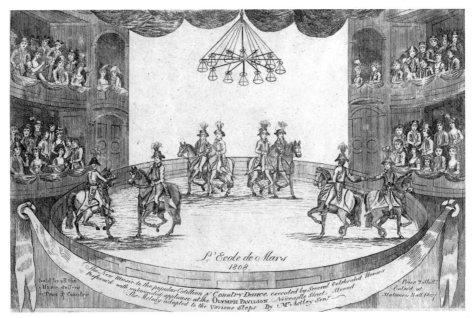

Interior of Astley's Olympic Theatre, c.1808. *(British Theatre Museum)*

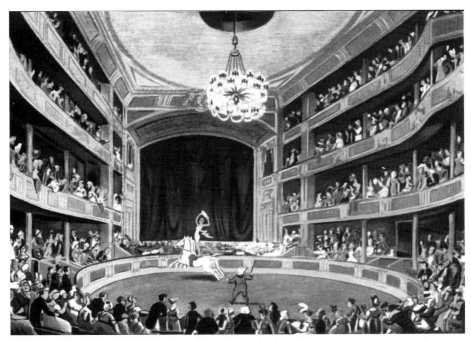

The interior of Astley's, c.1810. One of a number of colour plates reproduced by the Dutch Dairy Bureau in the 1950s for their album *The Colourful World of the Circus*. *(Author's collection)*

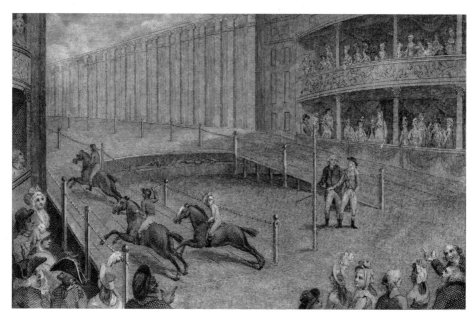

Pony racing at Astley's Amphitheatre during the eighteenth century. *(Artist unknown)*

Hercules Hall. *(Engraving in* The Sphere, *10 February 1917)*

The entrance to Astley's Amphitheatre in 1820. *(An engraving published in* Old & New London, *Vol. 3, by E. Walford, 1878)*

Craven House, the former site of Astley's Pavilion. *(An engraving published in* Old & New London, *Vol. 3, by E.Walford, 1878)*

Madame Saqui

The celebrated Performer on the Rope, at Vauxhall.

Engraved by Alais, from an Original Painting by Hutchisson of Bath.

Published for La Belle Assemblee Nᵒ. 132, Feb 1ˢᵗ 1820.

by J. Bell & Sold at Nᵒ. 16 Brydges Sᵗ. Covent Garden.

Madame Saqui performing at Vauxhall Gardens, c.1820. *(Engraving from* London Pleasure Gardens of the 18th Century, *by W. Wroth, 1896)*

Tomorrow evening will be opened a large Room in Bailie Fife's Close, opposite Blackfriar's Wynd, called New Tumblers Hall; where will be exhibited Mr Astley's EVENING ENTERTAINMENTS of Magical Card Deceptions, Experiments and Operations by the MILITARY HORSE and LEARNED DOG.

Admittance One Shilling. The particulars will be expressed in the Hand Bills.

FOUR MORNING EXHIBITIONS Of HORSEMANSHIP, ACTIVITY and other ENTERTAINMENTS

Each day the sun shines and the weather is not stormy, Mr Astley will make a Grand Display of his manly and surprising Feats of Activity etc., not to be equalled in Europe.

The doors to be opened at 11 o'clock, and to begin exactly at twelve. Admittance, Seats 2s., Standing places 1s.

MUSEUM

Those elegant pieces of Art which compose the Museum, now exhibiting at the Auction Room below Balfour's Coffeehouse, will continue to be seen a few days longer, from ten in the morning till two, and from four till nine at night …

(*The Caledonian Mercury*, 5 December 1774)

Although not stated, it is to be assumed that his equestrian exhibitions were still being presented at Comely Garden. Edinburgh was proving to be a lucrative season for Astley and his company and it was enabling him to develop his ideas further. In January 1775, Astley procured a prestigious venue in Edinburgh for his stage performances – the Theatre Royal. In what we might recognise as a variety show, he presented extracts from Shakespeare's *Romeo and Juliet*, and a musical piece named as *Jubilee*. Added to this were the regular feats of activity and lofty tumbling. Costmopolitan, the French clown, was still with the company and Miss Huntley was to sing a piece entitled *The Orange Girl*. The show concluded with a 'Grand Transparent painting of The Temple of Shakespeare' (*The Caledonian Mercury*, 7 January 1775). The company continued at the Theatre Royal through until the end of the month, giving their final performance on the 24th. Astley pulled out all the stops and gave a full and entertaining show, and in true form he advertised that 'as it is the last of Mr Astley's performances here, the whole will be inconceivably entertaining' (*The Caledonian Mercury*, 23 January 1775).

With his exercises of horsemanship no longer subject to being banned, Astley set out for London in order to reopen his riding school. It must be remembered that the journey from Edinburgh to London, some 400 miles, would have been an

arduous venture. The whole of the company with their costumes and equipment would have taken many carts and carriages and the journey would have lasted many days, especially at that time of year. It is probable that performances were given along the way wherever they stopped, and it is known that they gave at least one performance in Sunderland because the *The Newcastle Chronicle* of 11 March 1775 records an interesting story that relates more to the mores of the time:

> During Mr Astley's performances on Sunderland Moor, a few days ago, a very amiable young lady of great beauty and fortune in the neighbourhood of that place, attracted the attention of one of his riders; who, as soon as the exhibition was over kept a strict eye upon her motions, and, at some distance, followed her home. The youth then sent her a billet, to inform her of his flame, and required an answer immediately; when to his happiness he received a card by the bearer, intimating, 'That as opportunity would not permit her to give him the satisfaction he required, she hoped he would go home and reconcile himself, as he might be assured that she would give him the pleasure he wished for, by letter, in a day or two.' – The writer of this says, whether the lady acted in jest or in earnest, he will not pretend to declare; and only gives this as a hint to her parents, to make what use of it they please.

This reflects the whims of boys and girls the world over, and it is pleasing to note that they were as human as we are today. I wonder how the girl's parents reacted when they read the article – and what of Astley's poor love-sick young rider?

Heading south towards London, Astley next makes an appearance at the end of March, at the Stamford Fair, in Lincolnshire. From the advertising in the *The Stamford Mercury* of 30 March it seems that his company had been engaged by others to perform there:

> Messrs WHITLEY and HERBERT'S Company of Comedians, now performing with great success in this Town, have engaged Mr ASTLEY and his PUPILS for every Night during the Fair; and This Evening will be performed the New Comedy *The CHOLERIC MAN*; after which several new and surprising Exhibitions by the above Performers.

Although used to his own billing and directing his own shows, Astley was prepared to take work where it was offered. It would appear that here he and his company were merely support performers to the main programme being presented by Whitley and Herbert's group. Circus style entertainments were very often associated with fairs, from before Astley's time and well into the nineteenth century

and beyond, as commented on in *Showfolk* by Frank Bruce (2010). In this book is shown a copy of a watercolour by Alexander Carse (1805) entitled *Oldhamstocks Fair*. In the painting of a bustling fair can be seen a small troupe of circus artists providing entertainment. One can imagine that the Stamford Fair of only a few years earlier would have looked very much the same, with Astley's performers providing the amusements.

Astley returned to London for the summer of 1775, but it was not long before he was on the road again. January 1776 saw him back in Norwich, with a new and improved company. Equestrian skills were provided by himself, Mrs Astley, Mr and Mrs Griffin, and Master Philips. Tumbling was given by Master Philips, Master Robinson and Mr Porter, the clown to the act being Mr Balandine. A comic equestrian routine was performed by Mr Astley, Mr Griffin and 'a Native of Paris', unfortunately not named. The Egyptian Pyramids, or *Le Force d'Hercule*, as the act was more grandly entitled, were presented by a group of European performers: Signors Balandine, Savoi, Helm, Drez, Jacob, and Signor Costmopolitan, the clown to the act. 'This performance is quite new; and the Buildings will represent various Objects, taken from several Cities in Europe' (*The Norfolk Chronicle*, 6 January 1776). There is no description of this act but it can be imagined that the strong man balancing routine may have represented iconic buildings and statues from various parts of Europe. A later reference to this act in 1777 mentions specifically that they would represent a group of statues that were to be seen in the waterworks in the gardens of the Palace of Versailles. In addition to this programme, Astley was also exhibiting his travelling museum, which he claimed to have cost upwards of £2,000 to complete. To ensure as any people as possible paid their sixpence to see it, he advertised that 'It will never been shown in this city any more.'

What is valuable in this particular advertisement is that he gives the planned itinerary for his performances in January:

North Walsham	10/11
Aylsham	12/13
Holt	15/16
Wells	18/19
Burnham Market	20
Great Walsingham	22/23
Fakenham	24/25
Dereham	26/27
Swaffham	29/30

His entire outfit would have travelled in a variety of carts and carriages along roads that bear no similarity to our roads today. Following his itinerary, he would

have had to cover at the very least 90 miles, and probably much more, along winding and rutted winter roads. The weather at that time was particularly bad and there is an account of Astley having a baggage wagon overturned into a large pit while on the way to North Walsham. The maximum distance between venues was about 14 miles and the minimum about 6. It would have been hard work; as each show finished, the performers and others would have to take everything down, store it on the wagons and then move on to be ready for the next venue, only to have to build everything up again. With one exception, his tour was of two-night stands. Only at Burnham Market did they give one show, but the following day, the 21st, was fortunately a Sunday and there would have been no performance in any case. In major cities like Dublin, Edinburgh, and Norwich, Astley was able to set up for a lengthy period of time but he clearly saw that there was a market for taking his exhibitions to more outlying areas, to maximise the number of people who saw him perform. In this we begin to see the beginnings of the itinerant travelling circuses, something that grew throughout the nineteenth and twentieth centuries.

Later in the year, he returned to Norwich, which seems to have been a favourite venue of his. He set up at the New Riding School in Conisford, Norwich, and his performances now included a slack rope performance, along with a great variety of new Feats of Activity. Lofty tumbling was still being presented, with the Lion's and Salmon's Leap, and Flying over Chairs and Tables. The Egyptian Pyramids were still with Astley, and Astley himself was to exhibit the different exercises of the Broadsword. Mrs Astley, not named in the previous advertising, makes an appearance at the end of the month with her bees:

> Mrs ASTLEY will command a large Hive of Bees to quit their habitation and assemble on her Arm, representing a Lady's Muff.
> She with uncommon Art, and matchless Skill,
> Commands those Insects to obey her Will;
> With Bees all others cruel Means apply,
> She takes the Honey, but them doth not destroy.
> To kill the Cow for her Milk, the Hen for the Egg, or the Sheep for the Fleece it bears, would certainly be an Act of Cruelty: if a Mode could be lid before the Public, to prevent the annual Destruction of that useful Insect, such an Object would be commendable – This Exhibition proves there is a Probability.
>
> (*The Norfolk Chronicle*, 26 October 1776)

This was a sentiment that Daniel Wildman must have been pleased with, and certainly one that was promoting the conservation of the bee population.

Astley returned to London for the winter but was on the road yet again by February 1777. His first appearance was at the Theatre in Derby. It was a complete variety show that included all the regular acts, but also a 'Turkish Performance' by a father and son duo by the name of Carrata-Alli and young Alli. The young Alli also made an appearance on the slack rope. A Signor Rossignoel presented bird imitations and played a violin without strings, and Mrs Astley presented several large living serpents. There was also a theatrical burlesque named *Harlequin's Exploits* or *The Power of Magic*. There is no mention of Astley himself giving a performance on stage but he was still giving displays of Feats of Activity on Horseback elsewhere in the town.

From Derby the company moved on to Nottingham, and then a series of one-night stands in Mansfield, Chesterfield, Wirksworth, Ashborne, Leek, and finally in Newcastle-under-Line [*sic*]. I find it interesting that if Astley returned to his home town, there is no other mention of it in the press of the time. As a well-known and celebrated figure, it would have made a good story of a local boy made good. Given Astley's preponderance for self-promotion, surely this was an opportunity he would not have missed? The company made its way then to Oxford, where it performed equestrian feats in Gloucester Green, with its Great Exhibition (presumably the travelling museum) in the Great Room in Ship Lane. After Oxford, Astley and company returned to London.

The year 1777 also proved a difficult one in the courts for Astley. In April, a case was brought before the magistrates in Rygate, Surry [*sic*] in an attempt to stop his performances. The *Northampton Mercury* of 14 April gives a report:

> The court was moved to put a stop to Mr Astley's Activity and Horsemanship. The informing Parties, however, did not succeed in their Expectations. Should another Attempt of this Kind be made, there is no Doubt but Mr Astley would recover considerable Damages, as it is both cruel and oppressive to prevent a man from living by a manly and innocent Amusement.

There is no mention of who the informing parties may have been but it is evident that Astley had the support of the popular press. Later in July, a further case was brought against him, and Astley appeared in court again. M. Kwint (1994) gives more details of the case. It appears that a paid agent had attended two performances at Astley's and reported back that Astley kept a 'common and ill-governed place for public music' and that his presentations included unlicensed 'Tumbling, and Interludes and Farces'. He was also accused of causing disreputable men and women to come together as well as causing a general nuisance and bad example to

local residents. The case was brought to trial in October 1777, as recorded here in the *Kentish Gazette* of 17 October:

> On Thursday last came on to be tried at the general quarter-sessions of the peace at Kingston, in the county of Surry [*sic*], a Cause, the King against Philip Astley, Riding-Master at Westminster Bridge, in the said county. The indictment was laid under the 25th of George the Second, against Mr Astley, for performing various feats of horsemanship, accompanied with music; when, after a hearing of upwards of three hours, the defendant, Mr Astley, was honourably acquitted.

Astley refers to this particular court case in his book *Natural Magic: or, Physical Amusements Revealed* (1785):

> Not long after, the Public must remember I had the Misfortune to be taken by a Warrant, and all my Servants, Horse and Foot, sent to Bridewell, and myself admitted to Bail. At the following general Assizes at Kingston, I surrendered to make my Tryal [*sic*], and the little learned Horse, and the little Turk, with the Magical or Mechanical Table, being mentioned by the Council, threw the whole Court into great good Humour; Mr Howarth and Mr Lade (my Council) declared I only borrowed the Idea from the Figures at St Dunstan's Church, and my Intentions appearing perfectly innocent, I was acquitted [*sic*] of the supposed Crime of dealing with the Devil.

It seems that the authorities were unable to put a stop to Astley's activities, or his claims for damages. As early as 1773, he was suing Sir Joseph Mawbey, one of the magistrates in Surrey, for £10,000 damages in the case against him (*Bath Chronicle and Weekly Gazette*, 29 July 1773). Although Astley was acquitted in 1774, it is not recorded if his claim for damages was approved. It is clear that if Astley felt he could sue for so large an amount in loss of earnings, his various exhibitions were proving to be a lucrative venture.

Perhaps with a renewed sense of confidence at the outcome of his court appearances in 1777, Astley diverted his attentions to the property on Westminster Bridge Road. He did return briefly to Norwich and Cambridge in the spring of 1778, but the next two years would see the remodelling of his riding school in London. From working in theatres he realised that what was needed for his riding school was a roof. In this way he could provide year-round entertainments. For a small sum he acquired leftover timber from public viewing stands for a royal funeral and from local hustings, and set about having the amphitheatre roofed. During the winter of

1778/79, he leased a large room at number 22 Piccadilly and advertised 'Fireside Amusements Discovered':

> This Evening the following excellent Deception will be discovered by Mr ASTLEY (in a manner that everyone present may do the like immediately after).
>
> This present Evening, to make a guinea fly across the room to a shilling, from one Gentleman's hand to another.
>
> At the Large Room, No. 22, Piccadilly, THIS and MONDAY evening will be presented (in the English language) *LES OMBRES CHINOISES* or CHINESE SHADOWS.
>
> Between the Acts Comic Dancing, and a curious Display of Fireworks. Also Signor Rossignol, the original, will imitate various BIRDS. Likewise the droll Exhibitions of Mr Astley's Learned Dogs, Conjuring Horse etc. ...
>
> N.B. The AMPHITHEATRE RIDING-HOUSE, Westminster-bridge, the most complete building of the kind in Europe, will be opened in a few days, for completing Gentlemen and Ladies in the polite art of riding on horseback with ease and safety; as also for breaking horses for the Army, Road, Field, Draft, Shooting, Storking [*sic*] etc.
>
> (9 January 1779, quoted Decastro, 1824)

That year his new building emerged as the Royal Grove Amphitheatre and Riding House. The new roof was of a timber and canvass construction and the whole was painted with arboreal and pastoral designs, hence the name Grove. An engraving in the Royal Collection shows a circular arena with a stage at the rear. From the artist's vantage point the arena is encircled by two tiers of galleries, the lower tier appearing to have at least five banks of raked wooden benches. The ceiling is covered with foliage decoration and a large chandelier is suspended over the arena. The design allowed for equestrian performances and other amusements to be given in the arena, with musical and theatrical presentations held on the stage. It would have been like no other building in London at that time. By the end of 1779, Astley was up and running in his new home and was providing a full and varied evening of entertainment. Decastro (1824) gives a copy of an advertisement for 24 November 1780, which I give in full:

> WINTER EVENINGS' AMUSEMENT ...
>
> The whole under the direction of Mr ASTLEY. Notwithstanding the many improvements, no additional price in the admittance.
>
> Part the first, the *OMBRES CHINOISES* or LILLIPUTIAN WORLD, with many new scenes and other decorations. – Part the

second, HORSEMANSHIP on a single horse, by Mr Taylor, being his first appearance; also Mrs Taylor, a young lady from Vienna (who had the honour to perform many times by the command of the Emperor of Germany, and other Royal Personages at different courts in Europe), will perform several feats of horsemanship on a single horse, being her first appearance. – Part the third, the LITTLE CONJURING HORSE will go through his different exercises in a very surprising manner. – Part the fourth, Tricks of STRENGTH and AGILITY, by the cele-brated Mr Richer, equilibrist; Master and Miss Richer; Miss Hudson and Miss Vangable. (Clown to the little family) Sieur Baptista Duboi and Sieur Paulo. – Part the fifth, HORSEMANSHIP on two horses, part of which never exhibited, by Mr and Mrs Taylor. – Part the sixth, the POLANDER'S TRICKS on chairs, tables, pedestals, ladders etc. – Part the seventh, Lofty vaulting and manly agility, commonly called TUMBLING, over horses, flags, through hoops, over men's heads, tables, chairs etc., with the Trampolin [sic] Tricks, by Mr Nevitt; also Tumbling, by Mr Richer, Mr Porter, Mr Duboi, Mr Sonds, Mr Hallis and others. Clown Mr Burt. – Part the eighth, HORSEMANSHIP on two horses by the celebrated Master ASTLEY, the greatest per-former that ever appeared in any age, and as a horseman, stands unpar-alleled by all nations. – Part the ninth, NEW PYRAMIDS, or Men piled upon Men, with new dresses and other decorations. – Part the tenth, SLACKROPE VAULTING by Mr Dawson. – Part the eleventh, an EQUILIBRIUM on the perpendicular moving ladder; after which the BEAUTIFUL ZEBRA will walk round the Riding-School for the inspection of the Nobility, Gentry and others. To describe the beauties of the Zebra would be much too large for a news-paper, and as many ladies and gentlemen have visited him in the Hay-market, a description of him would be superfluous.

The Zebra to be sold for 400 guineas.

The whole to conclude with several uncommon pleasing feats of great agility by Master ASTLEY, who, in a most amazing equilibrium, whilst the horse is on a gallop, dances and vaults etc.; also plays an air on the violin, and displays a flag, in many comic attitudes, which have never been exhibited, or even thought of by any horseman in Europe. Clown to the above tricks by Mr Miller.

N.B. Mr Astley begs leave to remind the nobility, gentry and others, that no other place in Europe ever had, at one time, such great variety, and that in a constant succession. He also acquaints them, the celebrated Master Astley's amazing, unparalleled, and pleasing performances on

horseback, are only intended to make part of the entertainment for a few evenings.

Ladies and Gentlemen are carefully instructed to manage the horse and ride with safety. Horses broke for all denominations.

There are several features to note in this advertisement. Firstly, it now appears that Astley senior is taking on more of a directorial role, his only appearance now being perhaps the presentation of his Conjuring Horse. Secondly, his son, John Conway Philip Astley, at the age of thirteen, has been elevated to the starring role. Thirdly, the business is profitable enough for Astley to employ quite a large company of performers, several of whom are multi-talented. It is also clear that he employs many foreign performers. Fourthly, that he is also exhibiting a 'wild' animal. He had presented snakes and bees previously, and these are technically wild, but here we see the exhibition of a more exotic species. Granted, the zebra did not perform, but it is one of the earliest records of a wild animal being seen in such a venue – even if it was put up for sale afterwards. And lastly, we have something that we might recognise today: the circular purpose-built venue with its circular arena, the variety of physical skills being presented, the use of animals in performance and the ballyhoo and hype of the advertising. Astley's Royal Grove became the model for the many other companies that were to follow his lead.

Competition and expansion:
Astley conquers Paris

The 1770s had been a time of development for Astley. Although he may not have been the first or only equestrian performer, Astley deserves to be acknowledged in that he had, for the first time, brought together the audience and performers in a defined space on a 'pay-for-view' basis. In the absence of any serious competition he had gained the monopoly for equestrian exhibitions in London and his fame had spread throughout the kingdom. He had toured widely throughout England, Scotland and Ireland, and had even visited France and Spain. Wherever he went he ensured that his name was well known and remembered. From this position of relative security, it must have been with a little concern when his old rival, Charles Hughes, returned to London.

After his run-in with the magistrates in 1773, Hughes had been on the road with his company for eight years. During this time he had travelled widely across Europe, performing in countries such as Portugal, Spain, Italy and Morocco, and exhibiting equestrian feats of activity for many crowned heads. In his own sphere he was probably as well known as Astley, but he had not yet conquered Great Britain. What prompted his return to England is not recorded but in the autumn of 1781 he arrived back in London. It must be acknowledged that Hughes was an expert horseman and a seasoned performer. In 1782 he was to publish his illustrated book entitled *The Compleat Horseman*, which was promoted widely in the press and emulated Astley's book of 1775, *The Modern Riding Master*.

However, Hughes lacked the business acumen of Astley. He appears not to have had the capital to invest in his own amphitheatre but relied upon the collaboration and investment of others. He found a consortium of London businessmen who were willing to back his new venture. Charles Dibdin, composer, stage manager and dramaturge at the Covent Garden theatre decided to go into partnership with Hughes, and they engaged the services of Mr Grimaldi senior (father of the famous clown Joseph Grimaldi), who had been the dancing master and clown at the Sadler's Wells theatre. They also had the support of a Colonel West, who owned a plot of land near St George's Fields in Southwark, at the junction of the three roads leading from the three main bridges across the Thames. The site was known locally as St George's Cross and an obelisk marked the centre of the junction. It

was only about half a mile from Astley's, at the opposite end of the Westminster Bridge Road. The construction of a stone building was begun in 1782 under the grand name of the Royal Circus, Equestrian and Philharmonic Academy. When completed it had a central performance salon, flanked by two separate wings. One wing was opened as the Circus Coffee-house and the other was a private dwelling. It was not long before the name was shortened to the Royal Circus. Although the respective venues were known as 'Astley's' or 'the Circus', the word 'circus' was soon being used as a generic term for these types of entertainments. Astley had relied heavily upon wood for his construction material and although his Royal Grove Amphitheatre was 'permanent', it would not have had the durability that this new building could offer. While all this was going on, Astley and company had set out on their own European tour, seemingly unconcerned. In his 1802 book, *Astley's System of Equestrian Education*, he mentions some of the places that he visited:

> In my travels, taking Brussels, Vienna etc., in my road to Belgrade, in 1782, I had the honour to be introduced, (by sending my name to the professor), to every principal Manège in those countries. Sir Robert Murray Keith, then minister plenipotentiary at the court of Vienna, did me the honour of introducing me to the Emperor.

In September 1782, Astley had the good fortune to receive a royal letters patent:

> His Majesty has been pleased to grant unto Philip Astley, Riding-master, Westminster-bridge, His Royal Letters Patent for his most ingenious and approved Method of rendering Horses tractable and docile in a very short Time, and also familiarising them to the Sound and Recoil of Ordnance, beating of Drums, and all Sorts of Music; likewise rendering them so steady in all their Actions; that every Sort of Manly Agility and War Exercise may most easily be performed upon them without the least Danger. The said Patent also authorises Philip Astley, his Heirs etc., to use and exercise his said Invention at their Discretion solely. Officers in the Army, and the Public in General, may have restive Horses very soon educed to proper Obedience by Mr Astley's new Invention at the Amphitheatre Riding-school, Westminster-bridge, and nowhere else. Officers, Non-commission Officers of Dragoons and Light Dragoons, actually in the Service of His Majesty, and during such Service only, may have Privilege and Instruction Gratis, for the more effectually teaching unsteady Horses to stand Fire etc.
>
> (*London Gazette*, 23 September 1782)

A feather in the cap for Astley, and a lucrative business, especially if the Crown was going to pay him for instructing serving soldiers in his 'Method'. But the royal letters patent only permitted him to carry out instruction and not performance. Astley might have argued the case that giving exhibitions of feats of agility on horseback were for the purposes of education under the terms of this patent, but what justification there could have been for his other exhibitions would have been interesting to know. However – and this surely would have made Astley laugh – Hughes and Dibdin had embarked upon their building project before having gained the necessary licence. *The Ipswich Journal* of 19 October 1782 gave a full report of the application hearing:

> At the general quarter sessions held at Kingston upon Thames, on Wednesday last [16 October], Mr Hughes and Mr Dibdin, for themselves, and in behalf of the proprietors of that magnificent building in St George's-fields, applied for a licence. The court seemed very attentive to this motion; and after their counsel had made the request, the chairman [said] that the court had received two letters from the secretary of state, purporting that it would be very improper at this time, when the police of the country wanted a total reform, to license any new place of public diversion, and hoped the bench would consider it accordingly … it came out in the course of the debate that near fifty children of both sexes, from six years old to fourteen, were to be under the tuition of Mr Grimaldi … and were intended to act, speaking pantomimes, operas, medleys, drolls, and interludes under the direction of Mr Dibdin, as a chef d'oeuvres of the place. The horsemanship, by Mr Hughes, intended only to be served up as a dessert. After much altercation, the question was put, when the bench divided, eight for the licence, and twenty-six against it. It is most extraordinary that any man or men should erect such a building without a certainty of lawful leave to carry on the purposes intended therein to be performed.

And so it was; the Royal Circus opened in November 1782, without the necessary licence and largely due to this it had a much curtailed first season, with only a handful of performances being given. What performances that were presented were of a predominantly musical nature, with Mr Hughes's equestrian exhibition acting as almost an interlude to the whole programme. The relationship between the bombastic Hughes and his partner Dibdin was never an easy one. Decastro (1824) gives one account of the enmity between them. One particular evening the band had gone on strike and refused to play unless they were paid the arears owing to them. Dibdin appeared before the audience and asked for their understanding of the

circumstances and offered to accompany the piece himself on the pianoforte. The crowd good-naturedly agreed but at the very moment he sat to play, Hughes, at the head of his equestrian troop all in full performance costume, entered the arena to the accompaniment of fife and drum. This cacophony drowned out the sound of the pianoforte and it was clear to the audience that the relationship between Dibdin and Hughes was not a happy one. It was not long after this incident that Dibdin resigned from the Royal Circus and left Hughes to his own devices, and gradually the audience numbers declined.

As Hughes's fortunes appeared to be in decline from the very outset, Astley's seemed to be on the rise. Returning from their European tour, Astley and company visited Paris, where they gave a command performance before the King and Queen. When fifteen-year-old John performed a graceful minuet on three horses, Queen Marie-Antoinette was so captivated by his beauty and charm that she reportedly hailed him as the 'English Rose' and she awarded him a gold medal set with diamonds. At that time, the pre-eminent dancer of the period was a Frenchman named Vestris. He was known, particularly in England, as the 'French Rose', and it is thought that the Queen was comparing John Astley to Vestris in giving him the sobriquet of the English Rose. More importantly for Astley was that he was able to give a series of open-air exhibitions in the Boulevard du Temple, not far from the Place de la République today. Henri D'Alméras in *La Vie Parisienne* (1909) writes: '*Le 7 juillet, 1782, l'Anglais Astley avait ouvert sur le boulevard du Temple un Spectacle ou Amphithéâtre équestre.*' [On 7 July 1782, the Englishman Astley had opened an equestrian show or amphitheatre on the Boulevarde du Faubourg.] (Author's translation)

Such was the success of his visit to Paris that royal patronage was now assured should Astley wish to return and establish an amphitheatre in the city – something that he did the following year. But before that would happen he was to return to London for a winter season that would bring about his most trying time to date, and his potential downfall.

Apart from the competition that the Royal Circus now presented, one of Astley's first challenges came from his own father, Edward. Little is known about his father's life but it seems that he did begin working for Astley as a door keeper at the Royal Grove. Their earlier animosity between each other appears to have rumbled on because, on 24 December 1782, Edward Astley made a complaint against his son and swore on oath to the Lord Mayor that 'his son had used him with such unbecoming abuse and scurrilous language that the Deponent cannot, without impropriety, state the same in a public paper.' (BL)

Philip Astley responded to this accusation by stating that the offence had taken place while Edward Astley was a 'door keeper to a place of public amusement and would not listen to instructions'. The upshot of this was that Edward Astley ceased

working for his son and went to work for Charles Hughes at the Royal Circus as a bill sticker.

Worse was to follow. It really stemmed from the fact that Hughes was blatantly operating without a licence. This incensed the magistrates and they decided that action needed to be taken against such establishments working outside of the law. *The Hampshire Chronicle* of 6 January gave the full details:

> On Friday evening Justices Hyde and Croft entered the Royal Circus, jumped over the pit, proceeded to Mr Hughes's dressing-room and did apprehend him as a rogue and vagabond. Mr Hughes obeyed their summons and suffered himself to be taken away (first very prudently ordering a part of the back fence to be knocked down, to cover the retreat of those gentlemen, as he justly apprehended they would suffer some unpleasant treatment from the spectators, who appeared greatly incensed at being disappointed of seeing Mr Hughes's performance on horseback). Mr Hughes was carried to an alehouse, there examined, and committed as above, the justices refusing to accept the penalty or bail, unless upon condition he would acknowledge himself guilty of an offence against the laws of this country, and that he would restrain himself from displaying his performance on horseback in future. Mr Hughes having in his possession the opinion of very eminent Counsel that he was doing nothing contrary to law, he refused the matter, and now remains in Bridewell for trial at St Margaret's-hill on the 14th of January.
>
> Mr Hughes has performed with great applause before their Majesties of England, and their Royal brothers, the Kings of France, Sardinia, Naples, Spain, and Portugal; the Emperor of Germany and his Royal brother; the Emperor of Morocco at Mequinez; and was in the above countries treated as a man of merit, and not as a rogue and vagabond.
>
> The Justices also visited Astley's Riding-school, and in the course of the evening Mr Astley was committed to New Bride-well, St George's-fields. He offered to pay the penalty of 50l. [£50] which was refused.

The magistrates had made a two-pronged attack against the riding schools, using both the terms of the 1737 Theatres Licensing Act and the 1744 Vagrancy Act. The former banned all unauthorised 'Entertainments of the Stage', and both establishments had a stage as well as an arena. The latter also banned all unauthorised performances, but crucially, for the magistrates at least, it allowed for a summary custodial sentence to be issued for being a 'Rogue and Vagabond'. This was a way of removing both managers from their businesses and precipitating some decisive action against such unlicensed premises. The document of commitment issued to

the Governor of the House of Correction in relation to Hughes's imprisonment, here given in full, makes interesting reading and reflects how the magistrates interpreted the law for their own purposes:

> Receive into your custody the body of Charles Hughes, herewith sent you, brought before us Thomas Parker, John Croft and William Hyde, Esqrs. Three of his Majesty's Justices of the Peace, in and for the said county, by John Jenkinson and Thomas Adams, and charged and convicted before us the said Justices, upon the oaths of Peter Gough and Thomas Shirley, for being rogues and vagabonds; to wit, for acting, representing, and performing for hire, gain, and reward, at a certain place called the Royal Circus, in the parish of St George's, in the said county, a certain entertainment of the stage called Georgium Sidus, or the Dumb Orators, an oration by a boy, a procession of horses with drums and fifes playing, several scenes and views transparent, a boy making a long speech, and describing the different paintings, a large group of children one upon another, and after marching like soldiers against the statute etc. Him therefore keep in your safe custody until the next general quarter sessions of the peace to be held in and for the said county, or until he shall be thence discharged by due course of law; and for so doing this shall be your sufficient warrant.
>
> (*The Hampshire Chronicle*, 6 January 1783)

Astley was similarly charged for:

> being a rogue and vagabond, to wit, for acting, representing and performing for hire, gain and reward, at a certain place called Astley's Amphitheatre Riding-School, in the parish of St Mary, Lambeth, in the said county, a certain Entertainment of the Stage called The Ombres Chinoise, Views of Shipping, Tight-rope Dancing, Tumbling, Images Playing on Flutes, Whistling, Imitating Birds etc. against the statute ...
>
> (Surrey Quarter Sessions, 1780–1820 transcripts)

In his defence Astley stated that, having served with Colonel Eliot's Light Dragoons for seven years, he had developed a system for the training of horses so as to perform public feats of horsemanship – something that he had carried out for some sixteen years or so within his riding school. He also stated that he had no other source of income to support his family. He focused solely on horsemanship and made no mention of the fact that he had presented 'entertainments of the stage' in recent times. Offering to pay the penalty, he was refused. Astley and Hughes were

ironically imprisoned together and seemed to have been well and truly nailed by a group of zealous magistrates, led by Sir Joseph Mawbey, determined to close down such unlicensed premises. It is commonly thought that both Astley and Hughes remained in the Bridewell awaiting trial later in the month, but there is a piece of evidence that indicates that Astley may have been released on some form of bail. *Jackson's Oxford Journal* of 4 January 1783 reported:

> Last night, at Seven o'Clock, the celebrated Mr Astley was set at Large from the New Bridewell, St George's Fields, on the Validity of his Patent, granted him by His Majesty, for an exclusive Right to perform Horsemanship; Mr Hughes, it is said, was also offered his Liberty, upon promising not to perform any more; which he refused accepting, being advised to stand a Trial.

If this report is correct, and there is no reason to suppose otherwise, then it would seem that Astley had been released on the specific understanding that he could perform horsemanship, as specified under the terms of the royal patent he had received in 1782, and not to perform any other entertainments. Although his offer to pay the stipulated £50 penalty for being a 'rogue and a vagabond' had been refused, the fact that he had received some form of royal acknowledgement seems to have saved him from further incarceration. Not so for Hughes. Without a licence and any other form of support he was detained in the Bridewell. Had he promised not to perform further perhaps he would have been released, pending trial, but he was sticking to his principles and paid the price. The appeal trial was held before a full bench of magistrates at St Margaret's Hill on Wednesday, 15 January; Sir Joseph Mawbey was the chairman. *Saunders's News-Letter* of 25 January gave a very detailed account that shows just how far the magistrates went in gathering evidence against Hughes, and in attempting to close both venues. It was a story of paid informers, questionable evidence and legal technicalities – worthy of a television drama today.

> Wednesday the case of Mr Hughes came on to be argued in the nature of an appeal before a full Bench of justices at St Margaret's-hill, Southwark, Sir Joseph Mawbey in the Chair. Mr Bearcroft, quoting the 17th Geo. II commonly called the Vagrant Act, and making some observations on the exhibitions of the Royal Circus, prayed for a farther commitment, but said, if the prisoner would promise never to offend again, he should himself petition the court for his immediate discharge. The opposite Counsel called several witnesses, who were examined. Peter Gough described part of the performances, which he had seen at the Circus,

and said Mr Hyde had given him a shilling to go there; but when asked to identify Mr Hughes, he pointed to Mr Astley's son [who was in the courtroom with his father]. Thomas Shirley gave a similar evidence. He identified Mr Hughes, having seen him at the King's Arms after he was taken into custody, but could not say he was the man who exhibited at the Circus. John Tebbier, clerk to Mr Hyde, knew Mr Hughes, and identified him. Mr Blackerby, clerk of the peace, said that Mr Hughes applied to him for a licence on the 9th day of October [1782], for exhibitions at the Royal Circus; and Mr Mingay had formerly moved for a licence on behalf of the proprietors of the Royal Circus, who, he said, were some of the most respectable men in the kingdom, but that it was to stand in the name of Hughes. Mr Hyde said he did not prosecute Hughes, nor was he concerned in the prosecution; but he acknowledged that he paid the men for going into the Royal Circus. Mr Mingy, as leading Counsel for Mr Hughes, entered fully into the business. He contended the 17th Geo. II did not warrant a commitment upon such facts as had been given in evidence. The commitment stated that the offence was done in the parish of St George, in the county of Surry [sic]. There was no such parish in the county. St George the Martyr was the parish in which the Royal Circus stood. Mr Hughes was not indictable for dumb oratory exhibition, indeed he had heard of none, except the horses were the dumb orators. Mr Hughes ought to have acted, and performed, to have warranted a commitment. He was by no means indictable by the act upon which he was prosecuted, though perhaps he might be so under another statute, for musical performances. Upon the question being put, whether or not the appeal should be dismissed; there were eleven Magistrates for the admission, and seven for the dismission. Mr Hughes, of course, was discharged from custody; as was also Mr Astley upon promising never to exhibit anything more upon the stage.

The Hampshire Chronicle, on 20 January, gave an interesting addendum to its report of the trial:

Notwithstanding the impartial trial of Mr Hughes on Wednesday last at St Margaret's-Hill, there was a bill of indictment attempted to be preferred on the old story, which the Grand Jury yesterday morning threw out with the contempt it deserved.

A packed courtroom had cheered and applauded the verdicts as both men were discharged. Dibdin and Grimaldi had also been called before the court on the

previous day, but the case was adjourned until after the cases of Hughes and Astley had been dealt with. Clearly the magistrates were hoping that if Hughes and Astley were to be convicted then this would create a 'domino effect', and other perform-ers could be likewise convicted. Mawbey and his coterie of magistrates were deeply embarrassed that they had been outwitted by a clever counsel. They could do but little other than acknowledge the verdicts, and a few months later, in October, both the Royal Circus and the Royal Grove received their required licences. Clearly there was much support for both Astley and Hughes, and the trial became a water-shed into the acceptability of the 'circus' as a popular entertainment form. The acquisition of a licence now put circus on the same footing as the entertainments at the other 'minor' theatre at Sadler's Wells.

Both venues subsequently reopened to the public. Due to the publicity that the trials had caused there was an increase in audience attendances, although there were still managerial problems at the Royal Circus, and it was not until later in the decade that it would become more successful. The *Scots Magazine* of 1 June 1783 alludes to the opening of both venues, although in a not too complimentary manner:

> The two Riding Schools, or more properly called Equestrian Theatres, having made their peace with the Surrey Magistrates, are again permit-ted to open their stable-doors, and exhibit their power over the brute creation, by exercising the reason of horses, and giving their audience some idea of the transmigration of souls. Here one horse fetches and carries like a dog – there another tells fortunes on the cards – a third kneels down, and in a supplicating posture begs the attention of those who have hitherto paid more time to the study of men than instinct of horses. A gew-gaw [a valueless trinket] pretended French-instructed boy-ish minuet-jumping jockey dances on a saddle, whilst others of the Astley baboons, in silk jackets, inverting the order of nature, place their heads where their heels should be, whilst an upright lady, in a feathered hat, takes a standing gallop close to the semi-circled gazers. Horses, however, being a sameness of amusement, an infant groupe [*sic*] is brought forward to prove the ripeness of the age, and at how early a period of life the birch-rod and horn-book can be laid down for the mysteries of a drama …

This is interesting. Although it mentions both 'Equestrian Theatres', it specifically mentions Astley's. It shows that the main focus of the entertainments was still the horse, albeit with human performers exhibiting on them. However, it also gives an indication that children were performing 'drama' of some description, and the implication is that they had been trained, as many animals were at that time, by a

degree of force – the use of the birch rod. Cruelty to animals was a topic of social conversation at this period; bear baiting, dog fighting and even horse baiting still existed. William Hogarth, an ardent campaigner against animal cruelty, captured the spirit of the times in his engraving entitled *The First Stage of Cruelty*. Children in the workplace were treated with cruelty but it was to be many years before they became protected. Indeed, legislation against the ill-treatment of animals was in place before that of children. Astley was a man of the time and would have seen child performers and horses in the same light; in fact, he probably favoured the horses. Some years later, when he was living in Hercules Buildings Road, he had an altercation with William Blake, who lived just a few doors away from him. Blake apparently saw a boy in the street in shackles. Freeing him, Blake then fell into a violent argument with the boy's employer – Philip Astley. Why the boy was shackled we do not know but it is a clear indication that Astley was not averse to utilising what we would deem as cruel methods of child control.

Some have taken the referral to 'Astley's baboons' as indicating that he had a group of performing monkeys. I disagree with this. I think, in this particular case, the writer is likening the performers to baboons and is using the term in a disparaging way. Certainly Astley did have a performing monkey that went by the name of General Jacko (sometimes also Jackoo) and he made his first appearance in London in April 1785, as noted here in *The Times* of 5 April:

> Last night a most wonderful animal made its first appearance at this Theatre [Astley's amphitheatre]. It is the famous monkey from the fair of St Germaine at Paris, which has been so much the admiration of that metropolis for two seasons past. He is called General Jacko, and wears first a Hussar's dress. … He then appears dressed as a tumbler, with a balance pole on the tightrope. On this he balances a branch of lights in the form of a triangle, with which he runs along the rope. He jumps on the rope and imitates the dancers … in a word his whole performance is a very diverting, original, and extraordinary exhibition, and we make no doubt that he will be the most favourite monkey of the age.

Mike Rendell, on his website *Georgian Gentleman*, maintains that a handbill taken by his ancestor from one of Astley's performances in the early 1770s shows General Jacko in various riding positions on one and two horses. I think he is mistaken. A close examination of the images shows that they are distinctly human in form and not simian. Of the six images, four are adult male, one is female and one is a juvenile. Several of these images appear in various newspapers of the time relating to Astley's exhibitions of Feats of Horsemanship. In one newspaper the juvenile image is used with a speech bubble that says 'I am only five years old', and refers

to one of the first appearances of Astley junior. It would seem, from the article in *The Times*, that General Jacko had been performing in Paris since at least 1783, and possibly even before that. Astley had become a frequent visitor to Paris and it is more likely that he acquired the monkey on one of his visits there.

Astley and company returned to Paris in 1783. It had long been his intention to open an amphitheatre there and now that he had the patronage of the French royal court it seemed an opportune time. He acquired a vacant building at No. 24 Rue du Faubourg du Temple, not so far away from where he had given his open-air performances a few years earlier. There he established the Amphithéâtre Anglais, and he opened in the November. A description of the new amphitheatre and a taste of the entertainment provided is given in *Histoire des Chevaux Célèbres*, edited and published by P.J.B.N. in Paris 1821:

> *C'était un manège spacieux, couvert d'un plafond élégant, et dont la circonference était garnie du plusieurs rangs des loges peintes et décorées. Vingt-huit ou trente candélabres garnis, du plusieurs lampes en verres du couleurs, formant environ douze cents mèches, l'éclairaient d'une manière pittoresque. Au milieu était un théâtre destiné, dans les intervalles des exercices des chevaux, à faire des tours de force très-variés. Aux deux côtés étaient les écuries. Dans le haut était placé l'orchestre … On distinguait Astley père et fils et deux Anglais. Les chevaux partageaient à juste titre le mérite de ces exercices par l'intelligence la plus étonnante … Les siuers Astley executaient, avec des grâces infinite, un menuet à cheval … Le cheval qui rapportait était fort applaudi; après qu'on le lui avait jeté, il prenait un mouchoir dans ses dants, l'apportait, sans que les coups de chambrière qui cinglaient à ses oreilles par-vinssent à l'intimider l'attitude du cheval assis, comme un chien, est la plus difficile; il faut qu'il ai les pieds de derrière recourbés, ainsi que ceux de devant, et que le sabot soit appuyé sur le sol: le cheval d'Astley prenait cette attitude si difficile, au commandement de son mâitre.*

> [It was a roomy manège, covered with an elegant ceiling, and the circumference of which was furnished with several rows of painted and decorated boxes. Twenty-eight or thirty candelabra, furnished with a number of lamps in colored glasses, weighing about 1,200 pounds, illuminated it in a picturesque manner. In the middle was a theatre destined, in the interludes of the exhibitions of the horses, to make very varied creations. On both sides were the stables. At the top was the orchestra. … Astley father and son and two Englishmen were distinguished. The horses rightly shared the merit of these exhibitions with the most astonishing intelligence. The Astleys executed a minuet with infinite grace, and on

horseback. ... The horse, which was returning, was much applauded; after it having been thrown to him, he took a handkerchief in his teeth, brought it, without the efforts of a waiter who was shouting in his ears, to intimidate him. The attitude of the horse, sitting like a dog, is the most difficult. It must have the curved hind feet, as well as those in front, with the hoof resting on the ground. Astley's horse took such a difficult attitude at the command of his master.] (Author's translation)

From the description of the amphitheatre given above, from someone who actually visited it, Astley had evidently invested a lot of money into the venture. It became very popular and played to packed houses, with much acclaim. The season ran from November to the end of the following February, when Astley would return to London ready to open about Easter time. A poster from the end of that first season announces that the last three days of appearing in Paris would be 14–16 February 1784. It was a varied programme, presented in four 'divisions'. The show opened with a grand cavalcade and a 'Salute to the English', presented by the young John Astley, who would dance on horseback and present the flags at full gallop. The second part began with a musical piece, accompanied by the bird imitator Rossignol. The section would be concluded by Astley senior, who would give an exhibition of broad sword as used by the Light Dragoons. The third part began with the entry (on horseback) of a rough peasant, who then metamorphosed into a coquettish peasant. There was also English dancing, and the section concluded with a minuet on two horses danced to a Scottish air. The fourth and final part allowed Astley senior to perform his famous Taylor riding to Brentford routine, although in French it appeared as '*Le Combat de Tailleur Anglais*' (The fight of the English tailors). The section was completed by John Astley 'flying' with two horses and presenting a variety of poses and attitudes on horseback. The whole evening's entertainment concluded with a final parade of horses. It is worth noting that the monkey, General Jacko, does not make an appearance in the programme so perhaps Astley was yet to acquire him. It is also interesting that Mrs Astley does not appear and it would seem that her performing days were over by then; her name disappears from all subsequent advertising. John Astley is certainly the rising star of the entertainments.

Astley had conquered Paris. He now had amphitheatres in two capital cities and the name Astley was known across Europe. The Amphithéâtre Anglais was to become the home of his winter season for the next few years. With this success he returned to England for his summer season.

Chapter 7

Balloons, fireworks and other diversions

P hilip Astley was in Paris during November 1783 and was to experience
an event that set him on his next venture. Two French brothers named
Joseph and Étienne Montgolfier had been experimenting with the idea
that a balloon filled with hot air could be used to transport people. Their first
outdoor experiment was on 4 June at Annonay in France. The balloon was made
of cloth and lined with paper and was stitched together with an estimated 2,000
buttons. The whole was then coated with alum, a fire retardant material. A fire
was lit beneath the balloon, which filled with smoke; the Montgolfiers believed
at that time that the balloon was made to rise by the volume of smoke contained
within the structure. On this day the balloon rose to about 1,000 metres and
travelled approximately 2 kilometres. Their second venture was at Versailles in
Paris, on 19 September, before the King, and in this instance the balloon car-
ried a cock, a duck and a sheep in a small cage suspended beneath the balloon.
This time it rose only to about 500 metres and travelled 3 kilometres, but it was
a great success. Their most impressive, and perhaps most significant, test was
on 21 November in Paris when their balloon carried the first two men to ever
'fly' a distance of about 10 kilometres at a maximum height of 900 metres. The
age of flight had arrived. Astley quite possibly witnessed this, and as we have
seen earlier, his enquiring mind was not slow in recognising a moneymaking
possibility.

The experiments by the Montgolfier brothers caused great excitement across
Europe, and full accounts of them were widely reported in the international
press. A correspondent for *Jackson's Oxford Journal* wrote a lengthy article in the
27 September edition in which he discussed the potential uses of such air bal-
loons. He also pointed out that the Montgolfiers were not the first to experiment
in this field:

> A grand Exhibition of the Air Balloon is to be made this Week at Versailles
> before the King, and the Particulars of the Experiment are to be pub-
> lished from Authority. The first Observation of the extreme compara-
> tive Lightness of inflammable Air [hot air] was made many Years ago by
> Mr Cavendish. Dr Priestley has pursued similar Experiments with great
> Success, and is at this time carrying them much further than any other

Person. Mr Cavallo is also now preparing an Experiment of the same Kind, to be made shortly in Hyde-Park.

If Astley had hoped to be the first person to launch a balloon in England he was to be disappointed. On 7 November, *The Chelmsford Chronicle* carried this report:

> Saturday last Mr Blaggini sent off an aerostatical globe from Noble-street, Cheapside. It appeared over Smithfield and Aldersgate-street, but no intelligence has yet been received of its having fallen. The aerostatic globe, which was constructed by an ingenious gentleman, and sent into the air on Saturday last, was observed by great numbers of people in this metropolis to mount above the clouds, talking its direction horizontally W.N.W. passing over Highgate. A label was affixed to it, offering a reward to the finder, yet no tidings have been heard of it. It appeared, when above the clouds, like an opake [*sic*] object, apparently about the size of the moon. This is the first of the kind exhibited in England.

I think it is still quite interesting that we today, at fairs and carnivals, take great pleasure from attaching our names and addresses to helium-filled balloons and seeing how far they will travel when released. Although I think Mr Blaggini's request was more in the spirit of experimentation rather than fun.

'Balloon mania' swept across Europe. It even influenced ladies' fashion. It seems that in Paris women began to wear balloon hats modelled on the Montgolfier balloons, some of which were reported to be a full half a yard in width. There was a growing craze for experimenting with and publicly releasing hot air balloons. One vivid account given in the *Ipswich Journal* of 8 November 1783 reported that an air balloon was released in Falcon Square, London, and found the next day near Leominster, Herefordshire. The inhabitants were 'much alarmed' and 'fear and consternation seized their minds'. However, a few days later, the *Hereford Journal* discredited this report, claiming it to have been a hoax. It seems that even in the eighteenth century there were those ready to put out 'fake news'.

Hoaxes aside, there were genuine public displays. One of the more notable ones was that at the Artillery Ground, in London, on 25 November, reported in *The Derby Mercury* on 29 November:

> This Day at Noon the Air Balloon was displayed from the Artillery Ground, in the presence of Thousands of Spectators; its Ascent at first was rapid, and its Direction … after it had reached a particular Height, made to the Southward, and was plainly discernible for Half an Hour

over the City and St George's Fields – It was gilt with Dutch Leaf and from the great Splendour of the Sun made a most beautiful Appearance – *Lond. Even. Post.*

However, the display was not without event; an opportunist thief took the occasion to line her own pocket:

During the ascent of the Air Balloon … a foreigner of distinction (belonging to the King of Denmark) had his pocket picked of his purse, containing a valuable diamond ring, and upwards of forty guineas. The robbery is supposed to have been committed by a very genteel woman, who spoke French fluently, and took great pains to enquire of the gentleman the nature of the balloon.

(*Kentish Gazette*, 29 November 1783)

If the French royal family could witness the experiments in Paris, then the British royals were also treated to such exhibitions. In November, displays were given before the King and Queen on the terrace at Windsor Castle.

When Astley had concluded his winter season in Paris he returned to London in the spring of 1784. While his performances still continued at Westminster Bridge Road, he embarked on his new venture of public balloon launches. His first recorded release was in March 1784, as here recorded by *The Stamford Mercury* on 19 March:

The celebrated Mr Astley (the horse rider) we hear has contrived his Air Balloon, which he discharged from his Amphitheatre on Friday last, to make great explosion every 200 feet it ascended, and make three reports when it reached the height 4,000 feet. He offers a silver tankard to whoever shall find the large Balloon, and bring it to the Amphitheatre.

It is not recorded if the reward was ever claimed. However, Astley had his rivals. In the same newspaper a report is also given of a Mr Hounslow displaying in Lincoln the remains of an air balloon found by two young boys in Horncastle. The balloon had been discharged from York only a few hours before. We do not know the fate of Astley's balloon but it may well have suffered the same as that of Hounslow's, for the report states, 'Many people in this town were very curious to preserve a piece thereof.' Were pieces of the balloon sold off or did the people simply help themselves? After his successful initial balloon launch from his amphitheatre in London, Astley took his new interest to the provinces. In April, he made a launch in Derby:

On Friday at Noon, an Aerostatic Globe, or Air Balloon, made in the form of a Billet [billiard] Ball, was launched from a Stage erected in the Centre of our Market-Place, by the celebrated Mr Astley, of London. The Globe began to be filled a little after eleven o'Clock, and by a Quarter past twelve, the inflammable Air was composed of 10 Quarts of Vitriol, 15 of Steel Filings and 45 of Water; – it was 16 feet in Circumference, made of Italian Silk, and covered with elastic Gum, or Indian Rubber, dissolved in Linseed Oil, prepared from a Sand Heat. The Balloon was accompanied by a triumphal Car, 2 feet long, fastn'd by colour'd Ribbons, in Honour of the two Representatives lately sent to Parliament from this Place; – which Car was an exact Model of that in which Messrs Charles and Roberts ascended from the Thuilleries [*sic*] in France on the 2nd of December 1783. The Globe rose gradually (amidst the Joyful Acclamations of the People) to the Height of about 2,000 Feet, was in sight four or five Minutes, & travelled N.E. Direction at an amazing Rate. It was launched by Subscription from the Ladies and Gentlemen of Nottingham. A Label was affixed to it, offering One Guinea Reward on Delivery thereof to Mr Astley.

(*The Derby Mercury*, 8 April 1784)

There are several interesting aspects in this report. Firstly, it is evident that Astley had seen the December balloon ascent in Paris, or had at very least seen the gondola in which the two men were carried aloft. He was able to create a model of it and I have no doubt that, given Astley's fastidiousness, it was an accurate likeness. The second point is that this was an expensive venture. Although a relatively small balloon, approximately 5 feet in diameter, it was made of expensive silk that had been treated with some form of rubber solution. Added to the costs were the building and decorating of the car and the provision of the necessary components to create the 'inflammable air'. Astley was first and foremost an entrepreneur; he did little unless there was profit and glory attached to it. It is worth noting that the launch was by subscription and the income from this must have been enough to ensure that the project was successful and that there was some form of profit in it for himself. At least if people subscribed to the project he would have been assured of the money up front, rather than relying upon income on the day. Although not mentioned in the report, I feel sure that he also arranged some form of audience payment on the day. In July 1784, a balloon used by a Mr Lunardi was exhibited at the Lyceum in London and receipts were recorded at being upwards of £900 – a significant amount. Astley was also astute enough to ensure the support of the local Members of Parliament by displaying their colours. Although maybe not directly beneficial on the day of the launch, Astley was accruing favours that he might have to call upon in the future.

A few days after the Derby launch, Astley launched a balloon in Northampton. In some ways he was performing a current affairs service. By exhibiting hot air balloons, especially if modelled on those of the Montgolfiers, he was acting as the Pathé News of the time. For people who could not read, or for those who did not read newspapers, here was a live exhibition of a topical subject matter that could be seen and experienced. In a similar vein, Astley and other circus proprietors would later portray famous battles and other historical events. All of these, however patriotic and jingoistic they may have been, acted as reportage and informed the public as well as entertaining them.

There was always the possibility that a balloon, once launched, may never be found and returned. Astley must have had several available balloons to circumvent this problem. Was the Northampton balloon the same one that he had used in Derby? We simply do not know, but we do know that Astley's balloons were occasionally found and held by the finders until a reward could be solicited:

> Friday last, Ralph Drinkwater, a servant … near Chester, whilst riding a colt in a field at that place, perceived, at some little distance from him, a gas globe or balloon … which after pursuing a short time, fell to the earth … he remounted and thus he (and his inflammable captive) entered the village with no small degree of triumph. … This aerial prisoner is now securely lodged, in a suspended state, in a barn, where it is likely to remain … till the proprietor shall think proper to ransom it; – The following words are printed on the balloon, 'The property of Mr Astley, London'.
> (*The Leeds Intelligencer*, 10 August 1784)

It has to be remembered that these hot air balloons were things of wonder and, certainly in more rural areas, would not have been known of. It is little surprise that for some people these would have been quite terrifying supernatural apparitions floating through the sky.

Astley appears to have stopped exhibiting hot air balloons after April 1784, and this would coincide with his usual pattern of opening his summer season in London, before returning to Paris for the winter season. As well as performances in London, he sent detachments to exhibit in the provinces. Certainly in September a group were performing in Oxford, as an accident to two young boys who fell from a tree while attempting to watch the display was recorded in the *Reading Mercury* on 6 September. It was important that Astley should maintain performances around the country in order to compete with his rivals. During the summer of 1784, Parker and Jones, with pupils from the Royal Circus, opened a new circular riding school in Dublin and performed there until the end of the season. Their programme included feats of horsemanship, tumbling and the Egyptian Pyramids.

The rivalry between Astley's and the Royal Circus continued when Astley returned from Paris in the spring of 1785. Since the run-in with the magistrates and subsequent granting of a licence in 1783, both were now well accepted. In a counter budget proposal in the House of Commons in July 1784, both venues were specifically referred to by name when a proposal was made to levy a tax on places of entertainment and popular amusements. Advertising for both venues appeared side by side in *The Times* on 2 April 1785. At Astley's one could see Astley himself presenting his Philosophical Amusements (conjuring), performances on the tightrope, two new dances, horsemanship by Astley and others, a comic musical piece, dancing dogs, tumbling, and a pantomime or Harlequinade. Just down the road at the Royal Circus was offered horsemanship by Hughes and his pupils, a sequence of musical entertainments by Mr Dibdin, a display of magic by Signor Spinetti, automaton figures on the tightrope, a learned pig, and a conclusion of fireworks. Both proprietors were tempting their audiences. Hughes announced that the entertainments:

will be performed, upon a Plan, and in a Stile [*sic*], infinitely superior to any Thing ever yet attempted at that Place. … The Dresses, Decorations and every other ornamental Part of the different Spectacles entirely new. … Good Fires are continually kept to Air the Circus.

Astley countered with:

entire new Music, Scenery, Dresses and Machinery. … The Amphitheatre is illuminated in a Manner entirely new. The Chandelier has been invented by Mr Astley in order to give greater Effect to the different Exhibitions and to render the Illumination less incommodious to the Audience.

The London audience was spoilt for choice, although the entertainments at the Royal Circus tended to be more of a musically based nature. What possibly clinched the season for Astley was the arrival of the performing monkey, General Jacko, as mentioned in the previous chapter. Nothing like it had been seen before and the monkey became a favourite of the crowd, both in London and in Paris.

Astley was fervently patriotic, so when the celebrations for the King's birthday in June were being arranged he spared no expense. Always one for self-promotion, he placed this notice in *The Times* on 4 June:

Mr Astley most respectfully informs the Nobility, Gentry and others, that a most capital Firework is purposely prepared, which will be displayed this Evening, in Honor [*sic*] of His Majesty's Birth-day, at the conclusion of a new Musical Piece called *The Rejoicing Night*; or *Huzza!*

King George and *Old England Forever*. N.B. Mr Astley has ordered a most
brilliant Firework to be displayed on the Thames at the conclusion of the
Evening's Entertainments … Mr Astley having ordered the Fire Barge to
be moored head and stern exactly in the centre of the Thames at a proper
distance from the Bridge.

It must have been a spectacular display, and the *Kentish Gazette* gave a detailed
report on 9 June:

Among the many illuminations that took place on Saturday, Astley's Bath
on the Thames was the most beautiful, from its situation. A most capital
firework was played off; most of the devices were quite new; the water-
fire balloon gave general satisfaction; first it exhibited a transparent light
of many colours; at the conclusion it burst, when a mine of not less than
6,000 serpents, stars, &c. sprang in the air and covered the whole Thames.
… The fireworks are said to have cost Astley fifty pounds.

Many of the fireworks were repeated, on a much smaller scale, in subsequent per-
formances that season at the amphitheatre. It was Astley's constant striving for
aggrandisement that kept him in the public eye; he was always ready to try new
ideas and this maintained his popular appeal. Since he had first begun performing
horsemanship in 1768 he had built permanent amphitheatres in London and Paris,
and several other semi-permanent venues around the country. He had owned a
travelling museum of curiosities; had exhibited hot air balloons; had dabbled with
conjuring; was presenting trained animals; had created a public bath on the banks
of the Thames; had introduced fireworks into his performances; and had experi-
mented with other wondrous illusions such as ombres chinoises. Above all, he was
constantly changing his programme of entertainments, introducing the public to
many accomplished foreign performers.

It was the arrival of his son John that really caught the public's attention and
placed Astley's at the forefront of the entertainment. By the time he was a teenager
he was an accomplished horseman. Since Astley had established the amphitheatre
in Paris, John had grown in reputation. He was the darling of the French audience
but had not, as yet, been released to the English public. In France he had developed
his own distinctly individual style of presentation. Astley senior's performances
had been very masculine; his Feats of Activity on horseback had been founded on
military activities. Astley was the embodiment of the loyal male heroic patriot; he
was tall and broad in stature, a war hero. Astley junior did not have the same mili-
tary background and he did not have the same stature. Although accounts say that
he was exceedingly handsome, he did not have the same presence. He had a very

masculine physique with quite long golden hair, like his mother, and was attractive to the opposite sex, but he also had a distinct feminine side to his nature. His performances were more graceful and included dancing a minuet on horseback while in full gallop. Yet he could also perform amazing feats of acrobatics on horseback. M. Mattfeld (2014) defines John's character as follows:

> John was an amalgamation of both the rough and ready British hero and the refined, polished and French gentleman. ... John embodied the gender codes of Britain and France in a unique form of masculine display.

Others were less kind in their description of John Astley. The *Universal Register* carried a column entitled 'Small Talk; or Chat on the Turf'. In this column characters discuss topics of the day. On 8 August 1786, this appeared:

> Lord Gallop: Pray, does Mr Hughes dance a minuet on horseback?
> Groom: Oh no, my Lord, he is too fond of manly exercises to dance a minuet on horseback like a he, she, girl.

Clearly there were those who were confused by John's androgynous nature. However, when he made his first appearance in London, in October 1785, he was an immediate success. I am sure that Astley senior had a cunning plan in unleashing John on the public so late in the season. He knew that his son would be a crowd-pleaser. Presenting him for only a short time before they closed for the winter and returned to Paris would ensure the popularity of Astley's in the forthcoming season. If that indeed was his plan, then it was a success. The public and the press could not get enough of John Astley:

> The Great number of People of all ranks that crowded yesterday Evening to Astley's Amphitheatre, in hopes of obtaining a sight of that truly inimitable PERFORMER in HORSEMANSHIP, YOUNG ASTLEY, is by no means a circumstance that can possibly afford the least degree of surprise, when it is considered, that he is no sooner produced to feast the Public Eye, than we are told, that he can only appear for a few Nights, to entertain the Town with his Horsemanship, his Equestrian Exercises, and Still Vaulting, now introduced by him for the first Time in England. Mr Astley sen. should have brought him forward sooner, as everyone ought to have an opportunity of seeing a Performer, who for strength and execution, as well as for grace and elegance, exceeds everything that ever has, or probably ever will, be seen in this or any other Country.
>
> (*The Times*, 25 October 1785)

This was praise indeed, but young Astley did not have the temperament of his father. Astley senior was self-driven and an indefatigable worker, but John was growing into something of a diva. He knew that he was an accomplished performer and he adored being the centre of attraction. Often he began to 'play to the crowd', especially the ladies. He was reputed to have had a string of young ladies and was often out late at night, drinking and partying – much to the chagrin of his father. In the following London season in 1786, the press did not actually turn against him but *The Times* of 21 June carried a veiled warning, which could be interpreted literally or metaphorically:

> Young Astley seems every night to become more and more the favourite of the town; he appeared on Monday evening even to outdo himself. He should be cautioned against admiring the ladies too much, lest he should be thrown off the saddle!

But in spite of this, Astley's was growing from strength to strength, and the same report above concludes with: 'There is no doubt that the Royal Grove, or Astley's Amphitheatre will long continue to take the lead of every other place of public entertainment.'

Astley's was as popular as it had ever been, and it seems as if almost daily the name appeared in a newspaper somewhere. It was a highly successful business and when, in November 1786, a Mr Jones had his application to open an equestrian amphitheatre in Whitechapel rejected, the news report stated:

> The proprietor of a certain riding amphitheatre cleared, upon an average, near £4,000 per annum; and that the expence [*sic*] for salaries to his people, and other contingencies, amounted to near £6,000 more, so that, it appeared, near £10,000 was received yearly at that place.
>
> (*Kentish Gazette*, 3 November 1786)

There is little doubt that the 'certain riding amphitheatre' referred to was Astley's. But for all the brashness and ballyhoo that was associated with the name, what is actually known about the Astleys' private lives? The answer is, relatively little. Decastro (1824) writes about Philip Astley in positive terms. Despite his reputation for being argumentative, he found him to a facetious and liberal person, although a little obstinate on occasions. Astley could be very opinionated but then he could be very forgiving. Jacob Decastro worked for Philip Astley, on and off, for thirty-eight years and would have known him quite well. In his memoires, written a few years after Astley's death, Decastro would have had no reason to be untruthful about his former employer and the anecdotes he records about Astley

paint the picture of a man who was quick to temper, yet quickly placated. Of his wife, Patty, we know very little indeed beyond her performances. It seems that she disappears from Astley's advertising in 1774 and we can assume that she gave up performing about this time. That she continued to support and travel with her husband is certain. Lodged in the back of the third volume of 'Astley's Theatre Cuttings' in the British Library is a letter dated 1786, written by a P. Astley in France to some friends at the 'Royal Grove or Amphitheatre Riding House near Westminster Bridge'. Some, like Kwint (1994), have conjectured that this is a letter from Philip Astley, but the wording indicates that it was written by someone other than himself, and the only other P. Astley associated with him would have been his wife Patty. The letter is a very personal one and I have given the full transcription below, complete with its eighteenth-century spelling and punctuation, as it allows a rare insight into the life of the Astleys at that time:

According to promise in my last on the 20th, I sitt down to write to my dear Mr and Mrs Pownall first I forgot to mention in my last concerning the monkey if it has no tail and tractable, Mr Astley would be glad you would purchase it for him, but if a tail he won't have anything, we have lost another since we came to Paris the little blackfaced one dyed partly the same as the other. I think we are rather unlucky in that Spetia of Animells. Now for our journey from Calais. I was taken very ill the first night there with a violent pain in my heart shot throw to my sholder could not turn in my bed scares breath without screaming continued so two or three days; but thank God now am quite well – Mr Astley was so kind to accompany us in the carige, but I must not ask this favour any more for there is none in troop can be trusted to bring them to Paris, except John Taylor and son – he could not be spaird, poor J. Taylor. I think he is a little cracked for he has not been in Paris a week but he packed up his alls and was going to London kipd in his room as if he was just come of Bedlam he sett off and lay one night at the place he was to take his carige from (which was a fish cart by the by) but the smell I suppose either turned his stomach or his reason returned as he came back I have told him what you wrote. We was much (but not agreeably) surprised to find the nearer we came to Paris we found snow. It continued nine days very cold indeed we could not keep our selves warm but now we can sitt without fire again thank God for fireing here is a dear article we burned near two guineas the first week Genl Jacko did not arrive before the 18th and we opend the 19th it was lucky we saild when we did or we should have been weather bound many days as he was. The strong man is gone to Brussels for his children I dont know when he will arrive we had a poor house on Tuesday

I hope our pig will take as he performs very well. I fancy you are very busy about your little boy – God send you boath your healths to enjoy it many years pray Mrs Smith remembers to bring you some [indecipherable here] as I begd of her, have you many scholers, hope they will turn out better in the Rodeing [?] and year past. I shall esteem it a favour you will write every opportunity you have as that will add much to my presant happiness we go from here to Brussels in the time we wait for the Bank for we don't take but 17, 16 or 18 pounds a night only on the Mondays Mr Nicolle has done all he can to hurt us he has got our tumbling taken away which makes it lay very hard on poor John as he does his peasant on two horses every night and his knee very bad wears him out would to God we had to or three years back taken care of our cash and not run such lengths in building as we might have enjoyed our selves in the winter, but I doubt that grim looking gentlmn death will visit us before we shall have that comfort, Gods will be done. Mr Astley has made a stage to be supported by eight horses for them to tumble on but it is not finished yet, but we are in hopes we shall in spite of Nicoley obtain our old permition, Mr Hercule is not yet arrived from Brussels it will be a little respite for son expect him every day. I began this letter the 22nd but one hopes of good news in the schoole delayd sending it but to no purpose so shall conclude with all our respects. Most obedient humble sert to command.

P. Astley
Paris 4 Dec 1786

This invaluable letter tells us much about the lives and circumstances of the Astleys in the winter of 1786. I think there can be little doubt that it was Patty Astley who wrote the letter as she refers to Mr Astley by name in the third person. Clearly she was unwell and how she described her condition may have been an indication of angina. Interestingly, the NHS cite cold weather as a possible trigger for some forms of angina and it was very cold at that time, according to her letter. Nine days of extreme cold caused them an expense in firewood and kindling, but they must have been hardy people as she wrote that they could 'now sit without fire'; I doubt that we today would sit in an unheated house during winter. They seem to have been financially stretched, with only mediocre box office returns. This appears to have been because they had invested heavily in an extensive building programme, one assumes at the amphitheatre in Paris. In the letter Patty Astley makes reference to performers, both human and animal. General Jacko gets a mention and he was obviously shipped from England separately to the Astleys, arriving just in time for the opening performance on 19 November. Sadly, they did not seem to have as much luck with their other monkey and that is why Mr Astley was requesting a

replacement, should a suitable one be found in London. There also appears to have been some kind of 'Learned Pig' act on the bill for that season. The Mr Hercule mentioned is probably Peter Ducrow, a Belgian-born strongman who was known to have worked for Astley. Ducrow was the father of Andrew Ducrow, the later celebrated horseman who eventually became the manager of Astley's Amphitheatre in the nineteenth century. Poor John Taylor seems to have suffered some form of temporary breakdown. Taylor was also a horseman and may possibly be related to the nephew mentioned in Philip Astley's will and testament. Patty Astley's (née Jones) mother did remarry a Joseph Taylor on the death of her first husband, so there was a Taylor connection to the family. John Astley also gets mentioned and it is interesting to note that his mother is concerned about his injured knee, especially as the efforts of Monsieur Nicolet (to use the correct spelling of his name) were directly affecting his performances. At that time Astley was licensed for displays of horsemanship and not for tumbling 'on the stage'. M. Nicolet was a celebrated director of the Parisian theatre and he was later instrumental in nurturing the talents of the celebrated tightrope walker, Madame Saqui (S. Ward, 2016). At that time he had the sole licence in Paris to present feats of tumbling upon the stage. The new Astley's Amphitheatre was serious competition and he applied to the Lieutenant General of Police that a ban be placed upon Astley's inclusion of tumbling in his entertainments. Always ready to face a challenge, Philip Astley came up with a novel idea, the one that Patty Astley refers to in her letter. He took several horses, Mrs Astley refers to eight but a contemporary poster shows nine, and harnessed them together in such a way as to form a steady platform upon which to affix a stage. In this manner he was able circumvent any ban by maintaining, quite correctly, that his tumbling performances were still being given on horseback. This ruse appears to have been acceptable and a poster dated 27 December 1786 advertises:

Par Permission du ROI, & de Monseigneur Le Lieutenant-General de Police
EXERCICES
Surprenans
DES SIEURS
ASTLEY
Rue et Fauxbourg du Temple

And the accompanying image shows tumblers and vaulters performing on the horse-supported stage. Decastro records that this ingenuity was well received by the Parisian audience and Astley's invention drew more people to the amphitheatre than before. Once again, Astley had triumphed in the face of adversity; there could be no stopping him. His winter season in Paris was a huge success and he returned to London for the Easter opening at Westminster Bridge.

By now, John Astley was becoming the star performer in the company. *The Times* of 30 April 1787 hailed his opening London season:

> Young Astley will perform this evening ... his unparalleled new and graceful Equestrian exercises; among which are his vaulting, dancing, and flying over the garter and stick at the same instant, upwards of 12 feet from the ground.

As always, there was a full supporting programme with rope dancing, tumbling, General Jacko, the Learned Pig, and other equestrian and musical interludes. Astley senior performed an equestrian minuet with his son. As we have seen, Astley senior was always ready to embark on new ventures and by August he had introduced into his entertainments what he billed as 'The Three Monstrous Craws'. These were, according to *The Times* of 16 August:

> Wild born Human Beings ... two Females and one male, whose country, language and native customs ... are yet unknown to all mankind. It is supposed they started in some canoes from their native place, were blown off all sea in a violent storm, and providentially picked up by a Spanish vessel.

Like the American P.T. Barnum a century later, Astley had no scruples in exhibiting the less fortunate of society for his own gain. In fact, the 'Craws' were not an unknown race of people at all. They were from the Mediterranean region and all, sadly, had some form of facial deformity. There was to be a growing trend for exhibiting what has rather cruelly been termed the 'freak show', where people such as midgets, giants and others with many kinds of physical disabilities and disfigurements were displayed for public amusement and wonderment. Although we may find this idea distasteful and exploitative, for many people in such a position the entertainment business was a means of earning a living as opposed to destitution. A contemporary short film by the director Joshua Weigel, entitled *The Butterfly Circus* (2010), explores how the circus gives hope to a disabled man against all that he has believed in. Although set in America in the Great Depression, the film does give a feeling for how it must have been for such people. It is available to view on *Youtube* and lasts for approximately twenty minutes.

Always trying to better his rivals, in October Astley unveiled his new portable riding school. It was generally well received, especially by the military, who recommended it for infantry and cavalry training in rainy weather while in camp. The structure was approximately 100 feet in length, 50 feet wide and 25 feet in

height. It had a central equestrian ring and stabling for fourteen horses. The whole weighed 4 tons and could be transported on a wagon.

Uncharacteristically, Astley delayed the opening of his Paris winter season. Instead he headed north to Manchester, a city he had not appeared in since 1773, exhibiting at the riding school on Tib Street. The full programme was included, but of course the star was John Astley. Astley senior made it quite clear in his advertising that the stay in Manchester would be short, as the company would be visiting Chester and Liverpool before returning to Paris. It was not until early 1788 that the company opened its Paris season. But there were rumblings of social discontent throughout France and events were about to unfold that would open a new chapter for Philip Astley.

An age of revolution: Astley in Ireland and France

The 1780s was a difficult decade for Britain. There was a constitutional crisis and the King would become ill with a mysterious ailment that some thought was the onset of 'madness'. The American colonies had been lost, there was unrest in Ireland, ongoing conflicts in India, and tensions with France were never far away. Throughout all of this, after his earlier brush with the authorities over licensing, Astley seemed to grow from strength to strength. He was at the forefront of his particular style of entertainment and was about to expand his empire even further.

Ireland had always been a successful venue for him and he had a long-term plan to establish his own permanent amphitheatre in Dublin. The Theatre Royal on Smock Alley had been established in 1662; in fact, it was the only other Theatre Royal outside of London at that time. Under the terms of the First Irish Stage Act of 1786, all theatres, with the exception of the Theatre Royal, were closed in Dublin. This left the manager, Richard Daly, with the monopoly of licensed entertainment in the city. However, he had let standards slip and the clientele were not as grand as they once may have been. On 26 December 1787, it was reported in *The Hibernian Journal* that sections of the audience were 'hissing, booing, using indecent language, calling for improper tunes, throwing down apples, oranges etc., attacking every person within their observation'.

At this period in Irish history there was a growing revolutionary feeling within the country. A new, bolder form of radicalism demanded reform of the Irish parliament, away from the restraints of the London government. The Society of United Irishmen had been formed, but this soon evolved into a more revolutionary minded republican organisation, inspired by the events of American Revolution and with strong sympathies with the social and political unrest in France. One of the tactics that was frequently employed by the United Irishmen, and encouraged by one of its leaders, James Napper Tandy, was to use the theatre as a place of public protest and often performances would be disrupted, as shown in the above report.

With Daly managing the only patented theatre in Dublin, Astley saw the opportunity to establish an amphitheatre in the city. Using his military connections, he approached Sir Capel Molyneux, a well-known Irish politician of the time, and negotiated the purchase of an old Bishop's mansion on Peter Street, just to the west of St Stephen's Green in the city. Applying for the necessary licence, he was granted his letters patent on 23 April 1788 for performances from November

through to February. This allowed him to present feats of activity on horseback and other entertainments not in prose. In other words, he was not to perform pieces of dramatic theatre. Work began immediately on converting the building to the needs of an amphitheatre and he planned to open his season in the November of 1788 under the name of the Royal Amphitheatre. This he did, although building work in the amphitheatre was not fully completed until early the following year.

While work was progressing in Dublin, Astley was back in London. His empire was continuing to expand; as well as the three amphitheatres he now had in London, Paris and Dublin he also had a travelling troop of performers out in the provinces, managed by Mr Handy. The troop was advertised as being from 'Astley's and Hughes's Riding Schools'. On 4 June 1788, Astley presented a grand firework display as part of the King's birthday celebrations. A few days before this, he had been presented with a horse belonging to General George Eliott, his former commanding officer. Why Astley should be presented with such a gift is not recorded. Eliott, the Governor of Gibraltar, had been elevated to the peerage in 1787, as the first Baron Heathfield, in recognition of his part in the successful defence of Gibraltar during the Franco-Spanish siege from 1779 to 1783. He had ridden a pure white charger, known as the 'Gibraltar Charger', and it was this horse that he gave to Astley. The Gibraltar Charger is not to be confused with the other horse that he was given on his discharge from his regiment in 1766. This horse was often called the Spanish Horse, hence the confusion. Having gone through the Siege of Gibraltar, Eliott's horse was completely 'bomb proof', and this Astley showed off to great effect during his firework display. It was a grand affair, and *The Times* of 4 June 1788 carried a full report:

HIS MAJESTY'S BIRTHDAY

A Description of the Fireworks to be displayed This Evening on the Thames, immediately after ASTLEY'S Exhibition in honour of His Majesty's Birthday.

First Division: A VERTICAL SUN displaying variegated Fire.

Second Division: Two GRAND CAPRICES, and Ten ornamental Changes.

Third Division: A GRAND FIXED SUN, ornamented with a Glory, and a Comet of Blue Fire, remarkably brilliant.

Fourth Division: A GRAND HEXAGON, with Wings, forming True Lovers' Knotts [*sic*], with 12 Rays, followed by 12 turning Wheels, forming a circle of Butterflies, Serpents, Dragons, &c. which will conclude with fixed Stars.

Fifth Division: Two Grand PATERS, turning horizontally, surmounted by 42 Flying FUZEES, with FIRE PLATOONS of different coloured fire alternately.

Sixth Division: A Grand Pyramid of four Changes, the first composed of seven Vertical Suns, the second of Stars, the third followed by a grand Illumination, forming the same Pyramid; and the last a grand FIXED FIRE of two changes of brilliant Chinese Fire, succeeded by a FEU-JASMIN.

Seventh Division: A grand Horizontal and Vertical GIRANDOLLA, mounted with 12 Potfires, which will go off alternately, and will lance into the air, Serpents &c.

The whole to conclude with A BALLUSTRADE 38 feet long, illuminated, and composed of PEDESTALS, GARLANDS and EMBLEMS of PEACE, supporting a Gallery of Potfires, Sheaves and Roman Candles, with six Fans in CHINESE FIRE, supported by Pedestals; between which will be six FIXED SUNS; at each end of the Ballustrade a grand LUSTRE and POTFIRE, and in the middle VIVAT G. III. Illuminated with Stars, and terminated by a display of Flying FUZEES, representing the PRINCE of WALES's PLUME. The fireworks are made under the direction of Mr ASTLEY by Messrs CABBONELL and SON, who will let them off on the Thames THIS EVENING, at different Signals from Mr ASTLEY, Senior, who will be mounted on the GIBRALTAR CHARGER placed in a barge in front of the line of fireworks.

The GIBRALTAR CHARGER was presented by Lord Heathfield, (late General Eliott) to Mr Astley a few days ago.

People marvelled at Astley's horse, which, faced with this barrage of noise, lights and explosions, never flinched at all; it was a truly remarkable beast. Even more marvellous was that Astley was seated on the horse upon a barge in the middle of the river. The horse soon achieved celebrity status in its own right, and people flocked to Astley's subsequent performances in the amphitheatre, where he would exhibit the Gibraltar Charger surrounded by fireworks.

In March the following year, Astley attempted another great firework display to celebrate the recovery of King George from his mysterious illness. This occasion was to be held on St Stephen's Green in Dublin. However, things did not go to plan. Some of the fireworks were so damaged by the press of the crowd that, according to Astley's own account:

It was with great difficulty they could be displayed at all; many of the devices were totally broke off ... and trampled on by numbers, notwithstanding which, not the least accident happened from any of the pieces of Fireworks &c.

(*Saunders's News-Letter*, 19 March 1789)

H. Burke (2006) comments that rather than the press of the crowd causing disruption to the display, it was more possibly a deliberate act of sabotage by supporters of the United Irishmen, who damaged some displays and prematurely let off others. Unwittingly, Astley became seen as a loyalist representative of the British government. Some have even claimed that he was a British agent, but this has never been proven. He was fervently patriotic and this did not endear him to sections of the more revolutionary minded Irish public. Although extremely popular and well supported in some quarters, his Dublin seasons throughout the following decade were dogged by interruptions and escalating unrest. Rioting was not uncommon across the city and to protect his loyal (and perhaps largely loyalist) audiences Astley was forced to place a 'High Constable Box', a sentry box, in the gallery. An account of one quite violent interruption at Astley's is given in *Ireland before the Union* by W.J. Fitzpatrick (1869):

> We decided to put a stop to it at Astley's equestrian circus, in Peter Street, where it was nightly played; to the great irritation of the popular party [United Irishmen] and the exultation of the low Orangemen [loyalists] who congregated there to hear it. The moment the band struck up *Croppies Lie Down*, Hardy shouted out, 'Now boys, do your duty!' and attended by some followers, jumped into the orchestra and smashed all the instruments. A general panic and flight ensued, accompanied by a few feeble hisses from the Orangemen, who withdrew like geese.

The issue here seems to have been the playing of the loyalist song *Croppies Lie Down*. A croppy was a man who wore his hair short in the French style. The loyalist Yeomanry were renowned for terrorising the Irish populace and hunting down revolutionaries, particularly after the failed landing of French forces in Bantry Bay in 1796. When caught, the punishment meted out was often that of 'pitch capping', where the head of a croppy would be tarred and then set on fire. The song was composed by a notoriously brutal captain of the loyalist North Cork Militia and was very inflammatory to the United Irishmen. The fact that Astley allowed it to be openly performed shows his blatant disregard for the feelings of the Irish people or his earnest, but blinkered, loyalism.

Another Irish 'thorn' that irritated him was the manager of the Theatre Royal. Daly saw Astley's patent as serious competition, especially as audiences were now drawn to the Peter Street amphitheatre, and he sought legal course of action to try to close him down. The case rumbled on for many years, with complaints on both sides. Both accused the other of being in breach of copyright. In 1794, Astley presented an equestrian drama entitled *The Siege of Valenciennes*, which he had written himself, drawn on personal experience. When Daly decided to present

the same piece at the Theatre Royal, Astley was so incensed that he wrote a long column in the press condemning him:

> Mr Astley, senior, being the SOLE AUTHOR of this truly acknowledged grand entertainment ... it was with no small surprise, he saw advertised *The SIEGE of VALENCIENNES*, to appear at the Theatre Royal ... and with the deepest concern was informed (by many who saw it) how dreadfully it was mutilated in its Representation. This invasion of property Mr ASTLEY cannot but take notice of. If Mr Daly wished to amuse the public, with the local matter on the Continent, WHY NOT ... have been present at the transactions [the siege], where he would not only [have] acted as a good citizen, but have proved himself more fully entitled to that patronage the public now deign to show him.
>
> (*The Dublin Evening Post*, 11 January 1794)

In 1798, it is recorded that Astley had to pay £500 to Daly for giving a performance of *My Grandmother*, which Daly claimed to have ownership of. In fact, Daly challenged many of Astley's presentations, claiming that they were of a more dramatic nature than was permitted under the terms of his patent. Eventually the court case between Daly and Astley came before twelve judges, all of whom found for Astley and established his patent for the amphitheatre. Decastro tells an anecdote of Astley being visited in London by one of his legal 'advisers'. During the course of a very convivial evening, where much wine was dispatched, for every bottle of wine that was emptied the adviser announced that an additional judge was on Astley's side. After twelve bottles, he announced that twelve judges would be for Astley. It seems rather coincidental that all twelve judges found for Astley and one wonders how much influence this adviser had on the outcome. Decastro also records that if Astley had lost his case he would have been liable for £10,000 costs.

However popular Astley's entertainments may have been, they were still subject to the limitations of the law. On 8 April 1788, leave was given to bring in a bill before Parliament prohibiting the performances of plays, interludes and other such like presentations in unlicensed venues. This was commonly referred to as the Interludes Bill. The managers of the Sadler's Wells theatre presented a petition requesting to be excluded from the terms of the proposed bill. This was considered and the request granted. This prompted petitions from other places similar in nature to Sadler's Wells – the Royal Circus and the Royalty Theatre – but these were refused. Astley was absent from London at this time so had to employ an agent to submit his petition. A copy of this is held in the Parliamentary Archives (Main Papers HL/PO/JO/10/7/782) and reads:

The Humble Petition of John Grubb, Agent for Philip Astley.

That the said Philip Astley is proprietor of a certain Place of Entertainment in the Parish of St Mary, Lambeth in the County of Surrey called the Royal Grove Amphitheatre, which place hath been for many years licensed by the Justices of the Peace at the General Quarter Sessions for the said county, which under such licence the said Philip Astley hath exhibited Entertainments of Dancing, Singing, Pantomimes and other Performances of the like Nature And that in consequence of the Encouragement the said Philip Astley has received from the Public he has been induced to expend and lay out in Buildings and Improvements a very considerable sum of money And is now under Engagement to a very great amount to performers for the present Summer Season at the said Amphitheatre. But the said Philip Astley hath lately been informed that the Licence granted to him by the Justices as aforesaid will not authorise the exhibiting of the like Entertainments as have been usually performed at the said Amphitheatre.

That the said Philip Astley finds a Bill is now depending before your Lordship for licensing and regulating Places of Public Entertainment And that the said Bill contains certain provisions for authorising Justices of the Peace to License the Proprietors of a Place of Public Entertainment in the County of Middlesex called Sadler's Wells to exhibit and perform certain Entertainments similar to those usually exhibited at Sadler's Wells and also at the said Philip Astley's Amphitheatre And which Justices of the Peace are not authorised to grant to the Proprietors of any other place in the County of Middlesex or elsewhere, and the said Philip Astley must be deprived of exhibiting such Entertainments for the future unless the like Privileges as are by the said Bill given to Sadler's Wells are extended to the said Philip Astley's said Amphitheatre.

That the said Philip Astley now is and for a considerable time has been absent from this Kingdom And your petitioner received Instructions to apply to the Honourable House of Commons for the like Privileges on behalf of the said Philip Astley as have been solicited by the Proprietors of Sadler's Wells but the time limited by that House for receiving Petitions for Private Bills having elapsed before your Petitioner received such Instructions he was deprived of making such Application.

Your Petitioner therefore humbly prays your Lordships to take the said Philip Astley's case into Consideration And that he may be heard by his Council in support of his Petition And that the like provision may be made in the said Bill with respect to the said Philip Astley's said

Amphitheatre as is made to Sadler's Wells or That the said Philip Astley may have such other relief as to your Lordships shall seem meet.

John Grubb, 28 April, 1788

Simply put, Astley had been in Dublin at the time the proposed bill was laid on the table. By the time he was aware of what was happening he was too late to submit his petition in person, and therefore employed Grubb to draft and submit the petition. In early May, the matter went into committee, and the Lords heard counsel for the petitioners and witnesses were called. John Astley appeared on behalf of his father and proved that Astley had expended £15,000 since the licence had been granted. The managers of Sadler's Wells humbly apologised for being the oldest offenders against the law, in the hope that the Lords would look more favourably on their veteran humility and punish their more junior rivals. The Lord Chancellor at that time was Lord Thurlow. Astley had, in previous years, taught Thurlow's daughters to ride and this may have caused him to look more favourably upon the petitions. Whether this is true or not, we do not know, but Thurlow was of the mind that to license Sadler's Wells and not the others was:

a monopoly by no means in his opinion reconcileable [sic] to reason and equity. … He therefore moved that the indulgences in the bill should extend to all those places of public entertainment licensed under 25th Geo. II, which was agreed to.

(*The Scots Magazine*, 1 October 1788)

or, as Decastro records: 'Lord Thurlow however, on looking at the bill, said, "Is it because they are the oldest offenders that they should claim this? No, – all or none!"'

This then became an amendment to the bill: that the Royal Grove, Royalty Theatre and the Royal Circus be included. Other amendments were made, such as the proposal to prohibit the sale of liquor, wine and beer in such places of entertainment. The bill with amendments was passed by the House of Lords and returned to the House of Commons for concurrence. Yet again, Astley had weathered this storm and was about to face the next.

Social tensions across France had been increasing for some time and on 14 July 1789, the Bastille prison in Paris was stormed by the revolutionary mob. Subsequent events of the French Revolution meant that Astley could not operate his usual winter season in Paris for some time. His focus now became Dublin and London. When war was eventually declared on revolutionary France in early 1793, Astley had little option but to close down his Paris venture and he leased his amphitheatre to Franconi, who had been working for him for some years. Some accounts imply that he actually sold the property to Franconi:

En sa qualité d'Anglais, Astley avait du fuir au moment dù coalition européenne contre la France; Franconi qui s'intitulait citoyen de Lyon, gagna Paris aussitôt après la destruction de son cirque et acheta l'amphi-théâtre équestre d'Astley 21 mars 1793 (Les Théâtres du Boulevard du Crime 1905).

[As an Englishman, Astley had to flee at the moment of a European coalition against France; Franconi, who was a citizen of Lyons, returned to Paris immediately after the destruction of his circus and bought the equestrian amphitheater of Astley on 21 March 1793.] (Author translation)

Whilst the events of the French Revolution, and particularly the storming of the Bastille, may have put a temporary stop to Astley's performances in Paris it did present him with material for his subsequent later presentation entitled *Paris in Uproar; or the Destruction of the Bastille*. Wearing a National Guard uniform (acquired by his son), he presented a detailed scale model of Paris and re-enacted the storming of the Bastille. An undated news cutting in the British Library states: 'The earnestness and interest which are expressed by all ranks of people in this country, on the subject of the French Revolution evinces how strong the principle of liberty is implanted in the breasts of Englishmen.'

Crowds flocked to Astley's exhibition and it would seem that his presentation embodied a very loyalist sentiment. The Royal Circus presented its own version and the piece concluded with the Paris mob singing 'Hail Britannia!'

Always a man of action, Astley volunteered to serve with his old regiment on the outbreak of hostilities against the French in February 1793. Now in his early fifties he returned to war in charge of the regiment's horses, although he would later see action again. *The Times* of 26 April 1793 notes his absence:

Whilst Young ASTLEY is amusing the public at Westminster Bridge, the old veteran, his father, is certainly at this moment embarked with his old Regiment (15th Light Dragoons) ... and we doubt not, should an opportunity again present itself, in French Flanders, or wherever else it may be ordered, but that every soldier, to a man, will signalise himself as on that great and memorable day [Battle of Emsdorf 1759].

Indeed, Young Astley was quick off the mark in being as patriotic as his father. If he could not fight, then a least he could make a performance piece about fighting. As part of the entertainments at the amphitheatre John Astley had written a piece entitled *British Loyalty*, and one of the songs was sung by an actor dressed as a Chelsea Pensioner:

However disabled to you I appear
The enemy's front rank I'd soon make the rear
What dashing and flashing, Oh, what glorious fun
'Tis not the first time I've made the foe run

(Derry down &c.)

My heart beats with joy at the thought of a battle
Where trumpets are sounding and cannons do rattle
Then victory follows, but mark still the pleasure
We conquer to save, this is Britons' great treasure

(Derry down &c.)

Enough of this talking, do prithee let's go
My love for my country again I will show
The foes of Old England we always defy
'Tis for George our good King, so we conquer or die

(Derry down &c.)

(*The Times*, 12 April 1793)

It almost has the feeling that John was writing about his father, and one could easily imagine Astley senior in the role of the Chelsea Pensioner.

The 15th Dragoons arrived in Tournay on 14 May and within a week they were involved at the Siege of Valenciennes. Astley would have been involved and it is his experiences that formed the basis for his presentation piece of the same name. It is little wonder that he was angry when Daly, of the Theatre Royal in Dublin, presented his piece. Astley felt quite justified in pointing the finger at Daly and making the point that, unlike himself, he had not been present at the siege. In the theatrical presentation of the *Siege of Valenciennes*, Jacob Decastro, who wrote much about Astley in his memoirs, sang these heroic lines:

When sent the intrenchments to cover
Each danger we boldly despise
And oft is our task to discover
Where the force of the enemy lies
Still forward we dash
While bombs and balls clash
And the fire on all sides giving way

Still, still we pursue
And cut our way through
And true British valour display

Astley went on to take part in further actions during the war. One notable one, which brought him recognition again, was at the battle of Roubaix. The regiment found themselves cut off from their supporting forces and were forced to retreat through heavy fire from the French on all sides. During the engagement they lost the supporting artillery, but Astley, leading a small group of troopers, managed to retake two cannon and return to the lines. In reward he was given the horses he had retaken but he immediately auctioned them off and passed any money raised to the benefit and relief of his colleagues.

Astley was patriotically generous to his fellow soldiers. When he re-enlisted he arranged to take with him a chest full of flannel waistcoats, many of which had been made at the amphitheatre, for use by the soldiers during the winter season. Into the corner seam of each waistcoat had been sewn a shilling. Astley had funded this himself. But this was not enough for him. In November 1793, he wrote a letter to the printers of many British newspapers, encouraging other theatre managers to collect for the provision of further flannel waistcoats:

> Distribution of Flannel Waistcoats to the brave Defenders of our Liberty and Property on Foreign Service, under the Command of His Royal Highness the Duke of York.
>
> TO THE PRINTER
>
> Sir, This noble undertaking has, within these few Days been the Conversation of Persons of every Denomination, and who are endeavouring to promote it by every possible Exertion; and as you have, no doubt, many Theatres within the Circulation of your paper, I conceive this Hint to the managers thereof will not be unsuccessful.
>
> Your early attention in publishing this, in order to complete the Intention prior to the Severity of the approaching Season, will much oblige.
>
> Sir, Your humble servant,
> Philip Astley, sen. Late Manager of the Royal Saloon
> London, Monday, Nov. 11, 1793
>
> (*The Derby Mercury*, 14 November 1793)

There is an interesting point in this letter. It is dated and sent from London, as if Astley was there himself. Some writers say that he did not return to England until August 1794. We know that he re-enlisted in early 1793 and saw action during the

summer but then seems to reappear in England for the winter. The phraseology of the letter published above in *The Dublin Evening Post* of 11 January 1794 would also infer that he was in Dublin in person at that time. And R.J. Broadbent in *Annals of the Liverpool Stage* (1908) maintains that 'Old Astley was at the Theatre Royal in the March of 1793, and in March, 1794, he opened at the Circus in Christian Street.'

Could it be that Astley sought leave to attend to his winter season in Dublin, and then during his return to his London base took the opportunity to appear in Liverpool? Or, perhaps, was he on a designated fundraising mission for flannel waistcoats and then took the opportunity to oversee the winter season while he was back in England? Whichever it may have been, he did return to the Continent in the spring of 1794.

When he re-enlisted in 1793, he leased his London amphitheatre to his son John for a period of seven years. The building had undergone extensive refurbishment, with further enlargement of the stage and, under John, now became known as the Royal Saloon. In effect, John became the manager of Astley's. It was an extensive empire to manage, with regular venues in London, Dublin, Manchester and Liverpool. In addition to his equestrian performances, he was also developing more stage work as well as writing and directing dramatic pieces. In 1793, he was living at the Astley family home of Hercules Hall, on Hercules Buildings Road, in Lambeth, as we know the house was burgled:

ONE HUNDRED POUNDS REWARD
BURGLARY
Whereas the house of Mr Astley, called Hercules Hall, situate between York Place and Hercules Buildings, near the Asylum, Lambeth, was broke open early this morning, and robbed of about Three Hundred Pounds in cash, and a variety of articles, among which the following are at present found to be missing, viz. A large silver waiter, a small ditto, a large silver bread basket, a small sugar ditto, a silver coffee pot, a silver tea pot, with a crest, a plume of feathers issuing out of a coronet; four silver candlesticks, a pair of silver snuffers, two silver pint mugs, one a very old one; four silver table spoons, some ditto tea spoons, two gold French watches, one metal watch, which opens at the back and the front also. Among the cash is much silver, wrapped up in parcels of twenty-one shillings each, in blue and white paper; and upon some of the latter is marked the letter C. Whoever will give information, so that one or more of the offenders be brought to Justice, shall receive, upon conviction, the sum of ONE HUNDED POUNDS.
June 7th, 1793, JOHN ASTLEY

(*Newcastle Courant*, 13 July 1793)

It seems likely that this large amount of cash, especially as it was wrapped in guinea parcels, was the takings from the amphitheatre destined for a bank. It would seem that one Henry Gibson was convicted with others in September for the burglary, although it is not recorded if the reward was either claimed or given.

Sometime in the late 1780s, Astley had built for himself a house with this grand title, and moved there with his family. His sister and her daughters were also later to join him there. It is said that he named his house after the strong man act that had appeared at the amphitheatre but the Hercules Buildings had been in existence for several years before he built his own house. Certainly they were occupied in the early 1770s, as *The Ipswich Journal* of 10 September 1774 lists the bankruptcy of chapman 'Benj. Bristow, of Hercules Buildings near Westminster Bridge'. According to M. Philips (2014), Hercules Buildings was a terrace of twenty-six houses, all built at different times and therefore being of slightly different sizes. There were open fields to the front, which led down to the river Thames. Astley, when he had moved into his own home adjoining this terrace, would have been able to see his amphitheatre and it was well within walking distance; as was the rival establishment of the Royal Circus. At some point Astley eventually owned many of the Hercules Buildings and other dwellings nearby. Land Tax Records for Surrey (1780–1832) show that in 1790, as well as his own property, he owned nineteen houses on York Place. The previous year only his private residence was listed. In 1795, he is listed as owning those houses known as Hercules Buildings. We know that he owned the properties rather than rented or leased them because his name appears on the lists of Jury-Qualified Freeholders of Surrey for this period.

One can still walk down what is now Hercules Road in Lambeth. Some later Georgian style houses still exist but sadly the terrace of Hercules Buildings no longer stands. The properties became very run down and derelict towards the end of the nineteenth century and were eventually demolished in 1917. At the time that they were built they would have been modest but comfortable houses. M. Philips (2014) describes them as having two rooms back and front, with this pattern being repeated over two floors above. The whole was built over a cellar, although this would have suffered quite badly from damp as the properties were built on former marsh land. Some of the houses would have been extended upwards to have included an attic room. Now in place of the Hercules Buildings we can see the William Blake Estate, a complex of 126 properties, including apartments, houses and shops. But why is it called the William Blake Estate and not the Philip Astley Estate? William Blake, the poet, writer, artist and printer, lived at number thirteen Hercules Buildings from 1790 to 1800. It was here that he established his print and engraving studio. It is mentioned that Blake lived but a few doors away from Astley but pinpointing exactly where Hercules Hall stood is difficult. In the *Survey of London* (1951), the location is given as being on the southern triangle of

land between Hercules Road and the Westminster Bridge Road. John Astley's letter given above places Hercules Hall between York Place and Hercules Buildings. By contrast, a sketch of Blake's house by Percy Home that appeared in the 10 February 1917 edition of *The Sphere* shows Blake's property, identified by a circular disc on the wall. In the sketch, the entrance to Hercules Hall is clearly seen next door. The sketch seems to have been made from direct observation and I see no reason to doubt the veracity of the artist. Today, a blue plaque marks the location of Blake's house but there is nothing to show where Philip Astley once lived.

Philip Astley did return to England in August 1794, but not under the circumstances he would have wished for.

Chapter 9

A phoenix rises from the ashes: Astley's Amphitheatre of the Arts

O n 17 August 1794, the unimaginable happened: Astley's Royal Saloon Amphitheatre was ravaged by fire. Having relied heavily on timber construction, it was an accident waiting to happen. The *Hampshire Chronicle* gave a full account in the edition of 25 August:

> Sunday morning at half past one o'clock, a most dreadful fire broke out at the Royal Saloon, near Westminster-bridge. The fire, which began near the engine-house and reservoir, is supposed to have been occasioned by the carelessness of the watchman. From the impossibility of getting water, the fire rapidly communicated to the box-lobby and circus, and the whole theatre, with the scenery, wardrobe, &c. were entirely consumed; and the flames spread with such rapidity, from the want of water, that eleven new brick houses in the Westminster-road, and a public-house, a wheel manufactory, and several other houses in the back street were destroyed before four o'clock, when the engines, being better supplied with water, fortunately got it under. We are happy, however, to say, we have not heard of any lives being lost. Mr Astley jun. had nearly been burned in attempting to get out the engine belonging to the theatre. The loss is estimated at 30,000 l. [£], half of which is said to be insured.

It was a major catastrophe, made worse by the fact that Astley senior was with the Duke of York's forces on the Continent. Decastro wrote that he learned of the disaster through such newspaper reports as above, which had been sent to the Duke of York. As a volunteer, he was then released from service to return to England to deal with the problem. His return was also noted in the press:

> Astley, sen. the riding-school man, arrived the same morning [4 September] at Weymouth. He is lately from the Continent, and brought letters from the Duke of York to Prince Ernest. Prince Ernest introduced Astley to His Majesty; and this fresh instance of royal

notice and favour may in some measure console him under the misfortune of having all his premises burnt about a fortnight ago near Westminster-bridge.

(*Hampshire Chronicle*, 8 September 1794)

He also carried a letter from the Duke of York to the Queen, recommending him as a bold and honest soldier. As honoured as Astley must have been, I am sure that he would have much preferred His Majesty to dip into the royal coffers and offer some form of financial assistance. The loss of his amphitheatre in Paris and now this disaster at his London amphitheatre must have been a bitter blow to him. I know how catastrophic this can be, when, in recent years, a colleague of mine arrived in England for a circus festival, only to learn that his circus base in Germany had been destroyed by fire. However, Astley was not to be defeated. Always one to rise to a challenge, he gathered his company around him, including at that time Jacob Decastro, and announced that they would begin again. Those who wished to remain with him he would retain on half salaries until such time as he could reopen the rebuilt amphitheatre. In the meantime, he leased the Old Lyceum Theatre in the Strand as a temporary venue under the management of his son. The pit was converted into a ring for equestrian performances and the building was called Astley's New Circus. Some of his performers did manage to find work in other theatres and took much needed benefit nights there. Decastro himself was one such person, and on 22 September took his benefit at the Royalty Theatre. He had lost almost everything he possessed, including his prized three wigs that had once belonged to the famous actor David Garrick.

By 8 September, Astley was ready to lay the first stone of his new amphitheatre. An accomplished orator, he gave a rallying speech before his company and a great crowd of interested spectators. This was reported in *The Times* on 10 September; one of the very few records of Astley's public speaking:

FIRST STONE OF ASTLEY'S THEATRE

On Monday, Mr Astley, Sen. of Westminster Bridge laid the first stone of his New Amphitheatre, to be erected on the seite [*sic*] of the old one, lately destroyed by fire. The ceremony was performed at ten o'clock in the morning, in the presence of his troop, consisting nearly of 100 persons and a vast concourse of spectators. Mr Astley, in a speech nearly as follows, thus addressed his Company, viz.

'Gentlemen, the hand of Providence, which lately visited the Royal Saloon, and reduced it to ashes, as you now see, has occasioned a loss to us beyond all calculation; and which, indeed, is the more felt by myself, as it so soon followed that of my property in a neighbouring kingdom

[France], amounting to 12,000l. in consequence of a decree for the confiscation of British property. My Amphitheatre, which occupied this spot, having become a prey to the flames, nothing was to be done for the moment, but to find out a situation, in order to employ a part of the troop; the Lyceum, in the Strand, was accordingly engaged by Mr Astley, jun; and it is with pleasure I now inform you, that the inhabitants of London, feeling for my loss, have rendered the receipts at the Lyceum far beyond my expectations. I hope, by perseverance and industry, to re-establish myself on this ground; for which purpose I now deposit the first stone, relying on Providence, and on the patronage of a generous Public. Gentlemen, the time draws near, when you are to depart for Dublin, to witness that hospitality which you have so long and so often experienced. My best thanks are due to you, as also to the parishioners of Lambeth, and various other Gentlemen, who endeavoured to rescue, at the hazard of their lives, a part of my property from the flames; and believe me, that no time, circumstance, or event, shall ever erase from my memory that sense of gratitude which is now impressed on my heart.'

In November, Astley junior opened the Royal Amphitheatre in Dublin for the winter season. It was a delayed opening for, as he explained in the *Saunders's News-Letter* of 12 November, he had had to purchase the whole collection of a superb wardrobe of costumes from the late manager of the opera house on the Haymarket in London to replace that which was lost in the fire. Astley senior, meanwhile, remained in London to personally oversee the building of the new amphitheatre. People marvelled at how rapidly the building progressed and many wondered how he could have raised the capital to do so. Box office receipts from the seasons at the Lyceum and the Dublin Royal Amphitheatre were exceptionally good and perhaps this was a measure of just how popular his performances were, when the public were faced with the loss of such an important place of entertainment in London. Philip Astley had also written two new books, which were on sale in 1794: *Remarks on the Profession and Duty of a Soldier* and *A Description and Historical Account of the Places now the Theatre of War in the Low Countries*. Sales of these would have added to the coffers.

The New Amphitheatre of Arts and Sciences was opened to the public on Easter Monday, 6 April 1795. It soon became known as just the Amphitheatre of the Arts. The Duke of York was a patron and several public subscription performances were given to help defray the building costs. In design it had a more horseshoe shaped arena, rather than a circle, with a larger stage. It was planned so that every member of the audience should have an uninterrupted view and the new venue would be superior to any other place of public exhibition in England. The

opening performance was recorded in a pamphlet by H. Pace, grandly named *A New Prelude Founded on a late Calamitous Event entitled The Manager in Affliction, as performed at the New Amphitheatre of Arts Westminster-bridge Monday 6th April 1795*. The foreword to the pamphlet describes the events leading up to the building of the new amphitheatre but, perhaps more interestingly, Pace gives a description of the performance. It began:

> The curtain rises, and discovers a scene of ruins, similar to those occasioned by the fire at the late Royal Saloon. The manager is seen sitting in a dejected attitude on some part of the ruins. As the curtain ascends, plaintive music is heard, expressive of sorrow.

In addition to the role of the manager, other characters appearing in the Prelude included Destiny, Minerva, Hope and Britannia. At the end of the piece:

> Britannia waves her wand, and changes the scene to a MAGIFICENT SALOON, where the whole of the company is seen arranged in groups before the audience, to whom they bow. The dancers are discovered in action. Britannia waves her wand and dancing ceases. She addresses the audience with the following song:

Come what will of future bliss
Sure no scene can equal this?
British breasts devoid of guile
Beauty's fascinating smile
Honour, worth, and virtues rare
Rate this scene beyond compare.
Come and join in grateful chorus
Hail the prospect now before us.

With the opening of the new amphitheatre, there was much more emphasis upon theatrical performances at the expense of equestrian displays. Much of this was to do with Astley junior, who was leaning more towards the dramatic rather than equestrian. In that opening week the programme contained the Prelude, as above, a Pastoral Dance, a Comic-Musical piece. Equestrian exercises were still on the bill, but presented by pupils of Mr Astley (it does not specify whether this is Astley senior or junior), and a Tumblers' Medley. The evening was concluded with a Grand Pantomime and 'other entertainments'. This was to be the trend during the latter part of the decade. The New Circus on the Strand was still open and was presenting a more varied programme with Horsemanship, Tightrope Dancing,

Polander's Performances, and the still popular Taylor Riding to Brentford. The programme also included a new Pantomimic Dance but resisted the theatricals of its sister amphitheatre. Across at the Royal Circus, now in a period of resurgence, there was to be seen Slack Rope Vaulting and Equestrian Exercises, but these were supporting acts to a Burletta, a Pastoral Dance, and a new theatrical piece titled the *Prince of Candia*, with singing, dancing and action. The whole was to be concluded with a new Pantomime.

Admission prices for the new amphitheatre had increased, but Astley now employed a 'first' and 'second' price structure. People choosing to enter later could pay a cheaper 'second' price. Boxes were four shillings or two shillings; the Pit was two shillings or one shilling; and the gallery one shilling or sixpence. An innovation was the introduction of a season ticket priced at £2 12s 6d, tantalisingly offered as a 'Free Admission Ticket' for the season.

After the disaster of the previous year, Astley had bounced back with seemingly more vigour. He may have lost his amphitheatre in Paris but he now had a new one in London. He was also still using the New Circus in the Strand; Dublin was still going strong and he now had plans for Liverpool. Astley had first visited the city in 1773, where his company had performed in the open air in the Mount Pleasant area. He is not recorded again in the city until 1788, when they performed in the 'Royal Tent', an experiment under canvas. This was the portable riding school mentioned in Chapter 7, but it seems to have been short-lived and no further mention is made of it. Astley appeared at the Theatre Royal in Liverpool, although a circus had been opened on Christian Street somewhere around 1789 under the management of a Mr Tinker (sometimes Tinkler). In 1794, Astley appeared there and this caused a bitter argument between him and Mr Aikin (sometimes also Aickin), patentee of the Theatre Royal. Aikin gave Astley notice to quit the theatre, which he had rented for eight seasons at £100 per annum. In retaliation, Astley announced:

PROPOSALS FOR BUILDING an AMPHITHEATRE in the Town of Liverpool

Mr Astley having for a series of years rented from Mr Aickin the Theatre, and that Gentleman having given Mr Astley a certain form of notice to quit the same, he is under the necessity of immediately building an AMPHITHEATRE, for the following purposes; Music, Dancing, Pantomimes, Equestrian and other Exercises, Pieces of Mechanism, and Scenic Representations; for which purpose the sum of Five Thousand Pounds will be wanted, to complete the same. It is therefore proposed to build an amphitheatre by subscription, by way of Tontine [an annuity shared by subscribers], viz.

One hundred subscribers at fifty pounds each, to have a free admission ticket, on the same plan as the Theatre. The building to be held in Trust by six of the subscribers, by way of security. Mr Astley to keep the same in substantial repair, and pay every incumbrance [*sic*]. It is intended the Amphitheatre be open twice a year, viz. November and December, also July and August, and to continue three or more days in each week.

Further particulars will be made known on Mr Astley's arrival in Liverpool. In the meanwhile, such Ladies and Gentlemen as are inclinable to subscribe, either for themselves or families, are humbly requested to send their address immediately to Mr Astley, Westminster-bridge, London.

N.B. When the subscription is complete, Mr Astley will undertake to have the building ready in four months.

(*Gore's Liverpool General Advertiser*, 23 July 1795)

It is interesting to note that after the expense of building the Amphitheatre of the Arts in London, Astley appears not to have had the capital to invest directly in this Liverpool venture. He was relying very much upon his popularity pulling in the subscribers. Sir James Picton (1875) claims that the building was erected within six months. However, there is some dispute over this as Broadbent (1908) makes the point that Astley was back at the Theatre Royal in March 1796. He feels that if Astley had completed his own amphitheatre he would have been appearing there and not at the Theatre. Because of this he claims that Astley's attempt to raise the necessary capital failed and therefore he did not build such a venue. R. Brooke (1853) maintains that the amphitheatre was erected, and over the subsequent years and with many alterations it survived as the Adelphi Theatre, until its demolition in 1921.

The quarrel between Astley and Aikin continued unabated. In August, Astley felt obliged to publish Aikin's most recent letter and his response in the press:

Mr P. Astley, for the information of the public has thought proper to publish the following statement of the dispute between himself and Mr Aikin. The following is a copy of a letter received by Mr Astley.

Sir, Whereas on the third day of June last, I gave you notice to remove, and take away, within one month from the date thereof, all such scenery, machinery, dresses, and all other property whatsoever belonging to you, which was then lying and being in a certain Theatre, situate in the Town of Liverpool, in the County of Lancaster, and then and now in my occupation. And whereas the said goods and property are still remaining

in the said Theatre – Now, I do hereby give further notice, unless you remove and take away, or cause to be removed and taken away within fourteen days from the date hereof the said scenery ... I shall cause them to be removed at your costs and charges, from out of the said Theatre, to some warehouse, or other place of safety. Dated this sixth day of August, one thousand seven hundred and ninety-five. FRANCIS AIKIN

MR ASTLEY'S PUBLIC REPLY

Now I, Philip Astley, in consequence of the above paper being received by me, hereby declare, that I will not pay any rent or charge whatever. And I further give notice to all description of persons not to remove, or receive, under any pretence whatever, any part of my property, legally and peaceably deposited in the Theatre of Liverpool, for certain express purposes. And I do hereby caution the said FRANCIS AIKIN to be careful how he knowingly, wilfully, and unlawfully (not withstanding his illegal pretended month and a half's notice) deprives me of my goods and chattels, as well as the use of the Theatre in Liverpool (rented by me at one hundred pounds per annum); or from fair, open, and candid trial by jury, in open violation of the laws of England. And I, Philip Astley, further give notice to the said Francis Aikin, that I will oppose any unlawful attempt, either upon my person property.
London, 8th August, 1795, PHILIP ASTLEY
Witness; WILLIAM ADAMS
N.B. It is worthy of observation, that Mr Astley entered upon his eighth year of possession, prior to his receiving any notice, directly or indirectly, from Mr Aikin.

(*Gore's Liverpool General Advertiser*, 20 August 1795)

Threatening words indeed, and perhaps Aikin had not realised that Astley had had several encounters with the law in the past and he was well versed in his rights. Perhaps this very public statement by Astley caused Aikin to back down, for the matter appears to have been settled privately and Astley resumed performing at the Theatre Royal in 1796. So Liverpool became another performance base for the Astley empire.

In fact, 'circus', as a distinct multi-faceted popular entertainment form, had become well established across the country during the second half of the century. Whilst much of this expansion was due to Astley, there were others seeking to emulate him. By the end of the century there were permanent amphitheatres in Dublin, Bristol, Manchester, Liverpool, Edinburgh, Nottingham, Bath, and

London, owned and managed by a small number of proprietors. Indeed, circus was beginning to spread across Europe. Astley's influence had reached far and wide and there were now amphitheatres in France (albeit now under the management of Franconi), Spain, Italy, Serbia, Austria, Germany, Scandinavia, and even Russia. Hughes had been recommended to supply a stud of horses to the Imperial Court of Catherine the Great. He delivered them as commissioned, taking with him as ostler, according to Decastro, the estranged father of Philip Astley. Having the sense to take his own performing stud with him, he was invited to perform. The Empress was so impressed that she ordered an amphitheatre to be erected in St Petersburg and another, later, in Moscow. Hughes stayed in Russia for at least one year before returning to London. Circus also reached the newly founded America. John Bill Ricketts, a former pupil of Hughes, and later an equestrian at Jones's Amphitheatre, decided to try his hand across the Atlantic. Arriving in Philadelphia in 1793, he immediately built an amphitheatre. He travelled throughout America for the next seven years, building a least seven amphitheatres across the country. Wishing to return to England after this time, he sold his stud of horses and took ship for England, never to be heard of again. The ship, crew and passengers were all lost at sea; but it was through Ricketts that the American circus was founded.

Astley's continued to flourish. As well as regular seasons in London, Dublin and now Liverpool, touring groups visited the provinces under his banner. In May 1797, Astley was given the honour of another command exhibition before a royal party and their royal guests. This included the Dukes of York and Clarence, Prince Ernest and the Prince and Princess of Wurtemburg:

> The Prince had previously commanded Astley and his Troop of Equestrians to assemble in his riding-school, which was fitted up conformably to the Prince's plan, and under his immediate direction. ... The horse exercises commenced with Haydn's celebrated *Minuet*, danced by two horses, rode by Messrs Astley, sen. and jun. a performance much noticed by the Duke of Wurtemburg. This was succeeded by a train of Equestrian feats; at which the Royal visitors expressed to Mr Astley their entire satisfaction. At the head of the two troops appeared Young Astley and Handy, while the old Soldier directed his attention to the superintending and regulating the different species of entertainments. The exercises concluded with tumbling, and the performances of the Monkies [*sic*], which seemed to give great amusement.
>
> (*The Times*, 30 May 1797)

Such events only reinforced Astley's sense of loyalty and patriotism. His generosity towards the military was well received. He made seats available free of charge

to soldiers who had returned from the wars on the Continent. This made him very popular with the government, the military, and royalty. It also ensured him of full houses every night as many ordinary people wanted to see the brave soldiers who had fought for their country. In December 1797, he made the amphitheatre available, at a price, to the military for the cantonment of several hundred troops who had recently returned from the Continent. They were to attend the King on a procession to St Paul's. It was thought that keeping the men all together under one roof was a practical alternative to having them billeted around the city. Astley was quick to advertise this in the press, yet again endearing himself to the people through his generous, very public, actions.

It seems that John developed something of his father's adventurous spirit. Or perhaps he had spent too long listening to his father's stories of heroic military exploits. Never having shown any previous desire to enlist, on 20 June 1797 an announcement appeared in *The London Gazette* showing that 'John Conway Philip Astley, Gent.' had been commissioned as a lieutenant in the Eastern Regiment of the Surrey Provisional Cavalry. This, like many others around the country, was a volunteer unit that could be deployed if required to counter the threat of a rumoured impending invasion by the French. One imagines that Astley senior was immensely proud of his son carrying on the soldiering tradition. However, unlike his father, John would never see action.

The latter end of the decade brought mixed fortunes for Astley. His long-time rival, Charles Hughes, had been unable to sustain the successes that Astley had achieved. Earlier in the decade, the Royal Circus had gone through a period of decline and had been unoccupied for quite a while. In Union Street, Whitechapel, George Jones and James Jones (not related) had now established a venue for equestrian performances. Hughes encouraged them into negotiations with Lady West, the owner of the Royal Circus, and she granted them a repairing lease for twenty-one years at the rate of £210 per annum. Extensive renovations were carried out before it would reopen, but the licence was still in the name of Hughes. Not an astute businessman, he fell out of favour with the magistrates and lost the licence, which was then granted to George Jones. In early 1797, a Commission of Bankrupt was issued against Charles Hughes: 'Late of the Royal Circus, in the Parish of St George the Martyr, in the county of Surry [*sic*], Dealer and Chapman, but now a Prisoner in the King's Bench Prison.' (*The London Gazette*, 27 March 1797)

From being the proprietor of the Royal Circus he was now little more than a travelling salesman. He was a broken man and he died in poverty. He was buried on 13 December 1797 in the cemetery of St George the Martyr.

If Hughes had experienced problems with the law at this time, so had Astley. In August 1798, Thomas David Rees, a well-known mimic and stage imitator at the Royal Circus, incensed Astley with his burlesque imitation of him.

> Mr Rees, of the Royal Circus, having obtained a warrant against Mr Astley, of the Royal Grove, for an assault on his person, the latter appeared to answer the charge, which was very short, viz. only that of striking the prosecutor two or three times, and knocking him down on Friday evening. Mr Astley admitted that he had struck him, but the provocation was great. ... Mr Astley found bail to answer the charges at Sessions.
>
> (*The Chester Chronicle*, 24 August 1798)

The case went before the Kingston Sessions on 2 October. Accused of assault and threatened violence, Astley pleaded not guilty. However, by trial he was found guilty and was fined £5 before being discharged. The *Kentish Weekly Post* of 29 January 1799 gave a few more particulars of the case:

> It appeared, in evidence that Mr Astley did, on the King's highway, opposite his own door assault and strike Mr Rees. The defence set up was, that if Mr Astley had sustained any injury from Mr Rees, he should have pursued legal measures, and not have taken the law into his own hands, and accordingly gave their verdict – Guilty.

One might have thought that Astley would have had enough of dealing with the law, but no. In November of that year he was before the Court of King's Bench for refusing to pay the Sewerage Rate on his property Hercules Hall. Three gentlemen had been sent to inspect the property but Astley had brought an action of trespass against them and the case had gone to arbitration and had been awarded to the Commissioners. Astley continued to fight, not on the amount he was liable for – 17s 6d – but on a point of principle. His argument was that if he was liable, then 5,000 other properties were also liable to pay the rate. The matter rested on whether Hercules Hall was above or below the high water mark. The point was made that: 'Mr Astley was a loyal, gallant old soldier, but not sufficiently conversant in points of law. There was no doubt that persons whose premises were situated above the high water mark might be liable. (*The Times*, 10 November 1798)

Astley's case was refused and he remained liable for the appropriate rate. After his many dealings with the law over the years, one might imagine that to be told he had little understanding of the law must have been quite galling for him.

Events in Ireland also added to Astley's woes at home. Towards the end of May 1798, open rebellion broke out against the British. This was a planned action and the mail coaches leaving Dublin were seized as a signal for the uprising. Having seen the attempted French landing fail some years before, the British government felt confident that there would be no further support for the United Irishmen. The

rebellion was not well co-ordinated. Insurrection in the counties was not mirrored by events in Dublin. The crown retained control of the city while pitched battles were fought between rebels and British troops elsewhere. Throughout May and June, many battles were fought, with victories on both sides. Where government forces triumphed, particularly after the battle of Vinegar Hill in Wexford, retributions were quick and brutal. Rebel leaders were hanged and often beheaded, their heads being stuck on spikes for all to see. In retaliation, Protestant prisoners were piked to death, unleashing a wave of rape, plunder and murder upon rebels and their supporters. The British were startled in late August by the landing of a French force of about 1,000 men on the shores of County Mayo. This force, backed by rebels, made a striking victory against the British at Castlebar but by September the rebellion was running out of steam. The French were surrounded by a vastly superior British force at Ballinamuck in County Longford and surrendered. The French were treated as prisoners of war but the rebels who had joined them were summarily massacred. The short-lived rebellion had been crushed, with thousands of people losing their lives, mostly rebel Irishmen and their supporters. The legacy of this rebellion was to bring about the Act of Union in January 1801, giving the British parliament control over Irish matters.

The effect of all this upheaval was that Astley felt it appropriate to curtail his appearances in Dublin until such times as things calmed down. During this period he transferred to the Royalty Theatre in Whitechapel, although Astley junior continued at the Royal Amphitheatre on Peter Street until the end of February, to reopen for the winter season 1799 in the November. By March, Astley junior was opening at Westminster Bridge. Astley senior remained at the Royalty Theatre, and so, for a short time, the Astleys were running two shows in the city simultaneously. The performances were now leaning more towards the theatrical and dramatic, with exhibitions of equestrianism and other physical feats acting as 'fill-in' between the stage presentations. This format would continue for several years. So, in May 1799 at the Westminster Bridge amphitheatre could be seen an operatical ballet (introducing the Flying Cupids), a comic pantomime, and a new Spectacle Romance entitled *The Black Castle*, in which Astley junior would take the lead role. In addition to these stage performances there was the Troop of Equestrians, the Speaking (or Learned) Horse, and a Company of Trampoline Performers who amazed the public by flying over twenty soldiers, five horses and riders, and a pole 12 feet high. John Astley was moving more into a performer-manager role at the amphitheatre. As well as taking lead roles, he is credited with having written, composed and arranged the Operatical Ballet and with directing other parts of the entertainment. Astley senior had moved away from actual performing and was also creating new pieces. In September he is credited with having 'written, invented, adapted, planned, and arranged a new Military and Naval Spectacle of

Action entitled *The Philanthropic Female or The British Army in Holland*. Again, John Astley was responsible for directing the entire piece.

As the season drew to a close in September 1799, Astley senior announced that he would be withdrawing for ever his Little Learned Horse. Hidden in this announcement was the fact that Astley himself indicated his own retirement: 'As this singular little Animal cannot possibly be exhibited by any other Person whatsoever, he having been solely instructed by Mr ASTLEY, Sen. who after the present Season retires from any Public Capacity.' (*The Times*, 26 September 1799)

In fact, the Little Learned Horse continued to perform. In November 1800, it made an appearance in Ipswich with 'Astley's Celebrated Troop from London, superintended by Himself'. If Astley senior was the only person who could exhibit it, then the man himself had not yet quite retired. It seemed almost impossible for him to step down from the limelight; he was indefatigable.

Chapter 10

The final flourish: Astley's Olympic Pavilion

By 1801, John Astley had assumed sole control of both the Royal Amphitheatres in London and Dublin. After a brief appearance on tour in the east of England that year, Philip Astley began to take a back seat; it was John who was now in the ascendency. On 24 December 1800, he had married Hannah Waldo Smith, one of the rising stars at the amphitheatre. They had regularly worked together for many months and now, as Mr and Mrs Astley, they would achieve top billing for their dramatic presentations. John would still create and direct the pieces, as well as acting in them, but it was Hannah who would become the darling of the public.

During the winter of 1800/1801, the Royal Amphitheatre in London was closed for refurbishment and further development. The new building and new season was announced in *The Times* on 4 April 1801:

> Mr Astley jun. most respectfully begs leave to inform the Public … he has, during the Winter, entirely Re-built the Interior of the Amphitheatre; trusting that his Endeavours to render it one of the first Theatres of its kind in Europe.

By May, it was receiving praise in the popular press, not only for the performances but as a place of entertainment:

> The ROYAL AMPHITHEATRE, Westminster Bridge, under the management of Mr Astley jun. may now be considered from its elegant appearance; and the splendid and very able manner in which everything is produced, as not only a *horum* [latin; genetive plural of the word *hic*] of fashion and distinction, but, for real amusement and refined pleasure, the first place of its kind in the British dominions.
>
> (*London Courier*, 28 May 1801)

John Astley laid down strict rules and regulations for the performers at his theatres. The British Library holds a copy of these, which would have been on display. There are thirty-seven specified rules that were to be observed by all those performers engaged to perform there, and they included, with the attached forfeits:

That every person attend the theatre half an hour before the usual time of commencement	2/6
Gentlemen in liquor on the stage	1/1/0
Aggravating and offering blows	10/6
Defacing property	10/6
Addressing the audience without permission	5/5/0
Absent during a performance	10/6
Absence from a performance	1 week's salary
Eating and drinking	10/6
Unbecoming language	10/6
Sky Larking	5/5/0
Going on stage without the necessary properties	2/6
Making a noise or quarrelling backstage	5/0

Draconian rules they may seem to be but necessary for the smooth running of the performances. One wonders how much Astley actually took in fines each week; unfortunately there are no records. Although these specifically labelled rules belong to John Astley Esq., I am sure that Astley senior would have approved.

And what of Astley senior, apart from his brief tour of the provinces? Having handed over control to his son he was looking eastwards towards France again. Moves were being made towards peace on the Continent, and in October:

> When M. LAURESTON arrived in town on Saturday with the Ratification of the Preliminaries of Peace, Mr ASTLEY, the equestrian, being apprised of his coming, seized the opportunity of caressing the Minister, taking him in his arms in Downing-street, and giving him the fraternal hug.
>
> (*The Morning Chronicle*, 12 October 1801)

A strange and somewhat flamboyant way to greet a stranger it may seem, but both Astley and his son were Freemasons. In fact, John had founded the Royal Grove Lodge in 1787 (No. 240) and had been Worshipful Master the following year. The 'fraternal hug' was a Masonic form of greeting to a fellow brother and it is quite possible that Laureston was a Freemason. Peace was declared in April 1802 and Astley was once again free to travel to his properties in Paris, which he did almost immediately. His amphitheatre, which he had leased to Antonio Franconi at the outbreak of the war, had been initially requisitioned for military use but by 1795 had been reopened for daily use:

De cette date [1793] *aux premiers mois de la réaction, thermidorienne, les représentations ne purent avoir un cours bien régulier, disons toutefois, q'uelles eurent toujours lieu, à des intervalles plus ou moins longe, déterminés par les graves événements politiques qui se passaient tant à Paris qu'au delà des frontièrs. Le 25 novembre 1795, les exercices équestre recomencèrent quotidiennement et les Parisiens ne manquèrement pas de s'y rendre pour applauder les animaux savants et les écuyers.*

(H. Beaulieu, 1905)

[From this date [1793] to the first months of the Thermidorian reaction, the representations could not have a regular course, let us say, however, that always took place, at more or less lengthy intervals, determined by the serious political events which took place in Paris and beyond its borders. On 25 November 1795, the equestrian exercises recommenced daily and the Parisians did not fail to go there to applaud the learned animals and the horsemen.]

(Author's translation)

Astley made a personal appeal to the French government for the return of his property, along with compensation for the loss of rent during the period. Surprisingly, this was granted and Astley was able to take repossession. However, events were very short-lived. In 1803, Napoleon Bonaparte laid an embargo on all ports and all English persons in France were detained as 'prisoners of war'. His justification for this action was that such Englishmen in France could be liable for militia duty against him. No more than 1,000 English nationals were detained, including Astley and his three nieces. Some managed to escape before the detention was in place, others petitioned for release on various grounds. Astley applied for permission to go to Piedmont on the grounds of ill health and this was granted. Decastro paints a vivid and heroic picture of his escape: 'As soon as he was able to travel far from the town, he drew a brace of pistols and forced the postilion to make with all speed for the frontier.' A fitting description for Astley, the man of action.

The Morning Post of 23 September 1803 gives us a slightly less dramatic account, and one presumably gathered from Astley himself:

About five weeks ago, on application to the Minister of the Interior, Mr Astley obtained a passport to go to Piedmont, where he proposed residing a few months for the benefit of his health. Thus provided, he set out from Paris, and proceeded leisurely to Frankfurt on the Main. On his arrival there … he determined at all hazards to make an effort to return to

his native country; and embarking on a boat on the Main, he took the first opportunity of proceeding towards the Rhine; and ere long found himself in the Prussian territory of Westphalia. From thence he continued his route by easy stages through the Northern Countries, and at length reached Husum, the place of his embarkation … and, after a tedious voyage, landed in England on Monday last.

No mention of pistols, or breakneck, daring-do escapes in this account; it all seems rather genteel and tiresome. Did the story of his escape become more embellished with every retelling, until we have the image of our hero brandishing pistols handed down to us through popular history?

In addition to the loss of his Paris amphitheatre, 1803 saw a series of personal tragedies for Astley. Earlier in the year, his sister Sarah Gill had died; it had been her three daughters that Astley had taken to France. While he was abroad, it was announced that his wife, Patty, had also died: 'On Thursday last, after a long and severe illness, Mrs P. Astley, mother to John Astley, Esq. of the Royal Amphitheatre, Westminster-bridge, aged 61.' (*The Morning Post*, 29 August 1803)

Was the illness commented on in her letter of 1786 part of her long and severe illness? It does seem strange that, if she was so ill, Astley should have taken himself off to France. It also strikes me as odd that she should be described as the 'mother of John Astley' rather than the wife of Philip Astley. Could this perhaps have some reflection on the relationship between Philip and Patty at this time, or of the prevailing public feeling towards Astley senior and junior?

More significantly for Astley I am sure was the fact that the Royal Amphitheatre was again destroyed by fire. It was reported widely, and in graphic detail, as here in the *Staffordshire Advertiser* of 10 September 1803:

On Friday morning, about two o'clock, a dreadful fire broke out at Astley's Amphitheatre, Westminster Bridge. … The utmost terror and dismay took place among the inhabitants … the whole Theatre was in one tremendous blaze, which every moment threatened destruction to the surrounding neighbourhood … the fire continued to rage with great fury, and was spreading rapidly to the adjacent houses … when the flames were got under, after every part of the Theatre was consumed, and nothing but part of the walls to be seen. … The greatest calamity … was the death of Mrs Woodman, the mother of Mrs Astley, late Miss Smith. Mr and Mrs Astley had gone on Thursday to their country house at East Sheen. The deceased was left with a servant to take care of their house in the front of the Theatre. … The flames had spread through the lower part of the house before she could get down stairs; a ladder was put to

the window, from which she might have been taken out to safety, had she immediately come away, but it is supposed that she wanted to preserve a small trunk or box, in which were deposited a quantity of money … jewels … &c. belonging to Mrs Astley. … As she was coming to the window a second time, and just as the gentleman who endeavoured to save her was taking hold of her arm, the floor of the room gave way. … In the course of Friday, part of this unfortunate lady's remains were dug out of the ruins. … Neither her head nor her arms were found that night. … Messrs Astley's loss is stated as £30,000, and they are only insured for £1,700. The poor performers all lose their benefits, and are thereby deprived of the means of clearing off many an annual score.

It was Philip Astley's *annus horibilis*. In the course of the year he had lost his Paris amphitheatre, his London amphitheatre was destroyed and he had to sell the Dublin amphitheatre due to the political turmoil in that country. His wife had died, as had also the mother-in-law of his son. For many lesser men all of this would have been too much. But the Astleys were to bounce back yet again. Headed by John, the Royal Amphitheatre was rebuilt, at great expense and with great speed, and was ready for reopening for Easter Monday in April 1804. It was bigger and better than anything previous:

The boxes are painted pea green, edged with pink, the tout ensemble of which is particularly pleasing. The gold triage over the stage had a very grand effect. This is surmounted by the arms of the Union painted in a beautiful manner. In the middle of the Theatre a most superb chandelier is suspended, constructed in a novel manner, the branches of which are elegantly cut, and when it is lighted up exhibits a most dazzling and brilliant appearance.

(*The Morning Post*, 3 April 1804)

It must have appeared a grand visual display. Charles Dibdin (the younger), son of Charles Dibdin of Royal Circus fame, wrote an account of the Royal Amphitheatre in 1824, giving a detailed architectural description of the building:

The front, which is plain and of brick, stands laterally with the houses in Bridge Road, Lambeth, a short distance from Westminster Bridge, the access to the back part of the premises being in Stangate Street. There is a plain wooden portico, the depth of which corresponds with the width of the pavement, and is lighted by large gas lanterns. This leads to the boxes and the pit, the gallery entrance is lower down the street and separated

from the front by several houses. The boxes are approached by a plain staircase, at the head of which is a lobby, which is 11 feet and 9 inches in depth, and about 6 feet wide, with passages behind the side boxes; at the back of the lobby is a fruit room. There are long seats attached to the wall of the lobby, all round, and in the centre is a large and handsome patent stove. The backs of the boxes, from about 5 feet from the floor, are entirely open to the lobby, which is customary at most of the minor Theatres. The form of the auditory is elliptical, and is lit by a very large cut lustre, and chandeliers with bell lamps; gas is the medium of illumination used all over the premises. There is one continued row of tier of boxes around the auditory, above the central part of which is the gallery, and there is a half tier of upper boxes on each side, with slips over them. There are three private boxes on each side adjoining the proscenium, and one at each end of the orchestra. The floor of the ride, within the auditory is earth and saw–dust, where a ring or circle 44 feet in diameter, is bound by a boarded enclosure. ... The proscenium is large and movable, for the convenience of widening and heightening the stage, which is perhaps the largest and most convenient in London.

The new season's entertainments were as sumptuous as their surroundings. Following the growing trend for grand theatrical equestrian representations, Astley junior had devised and written a new spectacle entitled *Zittow the Cruel*, supported by other equestrian exercises and Mr Richer's rope dancing. The programme changed weekly, and was soon followed by another of Astley junior's creations, an adaption of Ovid's *Pyramus and Thisbe*. In this, Mrs Astley played the leading female role of Thisbe. Supporting acts included equestrian exhibitions, new songs, a Caledonian Ballet of Action, a Troop of Jumpers and a new Harlequinade. It was not long before Astley junior was on the stage himself once more. By September he was presenting his acclaimed work *The Black Castle*, in which he took the lead of Asphar, opposite his wife's role as Lamora. He also presented a new comic pantomime, *The Silver Star*. Although by now he was not presenting his own equestrian act as often as once he had done, he was developing into a talented deviser, writer, arranger, composer, director and actor – as well as manager. His talents had now eclipsed those of his father.

But still Philip Astley could not completely let go of the empire he had created. Decastro attributes the following quote to him: 'Jemmy, I'll never let the reins altogether out of my hands any more; for I'll always have a horse in the team; and keep the whip hand.'

John was well established at the Royal Amphitheatre and the Royalty Theatre, although he only had a half share in the business. Astley senior had sold his half

share to a consortium of other performer/managers: Parker, Handy, Crossman and Smith. Davis, the renowned equestrian who had toured with his stud under the banner of Astley, also had a part share in the enterprise and he would eventually become manager, and the amphitheatre eventually known as Davis's Amphitheatre. By 1805, Astley senior was embarking on a new project for himself. In August, he signed a lease with Lord Craven for premises that were to be called the Olympic Pavilion. The lease was to run for sixty-one years from 29 September 1805, subject to payment of £100 quarterly, clear of all taxes and rates. The terms of the lease were that Astley would agree to erect and furnish a theatre, according to the plans of Lord Craven's surveyor, within four years, and to lay out in its completion the sum of £2,500. He was also to maintain the building, not to carry out any offensive trade or business on the premises, nor do anything that might cause a nuisance to the neighbouring tenants. The new theatre was to be built in the Drury Lane area upon the site of Craven House, which was demolished. The main entrances were on Newcastle Street and Wych Street. The construction of the Olympic Pavilion took over a year to complete; Astley had lost some of his vigour and drive by now. Using timbers from an old French warship a conoid, tent-like structure was erected. The roof was covered with squares of tin sheet, which caused strong vibrations to the accompanying music during the performances. The new Olympic Pavilion opened in September 1806, to much acclaim, and within the first week his performances were sold out.

> The general applause bestowed on the several performers, from Box, Pit, and Gallery, is highly flattering to the Manager. … The great number of Nobility, &c. who are nightly disappointed of places, arises, no doubt, from a special desire of all ranks to witness the unprecedented spirit of emulation in the Equestrian Department in general, for the palm of public favour. This strong trial of skill, d'Exercices, d'Equitation, the Manager has the pleasure to announce, will continue every Evening this week, to begin at Seven o'clock precisely, in the following order: – 1st Class, Grand Cavalcade. – 2nd Class, Horsemanship on One, Two and Three Horses. – 3rd Class, an Operatical, Pantomimical Ballet, called The HIBERNIAN REAPERS. – 4th Class, an uncommon Trial of Skill, by young Equestrian Artists. – 5th Class, Sagacity and Docility of the Horse. – To conclude with a Serio-Comic Pantomime called The INDIAN CHIEF; or, British Heroism.
>
> Boxes 4s; Pit 2s; Gallery 1s – Places for the Boxes to be taken from eleven o'clock till three.
>
> (*The Public Ledger and Daily Advertiser*, 26 September 1806)

Astley had returned to his forte: the horse. He was still to present comic ballets and pantomimes but it was the horses that drew great crowds; the age of the Hippodrama had fully arrived. Earlier in the decade, both the Royal Amphitheatre and the Royal Circus had begun presenting lavish theatrical presentations in which horses played a central role; John Astley had already embarked on this trend with productions such as *The Black Knight*, a copy of which exists in the British Library. Hippodrama was essentially melodrama on horseback. They were often less historically based and more romantic and chivalric in genre. Astley senior had relied earlier in his career on recreating famous British victories in the ring and these did involve many horses and men. Heroic battles were portrayed, albeit with a patriotic slant, and these bolstered the public spirit during a period of lengthy attrition abroad. Now, there was more emphasis upon the narrative rather than just the presentation; loose storylines were interwoven with spectacular scenes of battles and historical pageants. The structure of an evening's entertainment at Astley's now followed the pattern of some form of grand hippodramatic presentation as an opener, with a comic pantomime or harlequinade to conclude. These would take place predominantly upon the stage, along with ballad singing and dances. In between would be a series of other interludes and performances, supported by clowns to the acts, such as tumbling, slack and tight rope, equestrian exercises, and feats of strength and balance, all of which took place in the 'ring'. The hippodramas were especially popular, and Decastro records that a production of *The Blood-red Knight* in 1810 made a profit of £18,000 during the season.

Astley's Theatre (the Royal Amphitheatre) and Astley's Pavilion dominated the scene during the first decade of the nineteenth century, being regularly supported by royalty and the nobility. The two companies would often perform in both places, so that we find Astley junior and his wife on bills for both venues; the summer season at the amphitheatre and the winter season at the Pavilion. In the provinces, Powell's troop of equestrians were touring under the banner of Astley with a rising star by the name of Andrew Ducrow. He would later become the finest equestrian performer of the age and the manager of Astley's. It was a golden age, but not without its incidents. The audiences were always unpredictable and records show that glass bottles were thrown from the gallery, thefts occurred, and duels arranged. The performers took this all in their stride, including the heckling:

The Clown at Astley's, feeling himself greatly annoyed on Tuesday evening by a respectable man in appearance, in the pit, no longer able to endure his impertinence, addressed the audience in these words – 'Ladies and Gentlemen, that man (pointing very significantly to him) is very much like myself; the only difference between us is this – I am paid for making myself a fool, he makes himself one for nothing.' The

Clown received the general approbation of a most crowded and fashion-
able audience, and his opponent was quiet during the remainder of the
performance.

(*The Morning Post*, 11 June 1810)

The old Royal Circus had closed and its interior redesigned. It then reopened with
the name of the Surrey Theatre, under the management of Elliston; it now con-
centrated on presenting burlettas and comic operas. There was little competition
for the Astleys, apart from the Sadler's Wells theatre. This still presented a more
variety based programme, and of course, was the home of the most famous stage
clown of all times, Joseph Grimaldi. But it was to be Mr Davis who was the undo-
ing of Astley senior and his Olympic Pavilion. By March 1810, Davis had decided
to take his stud of horses and leave Astley, to establish his own riding school on the
Edgware Road. Attached to the school he erected a theatre and there presented
horsemanship, equestrian feats and other entertainments, including vaulting, tum-
bling, tight and slack rope dancing. This was a blow to Astley but, undaunted, he
began a programme of enlarging the Pavilion 'to outdo all others'. It was an expen-
sive venture that included strengthening the stage to take the weight of 100 horses.
The stage could be altered in shape and enlarged if required. It could also be com-
pletely removed for equestrian exercises, but all this took time and was not good
for a restless audience. *The Morning Chronicle* of 27 December 1811 described it
as: 'A dramatic stage, which takes off like the lid of a snuff box, forming a beautiful
scenic bowling-green for the equestrian exercises.'

The stage was 50 feet wide, 50 feet high and 60 feet long, with the scenery and
mechanisms required for performances taking up three fifths of the space. To draw
the crowds, Astley now introduced pony traces. These small 'Forest Ponies' were
ridden by young children:

WANTED immediately – several additional Young Practitioners,
under ten years of age, of some little Equestrian knowledge to ride in
a groupe [*sic*] of high blood forest racers, only 39 inches high; such
horses being intended for some Theatrical Amusement, at present in
active rehearsal.

(*The Morning Chronicle*, 28 November 1811)

These proved popular and along with the expansive melodramatic spectaculars
still attracted an audience. Bigger and better seems to have been the mantra of the
Astleys. In January 1812, Astley junior arranged, 'In the course of the Spectacle
various splendid processions, introducing the largest and most sagacious Elephant,
in this kingdom.' (*The Morning Chronicle*, 21 January 1812)

The elephant belonged to the menagerie owner Mr Polito, and had been procured by Astley at tremendous expense, probably the first elephant to be used in public performance, rather than being on display in a menagerie. But after this highlight of the winter season, the entertainments at the Olympic Pavilion the following season were reduced to comic songs, dances, pantomimes and harlequinades. The grand spectacles were too elaborate and expensive to stage, and the box office takings did not warrant the outlay. The Westminster Bridge Amphitheatre was still going from strength to strength, with seemingly more expansive hippodramatic spectacles. But it was a larger venue and could hold about 2,500 people, as opposed to the smaller Pavilion seating only about 1,500. Astley senior was reduced to including pugilistic sparring (boxing) contests as entertainments. Audience numbers dwindled and the days of the Pavilion were numbered. He decided to put the Pavilion on the market and soon Robert Elliston, formerly at the Surrey Theatre, made him an offer of 3,000 guineas and an annuity of £100. Astley readily accepted. He was seventy-one years old and now ailing. His life as an impresario had finally come to an end. He had created, and lost, an empire but the legacy of his pioneering work would continue with his son, and those who followed in their footsteps.

Now in ill health, he was advised to retire to his property in Paris to recuperate. His son John accompanied him and while there began negotiations to open an English theatre in the city. He returned to England in August 1814, leaving his father at his house on the Rue du Faubourg. Philip Astley died, from gout of the stomach, on 20 October 1814, and was buried in the Père Lachaise cemetery in Paris. For someone who had lived his life fully in the public eye, and who had such an influence, he died in relative obscurity. His passing was covered in many British newspapers but only in one or two sentences in the 'death' notices.

In his will he appointed seven executors, amongst whom were his sister Elizabeth Harding, a nephew Robert Hall, and his three maternal nieces from his sister Sarah Gill: Sophia Elizabeth, Amelia Ann and Louisa. One might have expected his son John to have been one of the executors, but not so. He empowered the three nieces to handle the financial management of his estate, and for doing so he directed that all three should deduct a quarterly payment of £8 each. The balance of monies held in the estate was then to be handed quarterly to the other two executors – Vincent Declieve and Mr Thomas Romney. After all debts, rents, annuities etc. had been paid, the quarterly balance was to be given to John Astley. Philip Astley then directed that, should John die without issue, all rents and profits from his leasehold properties were to be divided into sixteen shares as follows: two shares to his sister Elizabeth Harding; one share to his nephew Robert Gill; one share to nephew Robert Hall; three shares to niece Sophia Elizabeth Gill; two shares to niece Louisa Gill; three shares to niece Amelia Ann Gill; two shares to

niece Harriet Lavenu (née Gill); and the last two shares to his daughter-in-law Hannah Astley. In the event of any of those named dying, their shares were to be passed to Elizabeth Lavenu and John Lavenu, children of Harriet Lavenu. He also made specific monetary bequests to the named above and to another nephew, Philip Taylor. He instructed his executors to dispose of all his properties in France as they saw fit, including the amphitheatre, buildings, tenements and shops in the Rue de Faubourg. The property at Hercules Hall and all its contents were left to the three nieces Gill, as was the copyright on all his publications. This was in recognition of the care and assistance they had given him during his illness. However, he also authorised that his son, should he so wish, have use of Hercules Hall and the attached stables and coach house for as long as he should judge proper.

He was as generous and judicious in his will as he was in his lifetime. He did not suffer fools gladly and he was well aware of John's failings. He knew that if he left everything to his son, without any control, his estate would soon have disappeared. As it happened, John had no children and only outlived his father by seven years, dying in the same bed as his father had done in Paris, on 19 October 1821. He was only fifty-four and had been suffering from a liver complaint. He was buried near his father in the Père Lachaise cemetery in Paris. Unlike his father's five-page will, John's barely filled one page and left everything to his 'beloved wife', Hannah Waldo Astley.

The reign of Astley, father and son, had finally come to an end. But it was not the end of Astley's. Successive managers would keep it going – Davis, Ducrow, Batty, Sanger, all famous in their own right – until it was finally demolished in 1893. But for many the name of Astley would always be associated with the circus.

There is no place which recalls so strongly our recollections of childhood as Astley's. It was not a 'Royal Amphitheatre' in those days, nor had Ducrow arisen to shed the light of classic taste and portable gas over the sawdust of the circus; but the whole character of the place was the same, the pieces were the same, the clown's jokes were the same, the riding-masters were equally grand, the comic performers equally witty, the tragedians equally hoarse, and the 'highly-trained chargers' equally spirited. Astley's has altered for the better—we have changed for the worse.

(*Sketches by Boz*, 1850)

Select bibliography

Anderson, M.S., *War and Society in Europe of the Old Regime*, Fontana, London, 1988.

Astley, P., *The Modern Riding Master*, London, 1775.

Astley, P., *Remarks on the Profession and Duty of a Soldier*, London, 179.

Astley's Cuttings from Newspapers 1768–1856, (BL).

Beaulieu, H., *Les Theatres de Boulevard du Crime*, Daragon, H., Paris, 1905, (BNF).

Bemrose, P., *Circus Genius: A Tribute to Philip Astley 1742–1814*, Newcastle-under-Lyme Borough Council, 1992.

Boswell, J., (ed. Pottle, F.), *Boswell's London Journal 1762–1763*, Yale University Press, 1950.

Broadbent, R.J., *Annals of the Liverpool Stage*, E. Howell, Liverpool, 1908.

Brooke, R., *Liverpool as it was during the last quarter of the eighteenth century 1775–1800*, J. Mawdsley & Son, 1853, Liverpool.

Bruce, F., *Showfolk: An Oral History of a Fairground Dynasty*, NMS Enterprises Ltd., Edinburgh, 2010.

Burke, H., *Jacobin Revolutionary Theatre and the Early Circus: Astley's Dublin Theatre in the 1790s*, Theatre Research International, Vol. 31/1, 2006.

Cannon, R., *Historical Record of the Fifteenth or the King's Regiment of Light Dragoons, Hussars*, J.W. Parker, London, 1861.

Chandler, D., *The Art of Warfare in the age of Marlborough*, Batsford Ltd., London, 1976.

D'Alméras, H., *La Vie Parisienne*, Paris, 1909, (BNF).

Decastro, J., *The Memoirs of Jacob Decastro, Comedian*, Sherwood, Jones & Co., London, 1824.

Dibdin, C., *An Account of the Royal Amphitheatre, Westminster Bridge*, London, 1824, (BL).

Dickens, C., *Sketches by Boz*, Chapman & Hall, London, 1850.

Fawcett, W., (trans.), *Regulations for the Prussian Cavalry*, London, 1757.

Fitzpatrick, W.J., *Ireland before the Union*, W.B. Kelly, Dublin, 1869.

Frost, T., *Circus Life and Circus Celebrities*, Chatto & Windus, London, 1881.

Hayter, T., *The Army and the Crowd in mid-Georgian England*, Macmillan Press Ltd., London, 1978.

Jenkins, J.G. (ed.), *A History of the County of Stafford; Vol. 8*, London, 1963.

Kemp, A., *15th Hussars Dress and Appointments 1759–1914*, Almark Co. Ltd., London, 1972.

Kwint, M., *Astley's Amphitheatre and the Circus in England 1768–1830*, Ph.D. thesis, Magadalen College, University of Oxford, 1994.

Manning-Sanders, R., *The English Circus*, Werner Laurie, London, 1952.

Mattfeld, M., *Undaunted all he views: The Gibraltar Charger, Astley's Amphitheatre and Masculine Performance*, *Journal for C18th Studies*, Vol. 37, No. 1, 2014. *Newspaper Cuttings, Olympic Theatre 1805–1821*, (BL).

Newspaper Cuttings, Olympic Theatre 1805–1821, (BL).

Pace, H. A., *New Prelude Founded on a late Calamitous Event, entitled The Manager in Affliction*, H. Pace, 1795, London, (BL).

Phillips, M., *William Blake: Apprentice and Master*, University of Oxford, 2014.

Picton, Sir J., *Memorials of Liverpool*, Liverpool, 1875.

Pinkerton, W., 'Astley's', *Once A Week: an Illustrated Miscellany of Literature, Art, Science and Popular Information*, Volume VIII, December 1862 to June 1863, Bradbury & Evans, London.

P.J.B.N. (ed. and pub.), *Histoire des Chevaux Célèbres*, Paris, 1821, (BNF).

Raithby, J. (ed.), *The Statutes at large of England and of Great Britain from Magna Carta to the Union of the Kingdom of Great Britain and Ireland*, Vol. VVII, London, 1811, (PA).

Rendell, M., *Astley's Circus; The story of an English Hussar*, Mike Rendell, 2014.

Rimbault, E., *Notes and Queries*, Vol. 9, 17 June 1854.

Roberts, H. & Godfrey, W. (ed.), *Survey of London: Vol. 23 Lambeth, South Bank and Vauxhall*, London County Council, 1951.

Rudé, G., *Revolutionary Europe 1783–1815*, Fontana Press, London, 1985.

Saxon, A., *Circus as Theatre: Astley's and its Actors in the Age of Romanticism*, *Educational Theatre Journal*, October, 1975.

Schama, S., *A History of Britain: The British Wars 1603–1776*, BBC Worldwide Ltd., London, 2001.

Selby-Lowndes, J., *The First Circus: The story of Philip Astley*, Lutterworth Press, London, 1957.

Smollett, T., *The Expedition of Humphrey Clinker*, Penguin Books Ltd., London, 1967.

Stoddard, H., *Rings of Desire: Circus History and Representation*, MUP, 2000.

Tyrwitt-Drake, Sir G., *The English Circus and Fairground*, Methuen & Co Ltd., London, 1946.

Ward, S., *Sawdust Sisterhood: How Circus Empowered Women*, Fonthill Media, 2016.

Willson Disher, M., *Greatest Show on Earth*, G. Bell & Sons, London, 1937.

Worsley, G., 'Before the Big Top', *Country Life*, 3 December 1987.

Wylly, Colonel H.C., *XVth (The King's) Hussars 1759–1913*, Caxton, London, 1914.

Further resources from:

Bibliothèque Nationale de France (BNF): http://www.bnf.fr
Brampton Museum: https://newcastle-staffs.gov.uk
British Library (BL): http://www.bl.uk
British Newspaper Archive: http://www.britishnewspaperarchive.org
Chetham's Library: http://www.library.chethams.com
Digital French Newspaper Archive: http://www.gallica.bnf.fr
Imperial War Museum: http://iwm.org.uk
Internet Library of Early Journals: http://www.bodley.ox.ac.uk/ilej
Light Dragoons Museum: http://www.lightdragoons.org.uk
National Archives: http://nationalarchives.gov.uk
Parliamentary Archives (PA): http://www.parliament.uk
Staffordshire archives: https://staffordshire.gov.uk/leisure/archives
The Times Digital Archive: http://gale.cengage.co.uk
Victoria and Albert Museum: https://vam.ac.uk

Index